CONTEMPORARY
DRAWING

CONTEMPORARY
DRAWING

KEY CONCEPTS AND TECHNIQUES

MARGARET DAVIDSON

WATSON-GUPTILL PUBLICATIONS
NEW YORK

Published in the United States by Watson-Guptill Publications, an imprint of the Crown Publishing Group,

a division of Random House, Inc., New York.

www.crownpublishing.com

www.watsonguptill.com

WATSON-GUPTILL is a registered trademark and the WG and Horse designs are trademarks of Random House, Inc.

Library of Congress Cataloging-in-Publication Data

Davidson, Margaret (Margaret A.), 1949–

 Contemporary drawing : key concepts and techniques / by Margaret Davidson.

 p. cm.

 ISBN 978-0-8230-3315-7

 1. Drawing—Technique. I. Title.

 NC730.D278 2011

 741.2—dc22

 2010023294

Printed in China

Designed by Kara Plikaitis

10 9 8 7 6 5 4 3 2 1

First Edition

TITLE PAGE IMAGE Margaret Davidson, *Burning Gap*, 2009, soot and colored pencil on Rives BFK paper, 15 x 15 inches (38.1 x 38.1 cm) © 2010 Margaret Davidson; Photo: Nancy Hines

FRONT JACKET IMAGE Barbara Robertson, *Tilt,* 2009, archival pigment print, acrylic, collage, and graphite on paper on panel, 24 x 30 inches (61 x 76.2 cm) © 2010 Barbara Robertson; Photo: Nancy Hines

for my parents, Harold and Phyllis Davidson, with thanks

My words are only a fraction of the information this book is meant to convey. The greater understanding can be found in looking at the art, varied and wonderful, that is pictured here. It is to the artists and their various representatives that my deepest thanks go. Their willingness, professionalism, and deep commitment to the art of drawing show that a picture is indeed worth a thousand words.

Equally important to this book are the professional and dedicated Nancy Hines and Christina Olsen Burtner, photographer/manager and digital photographer at the Classroom Support Services Department of the University of Washington in Seattle. Their skills with film and digital, with computers and color, were absolutely essential and inspiring, and I thank them for their patience with me as well as for their abilities.

Many thanks go to those who provided critical reading: Anne Moon, Joseph Pentheroudakis, Fran Lattanzio, and Sharron Pollack, and also to the members of my drawing group: Kathleen Coyle, Anne Moon, Tannis Moore, and Sheila Siden. They may not realize it, but they provided great aid and comfort during the writing of this book.

I glory in art books, and do much of my art study within them. Special thanks go to Beth Dunn, owner of Art Books Press in Seattle, who shares this love and was tremendously helpful in finding books I wanted, and introducing me to those I didn't yet know I needed. Thanks also go to Ramona Hammerly, who loaned me some hitherto unknown books on design and aesthetics, and to Michelline Halliday for the loan of her materials on Walter Tandy Much.

The concepts and ideas on contemporary drawing presented in this book have grown and developed through my twenty-odd years of teaching art, the majority of which has been done at Gage Academy of Art in Seattle, Washington. I have been very fortunate in working for Pamela Belyea and Gary Faigin as the Executive Director and Artistic Director, respectively. They have designed Gage Academy from its very beginning to be a school that promotes multiple styles and many viewpoints. In so doing, they have created an environment in which I feel happy and creative, where I have been able to develop ideas as well as drawing, and for all that I heartily thank them.

It is also thanks to them that Candace Raney, Executive Editor at Watson-Guptill/Random House, saw some of my drawings and suggested the idea of writing a book to me. Many thanks go to her for patiently fielding phone calls and e-mails from me while I worked my way through various false starts to the present work. Also praise and many thanks go to editor Alison Hagge, who has happily and patiently corrected my errors and helped me state things more clearly. This book is much the better for her work.

Finally, my gratitude goes to my friend Susan Free, who agreed to assist me with all of the incredibly detailed and exacting tasks that go with acquiring image usage permission, and organizing this disparate pile of things—text, slides, transparencies, digital files, e-mails, and usage contracts (all the details that really matter)—into something organized and ready for the publisher. More than once Susan calmly solved a problem I found insurmountable, and kept me from being too encumbered to go on. My thanks go to her and to the rest of the Free family for helping with whatever was needed. With seedlings on the windowsill, newborn puppies in the corner, and bread baking in the oven, it was a pleasure to work on this book at their house, with those reminders all around that this task was not overwhelming after all, but just another part of a cheerful everyday life.

CONTENTS

INTRODUCTION
THE STATE OF CONTEMPORARY DRAWING

Drawing has changed.

Drawing has changed. Even the most cursory glance at some of the recent books and show catalogs—such as *The Drawing Book: A Survey of Drawing: The Primary Means of Expression* (2005); *Drawing Now: Eight Propositions* (2002); and even *Contemporary American Realist Drawings: The Jalane and Richard Davidson Collection at the Art Institute of Chicago* (1999)—show us drawings that are new and different, and show us an interest in drawing that is unprecedented.

This new, contemporary drawing is its own art form, and is no longer merely preparatory to painting or sculpture. Why is this happening? I think it is because artists have discovered that drawing, in its own right, is something unique and different from painting. It is an intense, sensitive, compelling, personal, and utterly direct art form, one with its own concepts, characteristics, and techniques. It is these main concepts of contemporary drawing, and their specific characteristics, that I am writing about in this book.

"Contemporary drawing" is a phrase that covers any and all drawing—realist, abstract, modernist, post-modernist—from 1950 to the present. It is not governed by any particular imagery, but instead by the understanding, held by all contemporary drawing artists, that the choices with which they contend, the choices that pertain to the concepts outlined in this book—surface, mark-making, space, composition, scale, materials, and intentionality—are essential for the delivery of the image and meaning of the drawing, or are themselves the image and meaning. These issues are not about *what* is drawn, though they certainly affect that. Instead they relate to *how* something is drawn: what material is used, on what surface, at what scale, using what kind of mark, incorporating what kind of space, and involving what compositional structure. This separation of the "how" from the "what" is, in my opinion, what makes contemporary drawing so significant and able to stand on its own. Regardless of whether the final image is recognizable or unrecognizable, these issues—which artists must sort through, and about which they make their choices—are known as abstract issues. To arrive at the finished image, artists must work out how they are going to draw, not just what they are going to draw. To be a contemporary drawing artist it is necessary to be aware of this, and to work with these abstract issues constantly.

The most important overarching concept of contemporary drawing is intentionality. The artists who create contemporary drawings work consciously and intentionally, making specific choices for specific reasons. Everything about contemporary drawing that makes it what it is comes from choice, from artists choosing one surface over another, one scale over another, one material over

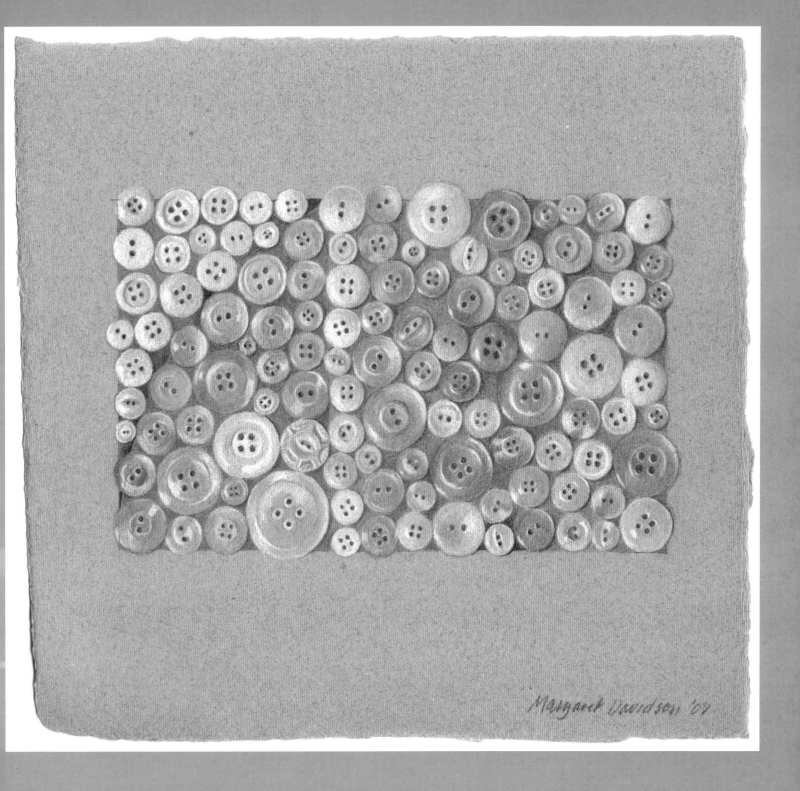

ABOVE Margaret Davidson, *Golden Button Mean*, 2008,
colored pencil on Twinrocker Cripple Creek paper,
8 x 8 ¼ inches (20.3 x 21 cm)
© 2010 Margaret Davidson; Photo: Nancy Hines

*Contemporary drawing often builds on the traditional, as in this
drawing, where the golden ratio was used as a structural foundation.
The colors and positioning of the buttons, and the colors of the
spaces, show the method of constructing a golden rectangle.*

The most important overarching concept of contemporary drawing is intentionality. The artists who create contemporary drawings work consciously and intentionally, making specific choices for specific reasons.

another. The reasons why artists make these choices vary, but there is always some kind of reason, some kind of logic, some kind of plan, and it is this logic and reason, this act of making choices intentionally and of planning, that is at the heart of contemporary drawing. Intentionality is an odd thing because it does not predict or preclude any particular kind of imagery. Every contemporary drawing artist behaves intentionally, even those who try to create randomly and without forethought. Choosing to do things randomly or letting chance guide your hand is still choosing, it is still an intentional act.

The first concept discussed in the chapters that follow is the drawing artist's deliberate choice of surface. What the surface is determines the nature of the mark. Furthermore, a focus on both the surface and the mark and the relationship between the two is one of hallmarks of contemporary drawing, and one of the most fundamental abstract issues drawing artists deal with. I believe this concept started with Georges Seurat, who developed his own stand-alone drawing style. Seurat's distinctive manner depended on using the nature of a certain textured paper to actively influence his black conté crayon marks, resulting in drawings that shimmer with crepuscular light, that are as much about the relationship of the marks to the surface as they are about the various subjects he drew. Artists today have taken the surface/mark relationship further by working on many other surfaces besides paper, including wood, glass, plant materials, stone, and cloth.

The second concept covered is mark-making, including discussions about the nature of different marks and the reasons behind different kinds of mark-making. One distinguishing feature of contemporary drawing is the choice being made by some artists of the source of the mark-making. Some artists let natural forces produce, or help produce, their drawing marks. Others look for cultural influences to map out or even control their mark-making. Many combine those two factors into a third realm of mark-making, wherein they set up the parameters but cannot foresee the outcome. Still others use machines to aid them in their drawings, with the machines sometimes being the mark-making tool and other times an aid to the artist's hand. These decisions to let outside forces influence the marks are made for a variety of reasons, and result in a huge variety of images, but they are all contemporary choices that add a significant layer of meaning to the drawings.

Third, as modern artists developed different kinds of space in painting (i.e., deliberately flat, deliberately giving the illusion of dimensional space, both flat and illusional together, and actually three-dimensional), contemporary drawing artists have pursued these different concepts further, in ways particular to both the materials and the techniques of drawing. The relationship between space and surface is a key thing, as well as the artists' intentions with illusion and reality.

The concept of space is incomplete without an examination of the fourth concept presented here: composition. Composition is a structure of one kind or another within which artists present their imagery and clarify their ideas. I will discuss two main compositional structures—the traditional and the modern—both of which keenly relate to space, and both of which are used by contemporary drawing artists.

Fifth is the fascinating concept of scale. Not until recently have drawing artists explored the respective realms of the very big and the very small drawings. Scale is a subject that I have approached from three points of view: how the scale relates to the artist, how the scale relates to the mark (which has to be quite different, depending on the size of the drawing), and how the scale relates to the viewer of the art, upon whom the impact is, maybe, the greatest.

Sixth is the concept of materials. The subject of paper, the most traditional surface used in drawing, is vast and varied—and with so many choices in fibers, textures, and colors, many artists choose to work just with paper. Thus, the materials chapter is devoted to the world of papers. (Since many contemporary drawing artists work on surfaces other than paper—in fact, this is one of the hallmarks of contemporary drawing—these materials are discussed in the various other chapters where these artists appear.) In addition, contemporary artists have many options of tools, with some made to create dry marks and some to create wet marks. Histories of these materials are provided, along with charts of various tools and a paper terminology list, all meant to help in knowing what to buy and how to buy.

The seventh thing I cover in this book is not really a concept, but rather an observation. Some artists today are crossing media boundaries, making drawings that are also sculptures, drawings that incorporate printmaking and video, or film/drawing mixtures that fit into both categories, and therefore are blurring the lines of distinction. There is plenty of legitimate argument about whether these works qualify as drawings. My point is that maybe the distinctions are less important than the art, and so if you find that following the

direction the art is taking you means going outside the boundaries, well, do it. In the end, the boundaries don't matter.

The eighth concept is intentionality, mentioned earlier. It is the thing that pulls this all together. For although these concepts are presented separately, they all interlock. Mark-making, for instance, is completely entwined with surface and with materials, not to mention scale and composition. The state of mind that sorts it all out and makes each concept understandable to artists and viewers as well is intentionality. Intentionality is something that must be learned, and then practiced on one's own art, and when looking at other art.

Included in each of the chapters in this book is an in-depth discussion about a specific technique. This is, after all, a book by a drawing artist for other drawing artists and for those who like drawings, and so I wanted to present more than concepts, but techniques as well. Like much of what is great about drawing, these technique presentations are mostly quite simple, but within each simple technique is depth and complexity, depending on how far you want to take it. That will, of course, be entirely up to you.

Drawing has come into its own, with contemporary drawing artists and viewers alike aware of how the abstract, formal issues are up front in drawing, fundamental to every decision and every move. This understanding is seen in artists today who work in vastly different sizes, with a large range of materials, on a wide variety of surfaces, producing every kind of image—from abstract to real and from temporary to eternal. The concepts followed, and the intentionality exercised, are the hallmarks that signify the value and uniqueness of this art form.

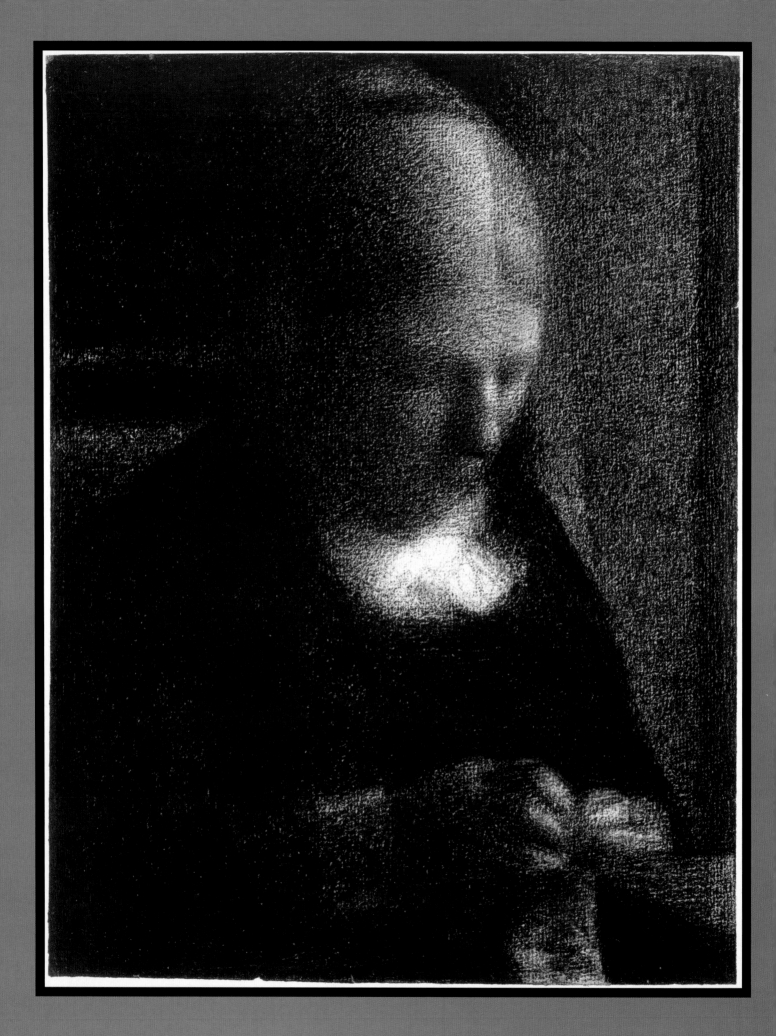

CHAPTER ONE

SURFACE

T he first concept I want to discuss is the drawing artist's choice of surface. This choice is now,
in contemporary times, important because the connection between the nature of the surface
and the look and meaning of the drawing is recognized and understood, and so is consciously and
deliberately decided upon by contemporary drawing artists. The surface directly influences the mark,
as well as the spaces around the marks, and so the choice of surface influences the choice of drawing
materials—and that in turn influences how the drawing is made, what it will look like, and what it will
mean. As obvious as this seems to us now, it was not always thought about in this way. The choice of
surface is so important that it comes first in this book, and tends to be one of the first decisions made
by drawing artists today.

A DELIBERATE CHOICE

What the surface is determines the nature of the mark, and focusing on the surface, the mark, and the relationship between the two, is a particularly important feature of contemporary drawing. This is easy to see if you simply draw a patch of tone with a 2B pencil on smooth paper, and again on rough paper. In the two sample swatches on the top of the facing page I used a Strathmore 500 plate bristol for the former, and Arches 140lb cold press watercolor paper for the latter. The tone looks gray and plain on the smooth paper, and spotty and bumpy on the textured paper.

The same thing happens when you draw an object on both kinds of paper, as seen in the image at the bottom of each of these two pages. The ball of yarn on the smooth paper is a more legible and realistic image that gives the viewer no reason to think about anything other than yarn. The ball of yarn on the textured paper breaks apart a little and becomes less realistic, calling attention to the textured surface itself. Because the surface thoroughly influences the nature of the mark, it thereby influences the nature of the meaning of the drawing. Furthermore, the surface itself can be the meaning; the medium really can be the message. When artists who are new to drawing start to realize this and make surface decisions consciously, they begin to understand one of the abstract issues in drawing, and begin to move into the realm of intentionality, which is a key factor in both modern and contemporary drawing.

BELOW Ball of yarn drawn with a 2B graphite pencil on Strathmore 500 plate bristol. The smooth surface allows me to draw plenty of detail and arrive at a full value range. Photo: Nancy Hines

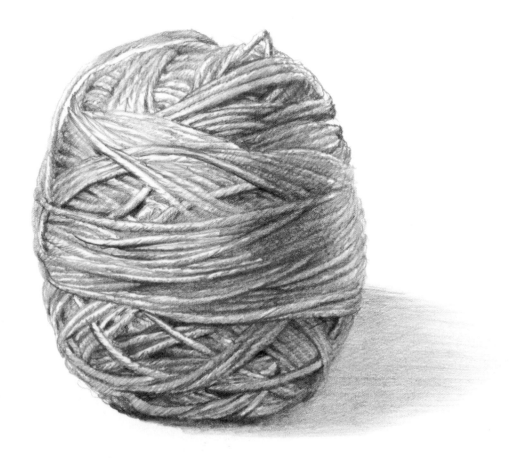

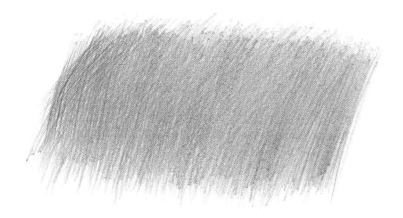

BELOW Ball of yarn drawn with a 2B graphite pencil on Arches 140lb cold press watercolor paper. This textured surface does not allow me to draw as much detail as the smooth paper, though I can get the same value range. Photo: Nancy Hines

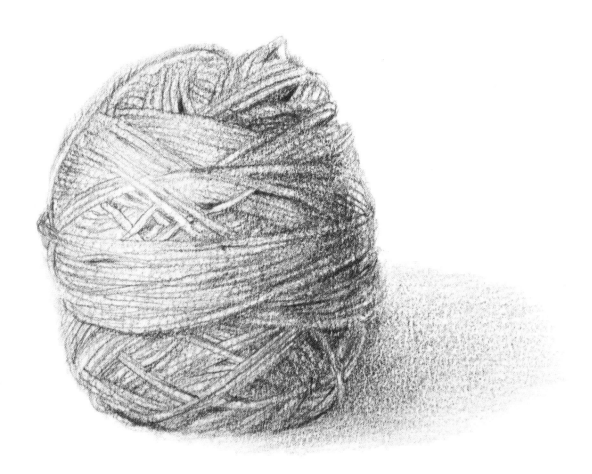

IT ALL BEGAN WITH SEURAT

This surface-mark relationship concept started with Georges Seurat. He was the first, I think, to develop a drawing technique that consciously explored the interrelatedness between the surface and the mark. He found that a textured paper limited a blunt crayon to speckly swathes of tone, with every mark broken apart and all opportunity for drawing tiny detail gone.

As Seurat pursued this technique, using the crayon in different ways, he found that his drawings showed form in a new way, with the marks defining space as much as object. With this new technique, Seurat created a series of drawings that shimmer with dark and light particles, drawings that seem to have solid forms with no outlines, drawings that are entirely dependent on these materials for the way they look—and so could not possibly have been made any other way. During Seurat's lifetime this concept was utterly new, and to this day it continues to be utterly contemporary.

The mature drawings of Georges Seurat show a deliberate, intentional inter-relatedness between surface and mark in order to arrive at edgeless forms and spaces, each sparkling with light and shadow. Seurat chose a toothy, textured paper on which to draw with black conté crayon. The crayon was incapable of being a refined, pointed tool, and the paper was too textured to allow much detail. The result is a collection of drawings that are both vague and subtly exact, seeming to be composed of the very particles of air surrounding the forms, as well as of the atoms of the forms themselves.

Because the bumpy paper has tiny hills and valleys, the crayon marks sit on the hills, leaving the valleys white. This is the case for any marks applied with light to normal pressure;

to get an area totally black he had to press the crayon hard enough to push it into the valleys—no mean feat. So each of the dark areas consist of a black tone with varying amounts of white flecks in it, the amount of white depending on the pressure applied, and every light area has varying amounts of black flecks in it. The total effect is a kind of pointillism, not of color, but of value. The result is a drawing technique unlike any other, a drawing technique that consists of the complete marriage of crayon marks that are too blunt to do more than suggest form, and toothy paper that is too textured to do more than allow form to be suggested.

This technique is dependent on the paper influencing the marks in three ways:

- It prevents strokes from being too detailed or too refined.
- It requires the artist to draw form according to light and shadow first and foremost, and not according to an outer edge, contour, or detail.
- It forces every crayon stroke to break into dots of black and white.

In this technique the shapes seem to be edgeless. The forms of people, carriages, and animals seem to advance from, and recede into shadow, entirely because of dots of white and black—dots that are created as much by the paper as by the conté crayon in the artist's hand.

This technique that Seurat developed on his own was unprecedented in his day, and remains so today. As far as I know, no other artist has worked this way, then or since. Other artists tried pointillism in painting, deriving from it what they would, and then moving on. But for some reason no other artist has taken on this particular drawing technique.

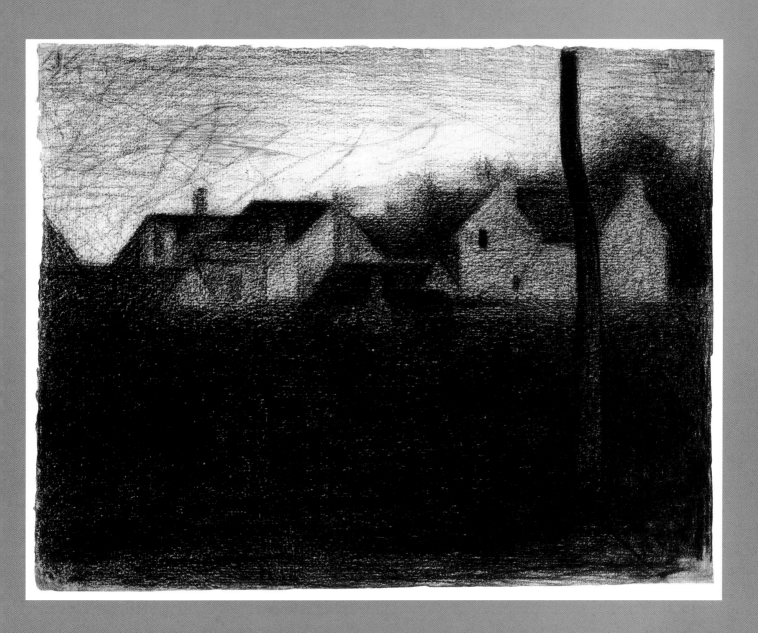

*Through a combination of various crayon marks that are influenced by
the textured paper, Seurat has achieved a great and subtle
range of tones, both in the lighter and the darker areas.*

COPYING SEURAT

There is wonderful scholarship on Seurat that is well worth reading and studying. (See bibliography.) However, real hands-on learning can also be gained by copying some of his drawings. By copying, one can get a sense of a technique, how it works, how it feels, and the kind of thinking needed to work that way. Seurat's technique turns out to be a complicated and difficult way to draw, as I learned when I copied his drawing called *Embroidery: The Artist's Mother*.

This drawing, which appears on page 12, is such an amazing drawing to look at, and is even more intense and fascinating to copy. It was drawn around 1882 to 1883 and the original is small, only 12 5/8 x 9 7/16 inches in size. This deceptively simple image consists of a woman sitting facing us, with the light coming from her left, looking down at the embroidery in her hands. In the lower foreground area on our right is the angled edge of a table.

As I worked on this copy I came to understand Seurat's subtle compositional structures. The strong vertical of the woman's body is quietly balanced by two horizontal parts of her chair, visible over her right shoulder. Her down-turned face is made more noticeable by the strong white collar, creating an area of high contrast and thus the primary focal point. Her hands are the secondary focal point; she is looking at them, and we naturally follow her gaze. Also, the table corner in the lower right serves both to point to the hands, and to form a sort of starburst shape with the hands.

LEFT My copy of Seurat's drawing, in its early stage, with the general areas blocked in. Using black conté crayon on cold press watercolor paper was difficult, and required me to work slowly. There is no erasing in this technique. Photo: Nancy Hines

To copy this drawing I tried to work at the same size that Seurat did. I also tried to work on a paper that was similar to the one favored by Seurat. He used a paper called Michallet. The Ingres paper mill today makes a sheet called Michallet, which they claim is the same paper Seurat used. In the book *Seurat: The Drawings* (the catalog from the 2007 exhibition at the Museum of Modern Art in New York), the scholar Karl Buchberg maintains that the actual Michallet paper used by Seurat is still not known for certain. Nevertheless, what is known is that Seurat's paper appears to have a laid surface—a surface that consists of rows of narrow parallel ridges all across the sheet—when used on one side, and a more overall bumpiness when used on the other. Seurat worked on either side of this paper.

For my copy, I worked on a readily available cold press watercolor paper, which has a texture similar to the back of the laid paper Seurat used. I found that, working with black conté crayon, I had to work slowly, taking care not to go too dark too soon in one area or another. In order to arrive at the softness that characterizes the edges of the figure, it was necessary to work the form from the inside out. I could lightly sketch in where the woman was positioned on the page, but as I worked on the tones, balancing the lights with the darks, I had to work all areas simultaneously and not allow an edge to get too sharp. Also, it was hard work to press the conté deeply enough into the valleys of the paper to get the darkest darks, with few or no white dots showing.

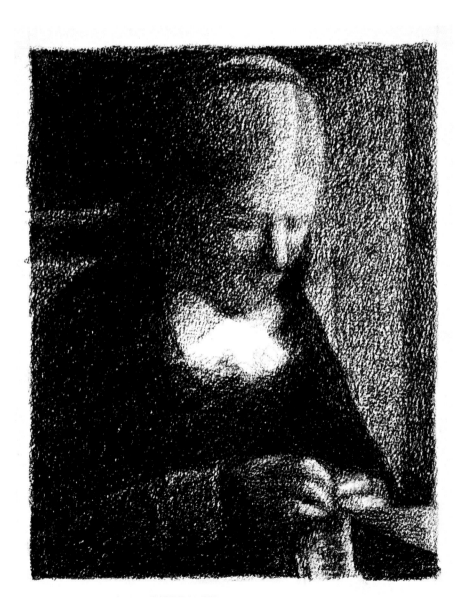

LEFT The finished copy of Seurat's *Embroidery: The Artist's Mother.* (The original appears on page 12.) This copy took several hours, over more than one sitting. Working in this manner is very intense, and demands constant attention. The most difficult thing is to keep the white and light gray areas light enough.
Photo: Nancy Hines

WAS THIS SEURAT'S INTENTION?

Can we be sure that Georges Seurat *intended* the paper to be as active a voice in his singular drawing technique as it is?

Could this style be a function, instead, of what paper was available, or what method he happened to stumble across? The answer, I believe, can be seen in the drawings themselves.

Seurat left behind something like 200 drawings. A few of them are early drawings he did as a student. These fully tonal figure drawings on a smooth paper show the classical training he received as well as a concentration on accurate form as revealed by strong contour, with shadow tones smoothly applied in parallel and gently hatched strokes. These drawings demonstrate that he certainly knew how to work this way, with the intention being to produce a sharp, clear, realistic image. But Seurat left this drawing style behind and did not return to it. Instead, the great majority of his drawings are done in his singular style of conté crayon on textured paper, a style that he invented, one in which no other artist worked at that time. We know he was trained in the classical style, and we know he had smooth paper choices available. But we also can see that he chose to draw with conté crayon on the bumpy paper for years, in fact for the rest of his life.

I can't think of any artist prior to Seurat who deliberately incorporated the nature of the surface into the act of drawing itself, so that the surface influenced the mark. But now, 120 years later, this is where we all are, and, in fact, because of Seurat, this is where we all *must* be. Because Seurat made the abstract issues of surface and mark as important as the subject matter of the drawing, he opened the door to contemporary thinking in drawing, to an abstract way of thinking and a sculptural way of drawing. His is the first drawing wherein the focus is not only on *what* but also on *how*, where the method of making the image is as important as the image itself. Seurat not only opened that door, but he also went through it himself, and now we artists of today are absolutely required to consider the surface/mark relationship whenever we draw. We are absolutely required to consider this in our own work simply because this idea, which is so powerful and fundamental, has been "said" in Seurat's drawings, and, once expressed, cannot be "unsaid." Instead, it has become the informing principle of everything that has come after.

THE RELATIONSHIP OF THE SURFACE TO THE MARK

Certainly, in all drawing, the nature of the mark is related to, in fact, is the result of, the nature of the surface. Artists have always had to choose among various surfaces to serve and support the tools they are drawing with. In the past, prior to Seurat, this decision was always made in the service of the narrative story of the drawing, what the drawing was a picture *of*. However, in both modern (1900–1950) and contemporary (1950 to present) drawing, thanks to Seurat, artists have a choice between making a drawing that is based on or about the image, or making a drawing that is based on or about the surface/mark relationship. This means that when selecting the surface to work on, the artist must decide whether he is choosing according to what best works for the picture, thereby choosing a surface that allows the mark to be in the service of the image, or choosing the surface according to what works best when the mark itself is the image.

The former is what many artists, both realist and abstract, tend to do. They choose a surface wherein the mark has a quiet, smooth time of it so they can concentrate on the image, because the image is the vehicle of their ideas. Realists often like a smooth surface so they can readily move the drawing into the realm of dimensional space and form, the illusion of reality, without disruption or distraction from the surface. When looking at some abstract drawings you can see the same decision being made by those artists, choosing smoother paper so that the imagery is unimpeded by the surface and the ideas are not hijacked by the texture. Smoother papers allow the mark-making to flow in an uninterrupted way, whereas textured papers have their own voices, which are sometimes loud, and always require a certain amount of attention. To put it metaphorically, smooth papers are quiet and accommodating, whereas textured papers are opinionated and assertive. Both kinds of surfaces contribute to the image in very different ways, and both kinds of surfaces are deliberately and consciously assessed and decided upon by both modern and contemporary drawing artists.

Since smooth surfaces are easy and accommodating to work on, and both realists and abstractionists often choose them, what is the value of textured surfaces—who bothers to work on them? The answer is that the textured paper, the opinionated surface, is essential to certain kinds of drawings, drawings wherein the artist, like Seurat, is deliberately seeking that interaction and interplay between the mark and the surface. One way that this is done is by drawing recognizable, illusory imagery on top of, and interrupted

Gary Faigin, *Target Practice*, 2009, charcoal on paper, 22 x 30 inches (55.9 x 76.2 cm), private collection
Photo: Richard Nicol

Faigin's intense realism and exuberant drawing style work best on a fairly smooth but strong surface.

by, the textured reality of the surface. The interplay of illusion and reality can be worked in a variety of ways when using this combination of quiet imagery and loud surface. As discussed on the pages that follow, artists like William Bailey and Walter Tandy Murch both work with this idea. Another reason an artist would seek out a textured paper or surface is to show the conflict between the deliberate mark and the chaotic surface, a sort of "Here I Stand" or "I Was Here" statement; the aggressive surface continually threatens to overwhelm the handmade mark, with the texture being a key voice in the drawing, an important part of the message.

This relationship between surface and mark is fundamental to contemporary drawing, and every kind of drawing artist today makes this decision deliberately: what surface to work on that best suits what the drawing is a picture *of,* and what surface to work on that best suits what the drawing *is,* in and of itself. The point is that the choice of surface must be deliberately and intentionally made so that the surface/mark relationship will be what the artist wants; and what that is depends on whether the artist wants the surface to be quiet and accommodating to the mark, or be more assertive and interactive with the mark. Interestingly, both realists and abstractionists operate in these areas. Also interestingly, this is a completely abstract decision for everyone.

In Pascal's Triangle *a mathematical solution for the relative probability of accidental repetition of chance occurrences results in a dynamic spiraling number system. Each line of this pyramid of binomial coefficients is constructed by writing the sum of each pair of adjacent numbers of the line above and putting "1" at each end. The relative probability is given by one particular term divided by the sum of all terms in that line.*

Starting with the equilateral triangle, the expansion accelerates so rapidly that if the structure were continued to a height of 22.9 feet, the base would be one mile long. If the base were extended from here to the sun (93 million miles), the tip of the structure would still be only 133 miles high.

Although Pascal's triangle is known and discussed by mathematicians, it has never before been realized in visual form, exposing previously unknown properties that can lead to new discoveries. For example, the drawing reveals that the theory is a three-dimensional, spiraling number system that fits around a shell (shell mathematics), pointing to basic patterns unifying rational thought and nature.
—Agnes Denes

This relationship between surface and mark is fundamental to contemporary drawing, and every kind of drawing artist today makes this decision deliberately: what surface to work on that best suits what the drawing is a picture *of,* and what surface to work on that best suits what the drawing *is,* in and of itself.

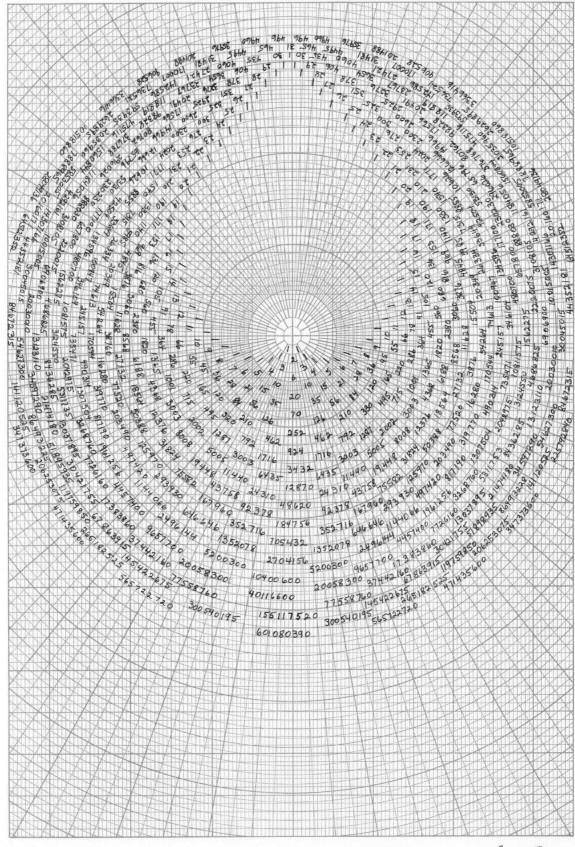

Pascal's triangle

Agnes Denes 1973

SURFACE OPTIONS

Drawing artists make several abstract decisions in the course of creating. This decision—what surface to work on—is perhaps the first. On the following pages are some examples of different artists and their surface choices.

Smooth Paper

The artist who always comes to my mind when thinking about realist drawing on smooth paper is James Valerio. His drawings are usually done on a wove paper, which is somewhat smooth, though not the smoothest paper out there. Valerio often works in graphite and colors in every

tone except the highlights, letting the paper supply those. So, his backgrounds as well as his forms are thoroughly toned in. The wove paper allows him the greatest tonal range and smoothest coverage for blending his graphite strokes, helping him create the value range and intense detail that imply real shapes and real textures in a convincing illusion of three-dimensional space. Valerio's command of the illusion of space has a lot to do with his control of the background value, and the values of the edges of his forms. By making the air consist of graphite, the graphite forms can more comfortably move forward and back within it, and their graphite edges can more easily melt into the graphite shadows.

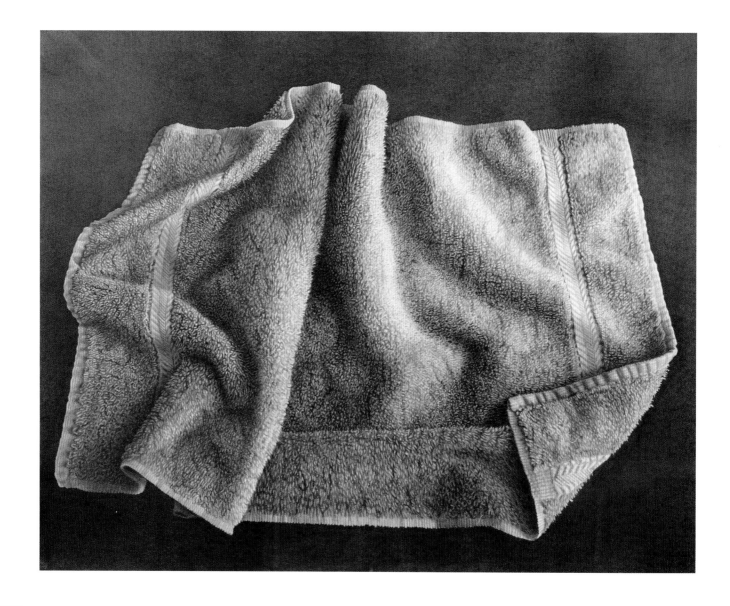

Slightly Textured Paper

William Bailey is a realist artist whose quiet strokes are balanced by the spaces of air between them, spaces of air whose actual texture, which is provided by the paper, gives them weight and presence. This weight, though slight, is the perfect counterbalance to the pale hatching pencil lines, all crisscrossing each other, which seem to softly hover on the paper, coalescing just enough to show us a still life. The pencil lines are just barely broken by the textured paper, and the slightly bumpy spaces between the pencil strokes, the textured air, hold the strokes sort of hovering in place, keeping them gently in position.

The somewhat smooth wove paper allows Valerio to draw in great detail. By coloring in the background, Valerio has complete control over the tonal variations that help create the illusion of space and form.

Bailey's calm marks on this slightly textured surface call to mind the shimmering nature of a city skyline seen from some distance.

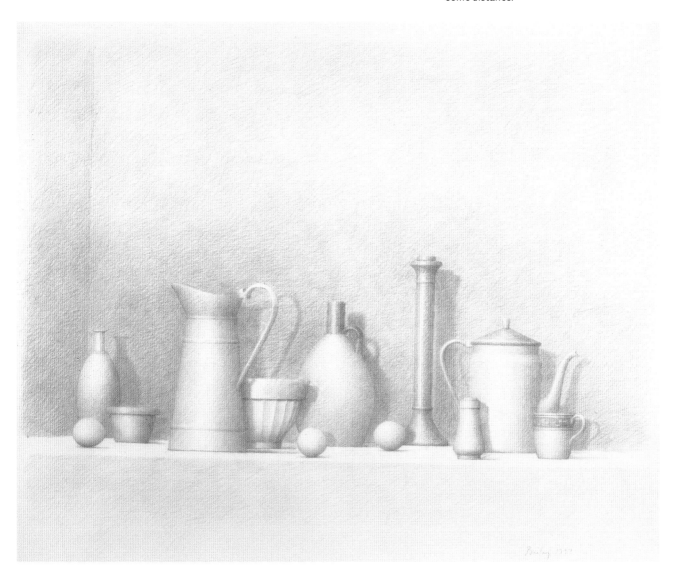

Intensely Textured Surface

In both drawing and painting, Walter Tandy Murch sought to indicate several truths, one being that in life seemingly weighty objects, when considered atomically, are mere wisps, and another being that in art both objects and air are made of, and indicated by, the same thing: a substantive surface and mark, both made of tangible, texturous materials. His images of plain, solid objects—fruit, blocks, bowls, flowers—show them drawn on intensely textured surfaces that he creates himself, with the marks existing behind, within, and upon the surface. The objects float in and out of clarity, seeming to be solid only occasionally and intermittently. The air is equally changeable, sometimes solid and sometimes vaporous. Our minds tell us the object is a solid thing; after all, it's a bowl or a lemon, and everybody knows that it is a solid thing. But the drawing's textured surface tells us that the only solid things, actually, are the marks and the surface, and that they are depicting air as well as objects.

Murch is engaged in showing us what art really is for him: a combination of the illusion of the image and the reality of the surface. In so doing, he has not only created art that works on several levels, but he has also effortlessly brought into consideration optics, physics, and psychology. At the same time that Murch shows us what seems to be a solid object in a transparent space, his intensely textural surface/mark relationship makes the object vaporous and the air as dense as a cliff face. The two switch back and forth from the material to the evanescent perpetually, reminding us that matter and energy are constant and interchangeable—or at least they used to be, in Murch's pre-quantum day.

Toned Paper

Kiki Smith's drawings of animals on wrinkled toned papers are subtle and deeply personal. She is working with ink on a kind of dyed rice paper, several sheets tiled together, which is thin and soft but also strong. The papers are intense, with their creased surfaces and deep color. The drawings are complex, full of detail and feeling. The two seem completely integrated: The drawings are not on the papers, but come from within them, the animals seeming to be comfortable and safely protected by the surface, as if the wrinkles were tall grass. We viewers, alas, are left to be on the outside looking in, maybe a little wistfully.

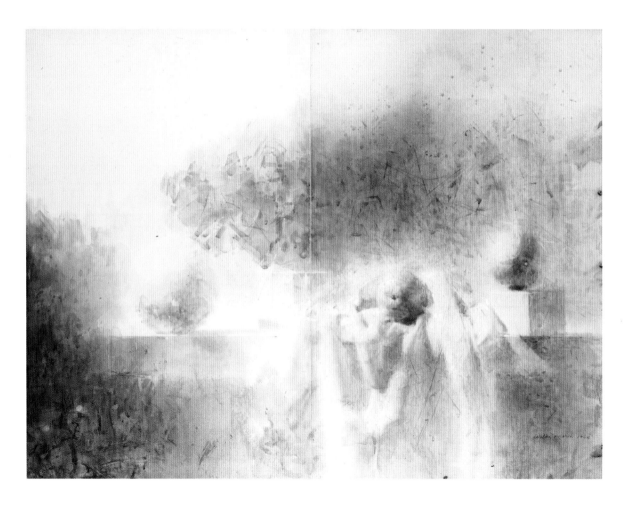

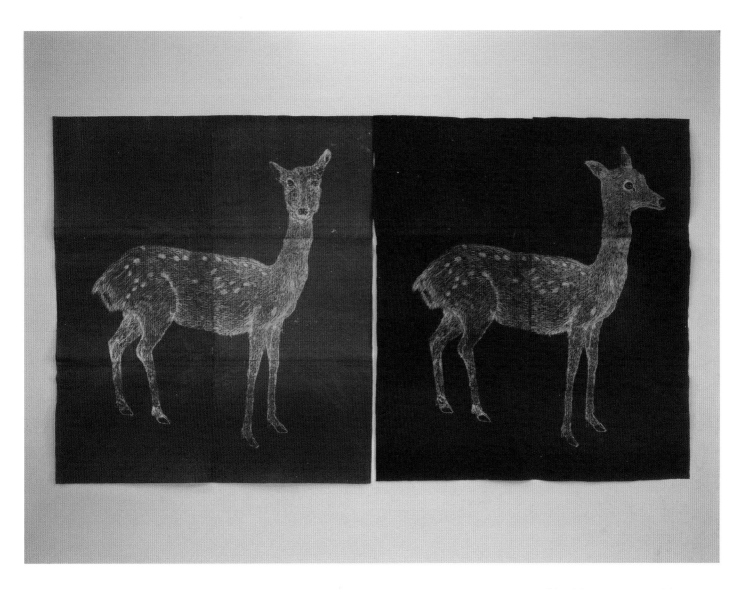

ABOVE Kiki Smith, *Two Deer,* 1996, ink on paper,
52 3/4 x 91 3/4 inches (134 x 233.1 cm)
Photograph by Ellen Page Wilson, courtesy
PaceWildenstein, New York, NY
© Kiki Smith, courtesy PaceWildenstein, New York, NY

*Each of the two deer is drawn on six sheets of toned papers
tiled together, with the bodies the same, and only the
heads drawn differently.*

OPPOSITE Walter Tandy Murch, *Dusky Bloom,* 1964,
gray watercolor and white gouache on paperboard,
29 1/2 x 39 1/4 inches (11.6 x 99.7 cm), sight size, signed
Private Collection; Courtesy of Michael Rosenfeld
Gallery, LLC, New York, NY
© 2010 Walter Tandy Murch

*By working his marks on top of, and also within, his
intensely textured surfaces, Murch creates both flatness
and dimensionality in his drawings.*

Translucent Paper

There are a few artists who work on translucent surfaces, and each is exploring the various concepts involved—space, surface, illusion—in a unique way. The artist pictured here, Paul Fabozzi, works with graphite on Mylar. I had thought at first that he worked on both sides of a frosted Mylar, with the clear lines and shapes worked on the front and the blurry lines and shapes drawn on the back. In fact, he works only on the front, drawing some of his forms crisply, and some in a softer, blurry way.

Fabozzi is interested in how the Mylar does not always seem to have a firm, solid surface. Because of its translucency, some marks on the surface appear firmly attached, while others seem to float into the air just in front of the actual drawing. This surface, which is both there and not there, is something he is investigating in his work, looking for that moment when things change, and giving the viewer a spatial experience that derives from, and depends on, the elusive quality of this particular surface.

Because of its translucency, some marks on the surface appear firmly attached, while others seem to float into the air just in front of the actual drawing.

OPPOSITE Paul Fabozzi, *Spectral Variant #2b 8.m,* 2008, graphite on Mylar, 38 x 19 1/2 inches (96.5 x 74.9 cm) © 2008 Paul Fabozzi
Photo: Michael Marfione

With the simplest of materials worked on translucent paper, Fabozzi creates forms that appear to shift and glide on a surface that seems to both melt and harden.

Both modern and contemporary drawing artists have at times chosen papers created by others: given, commercial papers that are machine-made, printed on, or in some way present a surface that is outside the artist's own manufacture.

These surfaces are chosen because of this machined, pre-printed quality, a quality that both contributes to the nature of the marks being made and becomes part of the message of the drawing.

Graph Paper

Graph paper is a given paper that comes in many varieties, and has been used by many contemporary artists, such as Chuck Close, Agnes Denes, and Bridget Riley. The pre-printed grid on the smooth, commercially made paper is a wonderful surface to work on. The machine-printed grid is key: The artists' marks are held by the constrictions of the grid, performing within its lattice, both confirming the framework and surprising us with the shift and glow that can happen, not in spite of the grid, but because of it. Machine-made graph paper also presents a surface that is scientifically precise and measured. It is meant to be trustworthy in that respect; the artists can trust that the grids are accurate, and so can build their art on that exact foundation.

Book Paper

Various kinds of book paper started being used as drawing surfaces by artists in the early twentieth century, and continue to be of interest to many today. These papers are chosen because of their content and because of their surfaces, and the artists who work on them create drawings that investigate and play off of both features. Depicted on the following pages are two artists, one modern and one contemporary, who have each worked quite differently on pre-printed book papers.

> The artists' marks are held by the constrictions of the grid, performing within its lattice, both confirming the framework and surprising us with the shift and glow that can happen, not in spite of the grid, but because of it.

OPPOSITE Chuck Close, *Phil/2,464*, 1973, ink and graphite pencil and stump and graphite powder on paper, 22 x 17 inches (55.9 x 43.2 cm) Photograph courtesy the artist and PaceWildenstein, New York, NY
© Chuck Close ; Courtesy PaceWildenstein, New York, NY Whitney Museum of American Art, New York, NY. Purchase, with funds from Lily Auchincloss in honor of John I. H. Baur 74.16

Close has darkened in the grid that the portrait occupies, so that it is even darker than the surrounding printed graph paper. The image of Phil is produced with softened, blurry pencil circles within this crisp grid, causing us to experience three things: the tightly hand-drawn grid, the loosely drawn portrait, and the machine-printed grid underneath it all.

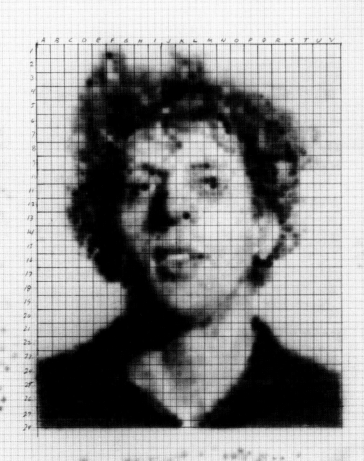

PHONEBOOK

The phone book provides a smooth paper with tiny, dense printing that has served artists well as a base material for drawings. The piece pictured here by Franz Kline is a small, powerful ink drawing on collaged pieces of a phone book. The drawing lines hold those torn, printed pieces together, as if his lines are forces of nature tying the topsy-turvy browned text together. The browning of this acidic paper contributes tonal change to the drawing, and also contributes the actual threat of disintegration, which sits underneath, and in fascinating contrast to, Kline's seemingly iron-strong lines.

TEXTBOOK

William Kentridge's charcoal drawings of figures on top of several pairs of textbook pages spread out in a long line, is the picture of image treading on word. The text is there, both to be read and to be thought of as landscape. Nearly all of the hand-drawn figures are carrying things, loaded down and traveling in a line. They travel across the text of a vertebrate anatomy book, and our attention is sometimes focused on the individuality and uniqueness of the figures, and sometimes on the nature and subject of the text, which can even be seen through some of the figures. The former idea is at odds with the machine-printed text, but the latter is connected to it, reminding us that there is reading and there is doing, and people are deeply involved in both.

OPPOSITE Franz Kline, *Untitled II*, circa 1952, ink and oil on cut-and-pasted telephone book pages on paper on board, 11 x 9 inches (27.9 x 22.9 cm) Purchase. (309.1983) © 2010 The Franz Kline Estate/Artists Rights Society (ARS), New York, NY Digital Image © The Museum of Modern Art/Licensed by SCALA/ Art Resource, New York, NY The Museum of Modern Art, New York, NY, U.S.A.

Kline's large, hand-drawn lines dominate the tiny, machine-printed text of the phonebook, and even seem to wrap around and hold pieces of phonebook that have been torn from another page and collaged into place here.

BELOW William Kentridge, *Procession on Anatomy of Vertebrates,* 2000, charcoal on book pages, 8 ⁵/₈ x 67 ³/₈ inches (21.9 x 171.1 cm) © 2010 William Kentridge Courtesy: Marian Goodman Gallery, New York, NY

Kentridge's hand-drawn charcoal images are soft, fragile, and erasable on top of the immutable words of the commercially printed textbook pages of Anatomy of Vertebrates. *The contrast between the movable and the permanent, as well as the image and the word, is compelling.*

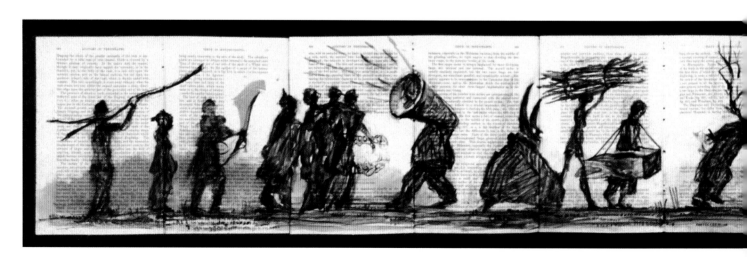

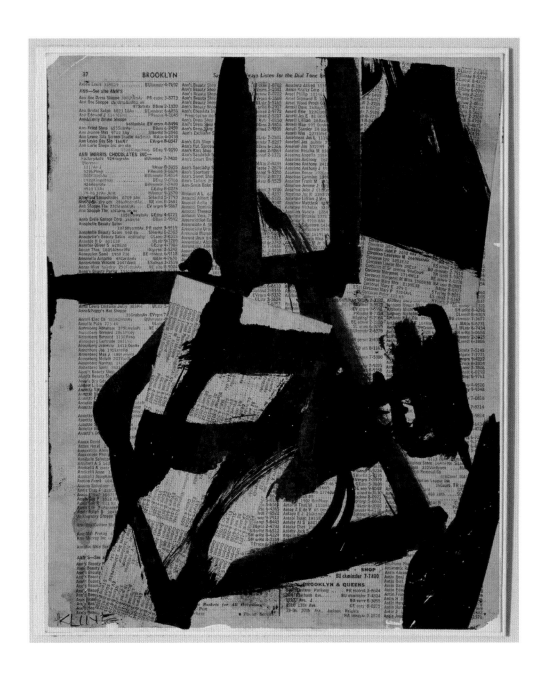

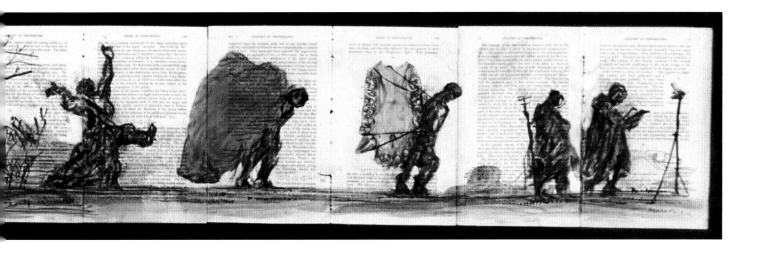

Ever since the beginnings of Cubism, when Picasso, Braque, Gris, and various other artists collaged surfaces such as wallpaper, newspaper, and wood veneer into their paintings and drawings, artists have realized that alternative surfaces are available to draw upon.

Other art movements in Europe, such as Tachisme, opened the door for artists to work with materials even further away from the classic flat surfaces of paper or canvas. Thanks to them, drawing artists today do not always choose to work on paper, but sometimes choose to work on other surfaces or materials. These choices bring the surface directly to the forefront of the message, the meaning of the drawing, expanding the concept of what drawing is as well as expanding the consciousness of both the artist and viewer.

Glass

The artist Xu Bing draws, prints, and paints on several surfaces, including traditional ones, like paper, and unusual ones, such as pigs. His drawing of a city skyline on glass—the skyline seen right outside that very window, in fact—is of interest because the drawing depends on the transparency of the glass, yet causes us to stop looking through the glass as soon as we look at the drawing. We end up either seeing the drawing or seeing the cityscape, but not really being able to see both at the same time. The drawing becomes something that is both "there" and "not there," more decipherable when it is not lined up with the buildings it traces than when it does.

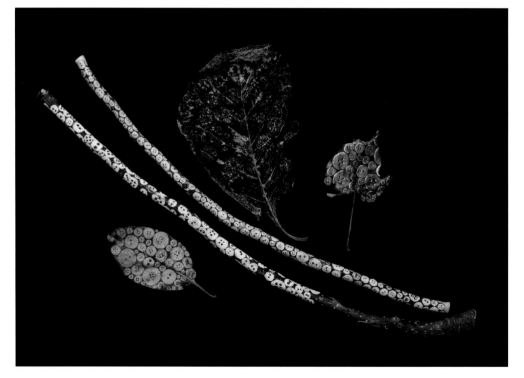

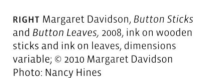
RIGHT Margaret Davidson, *Button Sticks and Button Leaves,* 2008, ink on wooden sticks and ink on leaves, dimensions variable; © 2010 Margaret Davidson Photo: Nancy Hines

The three-dimensionality of these surfaces completely changes the button imagery. No longer are the buttons believable, but instead they have become symbols and signifiers, allowing me to abbreviate them to circles and dots.

Wood and Leaves

My drawings of buttons on peeled wooden branches and on both fresh and desiccated leaves are an attempt to work a realist image of a manmade object onto an unlikely and natural surface. Both the image and the surface are changed by the encounter, with the end results being twofold: a natural object that has been made into an artifact by the addition of imagery (the sticks), or imagery that will soon decay and disappear because of what it is drawn on (the leaves). The sticks seem to harden into something permanent by the addition of the button imagery, whereas the leaves seem to soften and become even more likely to crumble and disappear because of being drawn upon.

BELOW Xu Bing, *Landscript,* 2000, ink on glass windows, approximately 14 x 80 feet (3.5 x 13.8 m) Installation view at the Art Gallery of New South Wales, Australia in conjunction with Biennale of Sydney, 2000, 12th international festival of contemporary art, Sydney, Australia.

This drawing is a cityscape made of words, or what seem to be words, drawn on the window glass, tracing the city skyline directly outside the window.

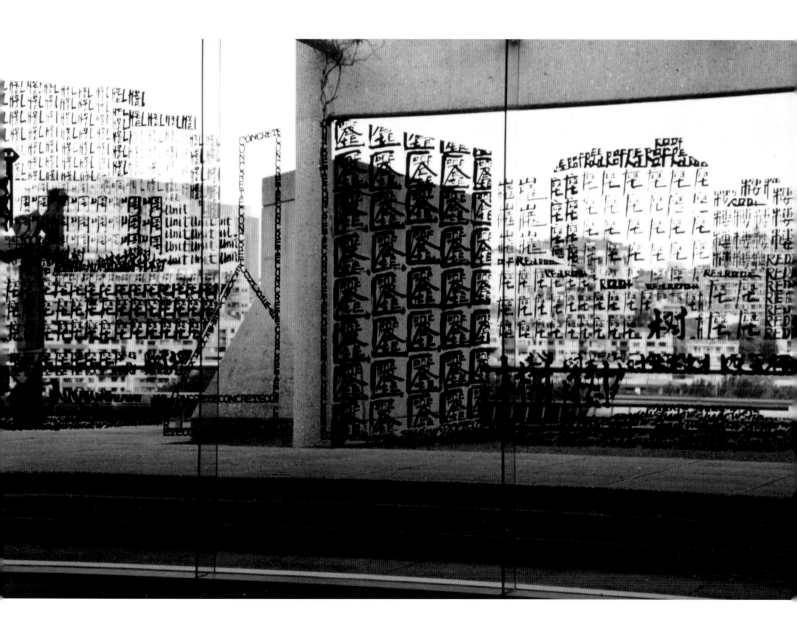

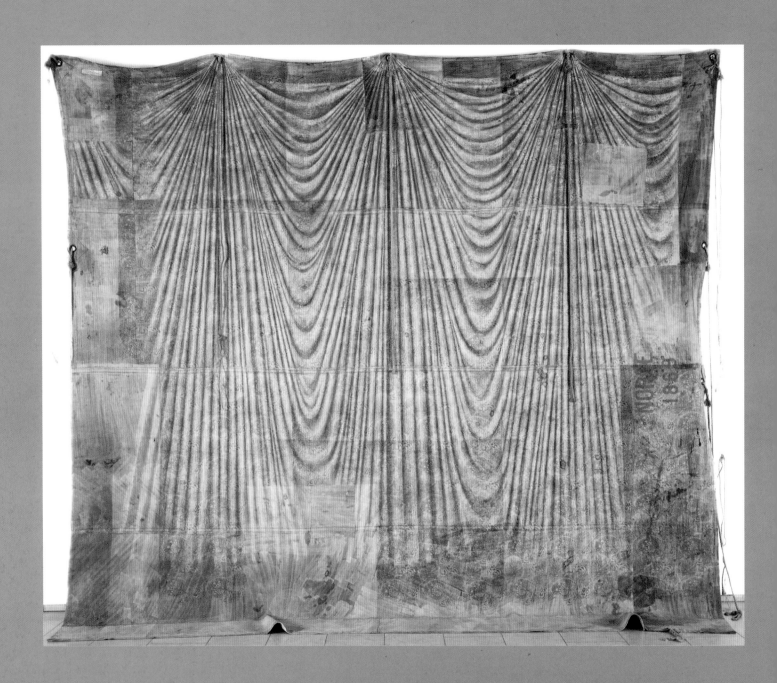

Cloth

Cloth is a substance that ranges from the gossamer thinness of silk to the lumbering heaviness of a housepainter's tarp. The artist Bente Saetrang draws on found canvas, canvas that has lived a hard life in the industrial world, and then is washed and drawn upon by her. That she draws the subtle and beautiful folds of thin cloth onto this heavy canvas is a way of emphasizing the contrasts, calling our attention to the differences in time, place, temperament, even genders of the two fabrics. She is also showing us the difference between the illusion of the image, soft as a whisper, and the hard, firm reality of the canvas, with seams, tears, real ropes, and actual grommets.

SUMMARY

The drawing surface, be it paper or some other substance, has an immediate and irrevocable relationship with the mark, and so is deliberately chosen by the drawing artist. This choice happens at the beginning of any drawing project, and is made as the artist plans what the drawing is about, and what the drawing is intended to look like. The first artist to do this was Georges Seurat, who worked with a blunt, soft, conté crayon on a bumpy, sometimes laid paper, creating soft but legible images in a thoroughly visible atmosphere that speak as much of the nature of crayon and textured paper as they do of figure and ground. Seurat's drawing technique was his own invention, and was a style he pursued to the end of his life. By drawing this way, Seurat both acknowledged and explored the relationship, the conversation, between the surface and the mark. By drawing this way, Seurat also opened the door for the rest of us to an awareness of the concept of the surface/mark interconnectedness, making it *imperative* that any drawing artist, regardless of the kind of image drawn, consider the surface, and choose it consciously.

If you, as an artist, want the image to prevail, to be the main vehicle of the message of the drawing, then you may find yourself choosing smoother papers, papers that will not intrude on or offer opinions about your mark-making. If you, as an artist, want the image and meaning to include a surface/mark conversation, or do not necessarily want total control of the mark-making, you may find your answers in more textured papers, more unusual papers, or surfaces that aren't papers, that will have a voice in your image, and that will influence your marks in ways you may find both surprising and exciting.

This shimmering drawing of cloth on cloth plays with, among other things, the nature of reality.

CHAPTER TWO

MARK

M arks are the essentials of drawing, though they do not stand alone. As you already know, marks are determined by what tools and materials are used, and are influenced by the surface they are drawn on. So how can we separate the mark from the tools, materials, and surface—and why should we? What is it about the mark itself that deserves our attention and examination here?

The answer is that since 1950 or so, the mark in drawing can be, and has been, used in more than one way, a situation not seen in older drawings. Before, the mark was the thing used to create the image, and, as the image was the message, the mark was the means to that end. Today's drawing artists have three ways they can use marks, not just one: the mark can be the means to the end, as before; it can be the end itself; or it can do both things together. This tripling of options is one of the significant ways drawing has changed.

THE FUNDAMENTAL TRUTH OF DRAWING

When contemporary drawing artists looked critically at the nature of drawing, they learned a fundamental truth, that all drawing is abstract. This has changed the way they approach the concept of mark-making. Philip Rawson said it clearly when he wrote:

> Nature presents our eyes with coloured surfaces to which painted areas of pigment may correspond, and with inflected surfaces to which sculptural surfaces may correspond. But nowhere does it present our eyes with the lines and the relationships between lines which are the raw material of drawing. For a drawing's basic ingredients are strokes or marks which have a symbolic relationship with experience, not a direct, overall similarity with anything real. And the relationships between marks, which embody the main meaning of a drawing, can only be read into the marks by the spectator, so as to create their own mode of truth.[1]

When drawn marks on the paper coalesce into a recognizable image, say, the saltshaker on the facing page, that image is not a real saltshaker, of course, but a symbol that reminds us of a saltshaker. By creating a symbol that the viewer "reads," the artist with his drawing marks is performing an abstract act. The actual reality in his drawing is the mark on the surface and the relationship that exists there. By understanding this, contemporary drawing artists have come to realize that the mark can be separated from the image, and the mark itself can be explored and experimented with; the mark itself can be the end result, rather than just the means to the end.

By understanding this, contemporary drawing artists immediately see that they have two options in how they can proceed in a drawing: They can draw marks on a surface to create a visual symbol, or they can draw marks on a surface to explore what happens with that relationship. There is also a third option, one that has grown out of an understanding of the previous two options: to combine both options together. Working with these options is one of the ways today's drawing artists have made contemporary drawing into its own unique art form.

I find that the best way to assess mark-making in contemporary drawing, therefore, is to look at these two primary choices: mark-making as the means to an end and mark-making as the end itself. You might be surprised to find that each concept has both realist and abstract art within it. How recognizable the image is has nothing to do with this division; rather, what counts is how and to what end the artist is using the marks.

The technique section in this chapter describes simple versions of some of the techniques used by various contemporary drawing artists. These descriptions offer you a chance to try out some techniques in an easy, beginner-level way. You may then leave it at that, or take things much further and explore the techniques in much greater depth, as the drawing artists shown here have done.

1 Rawson, Philip, *Drawing* (London: Oxford University Press, 1969), page 44.

OPPOSITE Margaret Davidson, *Saltshaker,* 2010, graphite pencil on Strathmore 500 plate bristol, 7 1/8 x 5 inches (18.1 x 12.7 cm) © 2010 Margaret Davidson Photo: Nancy Hines

This is not a saltshaker, but a visual reminder of a saltshaker, even a symbol of a saltshaker.

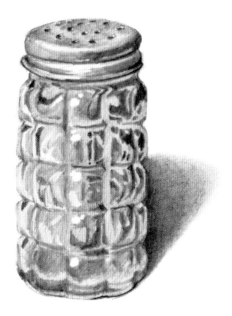

Before we go any further, a very short and general listing of marks is in order. Amazingly, the few types of marks listed on the pages that follow are the substrate of every contemporary drawing, even of every drawing ever made. One of drawing's wonderful properties is that such infinite variety can come from so few fundamental strokes.

Line

No mark comes closer to being drawing's own unique device than line. Line is so basic to the act of drawing, so likely to be the first mark ever made with artistic intent, that I think it is possible to give it its own scrutiny. Line is what many of us think of when we try to define what drawing is, and it is the kind of drawing mark that has been used most widely. Every kind of drawing tool makes lines, and every kind of drawing artist uses lines in one way or another.

So what, exactly, is a line? *Webster's Collegiate Dictionary, Fifth Edition*'s definition of line is: "A long mark or threadlike formation." My own, somewhat chattier, definition of line is: "A mark that is longer than a dot, and is made by dragging some sort of tool in a continuous way for some sort of distance." Line can go anywhere and do anything, and it can convey most every kind of form, space, distance, texture, and emotion. Line can be long or short, thick or thin, curly or straight—the list can go on.

As Rawson said, nothing in nature is actually outlined, so to do a line drawing of something is to create an image that is a symbol of that thing, an abstraction of it. This abstract nature of line is fundamental to why all the kinds of drawings—realist, abstract, scientific, or illustrational—are related to each other, share the same properties, and stem from the same principles. Throughout this book you will find drawing concepts illustrated with examples from all of those different fields, simply because of that basic and fundamental connection.

Tone

To the drawing artist, tone is a nebulous thing. It can be any shape, or no shape at all; it can be crisp and solid or transparent and vaporous; it can be any value; and it can indicate form or indicate the air around form.

Tone can be made by drawing multiple lines or dots near each other and overlapping each other until they visually lose their individuality and blend into one entity. These marks are sometimes rubbed or smeared until the artist arrives at the elimination of their original nature, turning them into an edgeless mist. Rubbed tone has a different relationship with the surface than does drawn tone, in that rubbed tone is pushed down into the indents of the surface, while drawn tone stays on top. This can give rubbed tone a very different look from drawn tone, and can be either exactly what the artist wants, or bewilderingly wrong for a particular drawing.

How tone is made is determined by what the tone is for in the drawing, what materials are being used, and, of course, what the artist wants to communicate. What tone communicates is different from what line communicates. Line indicates the shape of something, the edge between form and space, the movement of a form, or even movement itself. Tone tells us about lightness or darkness, weightlessness or heaviness, and dullness or shine. It can tell us depth in space or it can be space itself. Line and tone are often worked together in drawing, but each can also stand alone, either within the same drawing, or in separate pieces.

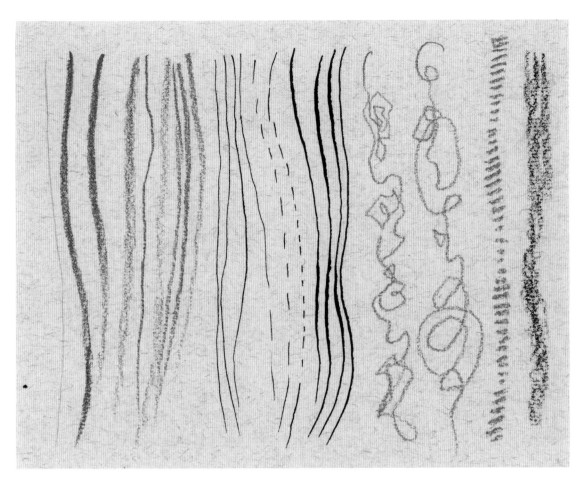

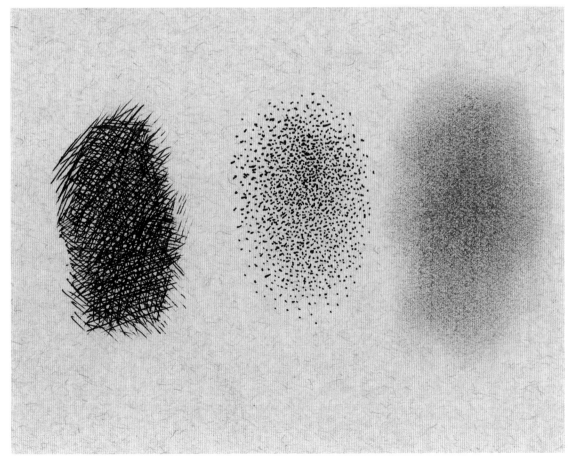

Other Marks

Line and tone are the two most standard and basic mark-making choices. Drawing artists use them constantly today, as artists have throughout the previous centuries. In addition to line and tone, other marks are available, including some that are particularly new, as they come from more recently created materials. Other marks include dots, gouges, splashes, splatters, sprays, mists, and dustings. What they are depends on how they are made and on the materials used. Below are descriptions of a few.

DOTS

Dots can be made with dry materials or wet, and consist of a single mark made in a single movement (e.g., by pressing a pencil against a paper and then lifting up, or letting a solitary drop of ink land on your surface). A dot can be made in a controlled way like I just described, or it can be made in a more random way (e.g., by throwing the material, say a piece of charcoal, at the surface). The common thread here is the singularity: A dot, whether wet or dry, whether controlled or random, is one mark created by one touch of the material to the surface.

SPLASHES AND SPLATTERS

Marks such as splashes and splatters are made with wet materials only, and are wonderfully out of control. To create a splash or a splatter, the wet material is literally propelled onto the surface by some tool, say, a heavily laden brush, a pen nib, or a spray bottle. The artist has very little control over the outcome of splashes and splatters, over where they land and how big an area they cover. This absence of control is often what is wanted in contemporary drawing, and this sort of mark is chosen exactly for that reason.

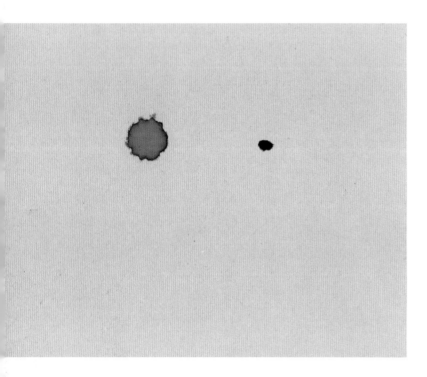

LEFT Two kinds of dots—an ink drip and a single charcoal mark—one wet and one dry, both on tan Rives BFK paper. Photo: Nancy Hines

BELOW Ink splashes created with peat-based brown ink on Nideggen paper. Photo: Nancy Hines

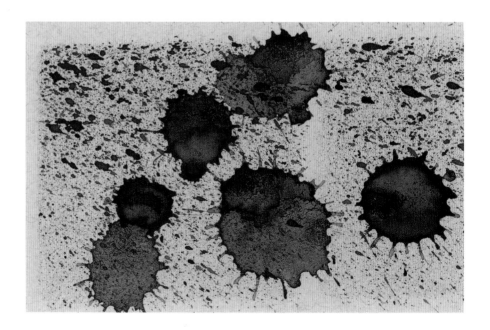

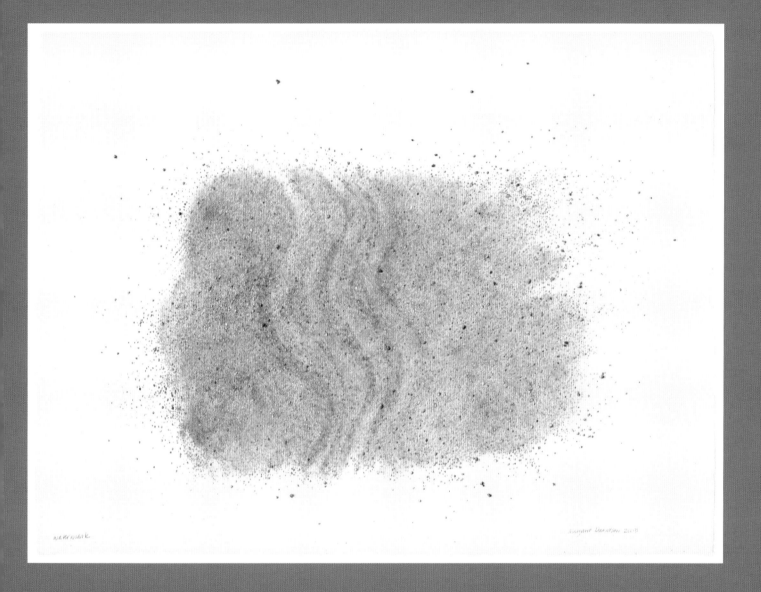

*The marks in sand left behind by water are also the marks humans
have used for millennia to symbolize water. At its most basic, art is
mark-making in response to the marks found in the world.*

The previous discussion of the three basic categories of marks will, I hope, give you the basics of mark-making characteristics, and ultimately help in understanding that contemporary drawing artists choose certain kinds of mark-making for certain kinds of reasons. These reasons are the subject of most of the rest of this chapter—starting with mark-making as a means to create a visual symbol.

When mark-making is the means to an end in drawing, the drawing mark is secondary to the message the artist wants to communicate through the image. The "end" is the image with its attendant message, and the type of drawing marks chosen are those that will best create the image without calling too much attention to themselves. Lots of realist drawing falls into this category, though not all, and plenty of abstract work does, too. The uniting factor is not whether the image is recognizable or not, but the fact that the artist wants the viewer to look just at the image, and not at the *way* the image is made. In these cases, the image is carrying the message entirely, and the mark-making is meant to be secondary.

In this area of mark-making I would like to begin with line, and in particular line in the arena where it is at its most obvious and also most communicative—that is, when line is used to describe and depict form. This will be followed by how some artists use tone alone to depict form, and then finally with how line is united with tone to depict form. In all three cases, the artists are using their mark-making as a means to the end, the end being the image. In all three cases, the mark-making is subordinate to the image.

Line That Communicates Form

Historically, Western drawing artists have nearly always wanted to depict form—in other words, draw something that looks believably three-dimensional and seems to sit in three-dimensional space. Two kinds of line have been used in the past, and continue to be used today, to depict form in space: the outline and the contour line.

THE OUTLINE

Form is often defined with some sort of outer line that traces its edges and separates it from other shapes and background areas. This outer line can be drawn in a variety of ways, and these ways will either help with the illusion of dimensionality or create something especially flat. In real life we see the dimensionality of forms best when they are partially lit and partially shaded; thus we find that this is the information in a drawing most useful to us when we are expected to believe an illusion of realistic form residing in three-dimensional space. An outline that shows us the light and shadow on the form is just such a line: It is thinner where the light falls on the form and thicker where the shadow resides.

Not all artists want to depict rounded form with their outlines; some artists want to create flatness in their forms, or an ambiguity of flatness co-existing with dimensionality. These artists know they can choose the unchanging closed outline as one of their flattening devices. This sort of line does not show any awareness of light and shadow, and by denying them, denies the sense of the roundness of form. Many of the drawings in this book have outlines, and so illustrate the variety that can be found in such a mark.

THE CONTOUR LINE

The contour line is a line that can be used as the outline at the edge of the form, or it can exist within the form, showing various interior shapes, patterns, or structures. Contour lines usually break, very often curve, and show the play of light and shadow on the part of the form that is inside of the outer edge. Contour lines are frequently used for shading the form with line rather than tone. Line shading can be done with groups of parallel lines that wrap around the form, or with parallel lines that lie at an angle to the form, or with hatched lines either wrapping the form or lying at an angle to it. Line shading using contour lines requires the lines to remain distinct; once they blur into each other you have entered the realm of tone. Contour line can also be used expressively as well as descriptively, as seen in this drawing by Barbara Fugate.

OPPOSITE Barbara Fugate, *Charcoal Figure Gesture*, 2010, compressed charcoal on paper, 36 x 24 inches (91.4 x 61 cm)
© 2010 Barbara Fugate; Photo: Nancy Hines

Futate's expressive line shows the form and movement of the figure, as well as her own energy and love of life drawing.

Expressive line is a kind of line that speaks, expresses both what the form looks like, and what the artist thinks of the subject. It is very subjective and personal, and is a way of seeing into the mind and feelings of the artist.

LINE AS IT IS USED IN SCIENTIFIC ILLUSTRATION

A specialized realm of drawing, called scientific illustration, has codified the outline and the contour line for the purpose of communicating very precise information about form. Each of the sciences has particular conventions for using these lines, and I think it's worth mentioning a few of them here because scientific illustrations show very clearly the use of these various kinds of lines. In fact, I don't think there is an area of drawing where they are any clearer. The line work found in scientific illustration is much the same as that found in any regular drawing where the artist wants to present the information of the form accurately and believably—it is just more precise and careful, as scientific illustrators must not only depict form clearly, but also need to be measurably accurate.

Scientific illustration is nearly always done with reproduction in mind: The art must be made in a form that can be photographed and printed in a book or scientific journal. Therefore, scientific artists have worked most often in black and white media, pen and ink in particular. Pen and ink is most tight, most reproducible, and makes a line that is crisp and easy to see the edge of, for measuring purposes. Pen and ink line techniques are used in most of the sciences (though not all) and will be what we look at here.

SHADING WITH PARALLEL LINES

This form of shading, falling as it does inside an outline of the form, conveys more than one piece of information: The curve of the lines tell the arc or depth of the form, the quantity of lines tells of the darkness of the shadow, and the solidity or brokenness of the lines tell something about the smoothness or roughness of the surface. It is used constantly in scientific illustration, and is also being investigated by one of my students, Lorrie Elliott, as a contemporary and semi-abstract way of showing light and shadow in her still life drawing.

A form of parallel line shading that has come down to us from such artists as Dürer and Michelangelo is called "bracelet shading." This consists of curved lines wrapping around forms, like bracelets around arms, to show shape as well as shadow. A very precise form of bracelet shading used today, mostly in medical illustration, is a technique called eyelashing. A special pen nib is used, one that will make a narrow line with normal pressure and a wider line with slightly heavier pressure. The width and taper of these parallel lines is used by the illustrator to show the roundness and shadow of his forms. In the hands of a master like Gerald Hodge, eyelashing is distinctive in its subtlety and succinctness. Every stroke says at least two things, and the cumulative effect speaks volumes.

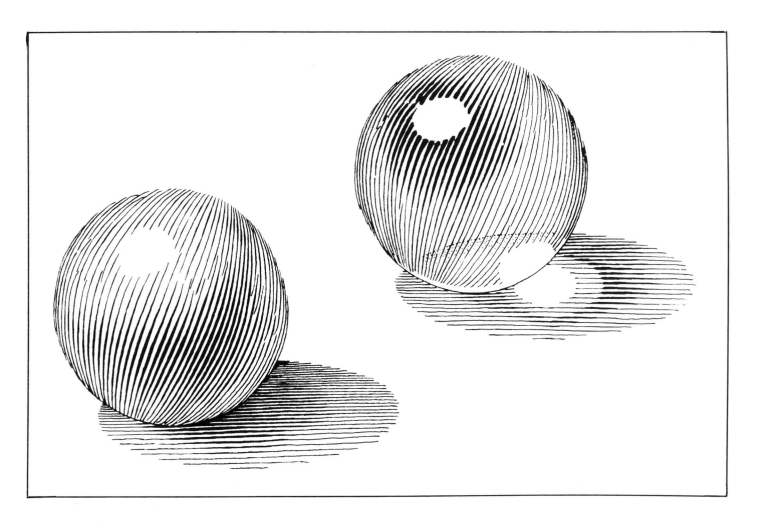

*Hodge makes this technique look easy, but I have always found
it terribly difficult to keep the lines equidistant, and to not curve too
soon or too late. His drawing here shows us two spheres, one solid
and one transparent.*

*Elliott has taken a crisp and factual scientific illustration technique and
made it more expressive by using compressed charcoal, and by drawing
her parallel lines in ways that pertain to abstract pattern as well as to
light and shadow.*

SHADING WITH HATCHED LINES

Shading by hatching is probably the most common way lines are used to create tone. The concept is simple—pile enough lines together in one place and you will arrive at some kind of tone, complete with soft and irregular edges. Hatched lines can be laid down parallel to each other, or they can be laid down crisscrossing each other. Artists and illustrators alike work with hatching in either messy or tidy ways—the former being useful (but not required) for organic forms, and the latter being useful (but not required) for machined forms.

My pen and ink drawing called *Two Skeins* utilizes hatching lines to depict the forms of the two skeins of yarn, the space they exist in, and something that I try to have fall between both form and space. The lines are always visible, sometimes working in concert and sometimes operating on their own; they are always communicating something about the yarn or the air, and also maybe a little something about pen and ink line itself.

The pen and ink lines that I used here sometimes curve around the forms of the skeins of yarn and sometimes stack upon each other to create a sense of air and space and vague edgeless tonality behind the skeins. I have tried to draw one of the skeins in a very solid way, and the other disintegrating into the tonal space, with the idea in mind that, as the lines move apart and break up the form of the skein, they stop being descriptive marks and re-assert their identity as drawing lines with their own abstract integrity. There is not a great difference in the length or thickness of the individual lines, but by using them in these different ways, I can suggest both the illusion of form and space while reiterating the probity of the mark itself.

It is worth looking at scientific illustration line drawing methods, because they offer us a chance to see line work in the service of precise and measurable form. This sort of line work is more rigidly controlled by various rules and conventions within the realm of scientific illustration, but is useful to know about, and can certainly be worked with in a more relaxed and personal way if an artist so desires. In the world of contemporary drawing, all techniques and all materials are possible choices, and the divisions between modes of drawing, like the previous division between art and illustration that are melting away.

> There is not a great difference in the length or thickness of the individual lines, but by using them in these different ways, I can suggest both the illusion of form and space while reiterating the probity of the mark itself.

OPPOSITE Margaret Davidson, *Two Skeins,* 2004, pen and ink on Twinrocker Simon's Green paper, 31 x 25 inches (78.7 x 63.5 cm) © 2010 Margaret Davidson
Photo: Nancy Hines

This pen and ink drawing is meant to show a transition from ink marks working in the service of the realistic image (in the skein on the left) to ink marks gradually becoming the subject themselves (in the skein on the right).

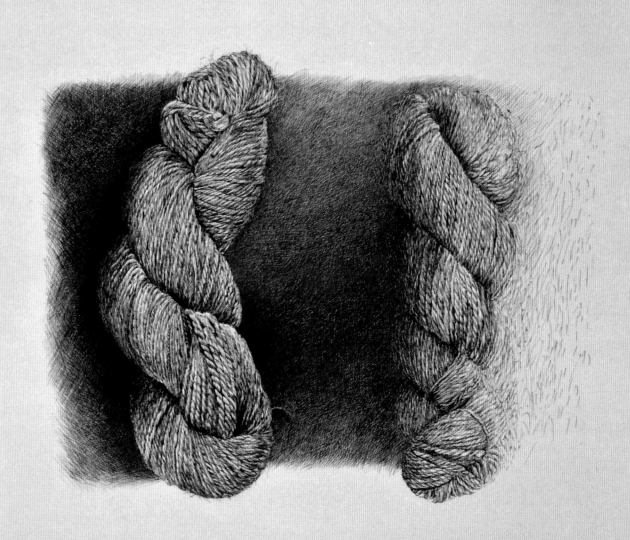

2 skeins Margaret Davidson '04

Tone That Communicates Form

Many artists rely on tone and its smooth gradations from light to dark to describe form. Any artist who wants to use tone to communicate form does so by showing the light and shadow on the form, and the shadow cast by the form. The five tonal areas—highlight, body color, body shadow, reflected light, and cast shadow—are the standard pieces of information needed to describe any form. Those five are the maximum, but many drawings are depicted with fewer tones. Reflected light, for instance, does not have to be drawn in, as can be seen in Martha Alf's drawing *Four Red Bosque Pears,* below. It is good, here, to remember that tonal drawings, using light and shadow to indicate form, are not just about the form, but are also about the *light* and the *shadows*—what they are, where they are, and their various relationships with the forms.

The artists who choose tone to describe form are often realist artists, though not exclusively, and they are masters at drawing tone in a variety of ways. Some draw lines, or pile up dots so continuously and in such overlapping layers that the individual marks coalesce into tone. The number of layers needed for this blending to happen smoothly is huge. This is because a dark tone arrived at with many layers at a light to medium pressure looks significantly different from a dark tone arrived at with just a few layers pressing hard.

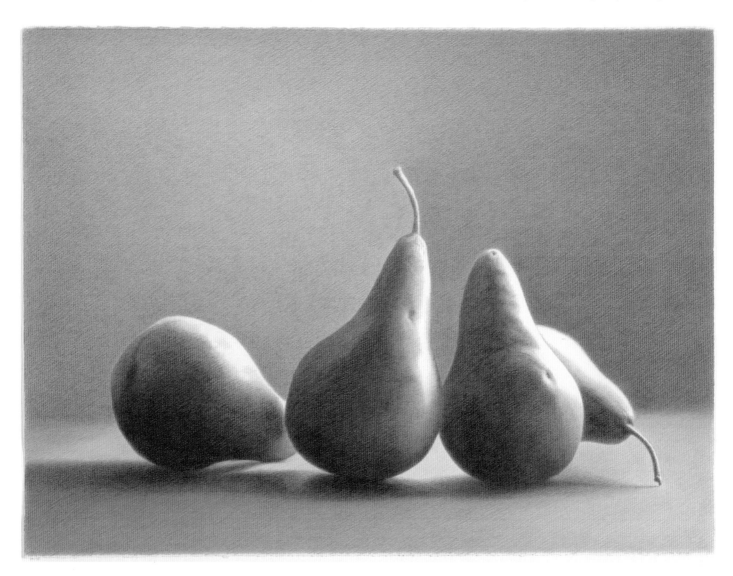

ABOVE Martha Alf, *Four Red Bosque Pears,* 1990, Verithin colored pencil on Arches paper, 22 1/4 x 30 inches (56.5 x 76.2 cm) Photo: David Kingsbury © 2010 Martha Alf; Courtesy Winfield Gallery, Carmel-by-the-Sea, CA

This is a drawing of light and air and how they form themselves around the four pears, as much as it is a drawing of four pears.

OPPOSITE Shaun Tan, *Ferry Landing* (from *The Arrival*), 2006, graphite pencil on cartridge paper, 16 x 12 inches (40.6 x 30.5 cm) © 2006 Shaun Tan. Image reproduced with permission from *The Arrival* by Shaun Tan, Lothian Children's Books, an imprint of Hachette, Australia, 2006.

When only tone is used, images have great subtlety and also great softness. In Tan's case, this communicates, among other things, a sense of nostalgia and sadness.

The difference is mainly in the reaction of the surface, and not in the tonality itself. The surface changes when tones are applied with hard pressure—it indents, and its texture, if it had any, is also indented and somewhat smoothed. The surface is not indented or de-texturized when the tones are applied gradually with gentle pressure. Often, therefore, artists who want the viewer to look at the image and not at the mark/surface relationship work the layers of tones gradually with light to medium pressure, so that all the tonalities mesh seamlessly, and the surface stays uniform throughout.

Shaun Tan has used tone powerfully and subtly in his graphic novel *The Arrival*, shown on the previous page. The monochromatic tonal drawings tell his story pictorially, with no words at all, not even page numbers. The images are arranged, sometimes many to a page, sometimes one across two pages. Always they use a full range of tones to depict form, space, light, shadow, action, and emotion.

Some artists depict tones with a buildup of lines but allow the lines to show, relying on the viewer's eye to do the blending. Martha Alf's drawings are done with various kinds of pencils. No smudging or stumping has been used, just a careful multi-layered application of the pencil, resulting in smooth, subtle tonalities even though the lines still show.

A few others use techniques that apply dry material with brushes or a chamois so that tone happens immediately, without having to be arrived at by accumulating marks. One of these tonal techniques also comes to us from scientific illustration, a technique called carbon dust drawing, which is thoroughly tonal and beautifully subtle. Basically, carbon pencils are rubbed against sandpaper to create small piles of carbon dust. This dust is then applied with soft brushes through stencils onto a slightly toothy paper, like vellum bristol. The tonalities are built up gradually, highlights are erased with a kneaded eraser, and the resulting drawings are seamless and without texture. This technique has been largely replaced in the scientific illustration world by the airbrush, but is still occasionally done in contemporary drawing, especially when smooth tonalities are desired. Cathy Böhlke creates still lifes in carbon dust, going much further than is usually done in scientific illustration because Böhlke depicts space as well as form.

The tonalities are built up gradually, highlights are erased with a kneaded eraser, and the resulting drawings are seamless and without texture.

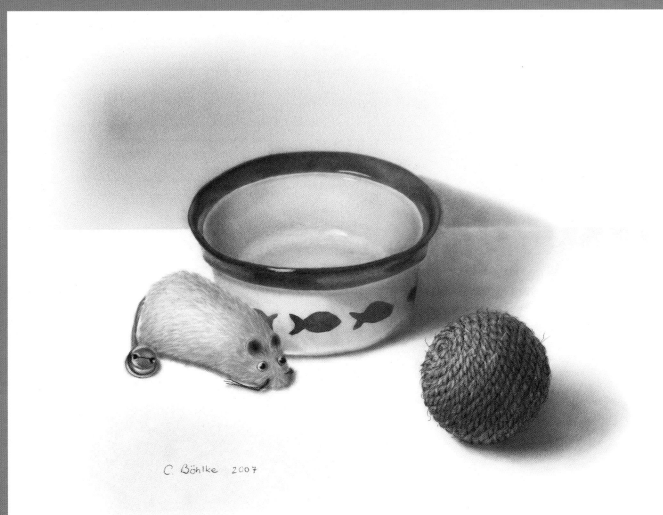

*Nearly every surface and texture can be depicted in
carbon dust, as Böhlke has shown in this drawing
showing ceramic, fur, and twine.*

Line and Tone Together That Communicate Form

For Barbara Fugate movement equals life, and to draw movement is to draw life. In her animal studies done at the zoo, Fugate combines line and tone in high-speed drawing to get down the essence of the living animal in the form of its movement. Her marks move at the speed of the animal, and she barely looks at the page while drawing.

The delicate, somewhat realistic contemporary drawings of Robert Marx, and the abstract modern drawings of Arshile Gorky, both use line together with tone as the means to an end, that end being the communication of their ideas through their images. Marx, working in the realm of a sort of psychological realism, where he wants to create a convincing sense of intense emotion within the confines of the head and torso, uses thin lines that sometimes stay linear and sometimes combine to create a colored in tone. The tones are gentle, and the lines are quiet, but it is the kind of quiet that could be either calm or petrified. To me, Marx's images are all compressed: constricted space, crowded lines, and compacted materials, with tone being a sort of anxious density of lines. The features of line and tone show themselves in relationships of subtle intensity with each other, and with the face of the subject. His personality, maybe even his psychological profile, are seen in the direction and speed of the lines, and in the rather sudden absence of direction of the tones.

Gorky, as seen on page 59, is also working with strong emotion and showing it through the nature of his biomorphic forms, the relationships of his forms to each other, and the nature of his lines. Gorky uses fluid, organic lines to create abstract biological forms that stand, sit, and sometimes float in a fairly realistic space. His contour lines show light and shadow, and his rubbed, sometimes edgeless tones reside both inside and outside his linear forms, in a sort of see-through universe. The forms may be abstract shapes, but they have weight and roundness and they sit in dimensional space—all very understandable because of his outlines, which show light and shadow and the roundness of his forms. Gorky's forms move, hover, and interact with each other with

ABOVE Barbara Fugate, *Flying Budgie,* 2009, conté on paper, 12 $\frac{1}{2}$ x 9 $\frac{1}{2}$ inches (31.8 x 24.1 cm)
© 2010 Barbara Fugate; Photo: Nancy Hines

The movement of the charcoal imitates the movement of the bird.

OPPOSITE Robert Ernst Marx, *Sam,* 2010, graphite on paper, 13 $\frac{1}{2}$ x 11 inches (34.3 x 27.9 cm)
© 2010 Robert Ernst Marx; Courtesy of the artist

The line and tone are interlocked in an intense relationship, full of emotion, tension, and depth.

intensity and feeling, all of which is transmitted through his particular usage of lines and tones.

Mark-making as a means to an end is almost unlimited. Artists will use any kind of mark to arrive at their chosen images. A completely tonal drawing style, a completely linear one, or some combination of the two can be used to describe and communicate form. This is familiar territory, and is the way things in the world of drawing have been for centuries: Artists have drawn pictures *of* things, such as landscapes, figures, portraits, even their own feelings. The mark, in these cases, is the means to an end, and that end is the picture of something. The artist is using the marks in a particular way to create an image that he wants the viewer to concentrate on; the image is the main conveyor of the message.

This continues to be the way things are in the twentieth and twenty-first centuries with many contemporary drawing artists. Whether the image is realistic or abstract, many of today's drawing artists use the mark as the means to the end, because that end is to communicate the message through the image. That being said, there are other contemporary drawing artists who do not draw like that, but rather use mark-making in a different way. These artists work with the mark, and mark-making, as the end in itself. The first option, the mark that delivers the message through the image, we have already looked at. The second and third possibilities—that the mark can be the message alone, or the mark and the image can deliver a multiple message—are fascinating and intense, and are what will be covered next.

Gorky's forms move, hover, and interact with each other with intensity and feeling, all of which is transmitted through his particular usage of lines and tones.

*The lines and tones related to each other, but do not
restrict each other; no tone is hemmed in by a line, and no
line is pulled up short by a tone.*

MARK-MAKING FOR ITS OWN SAKE

The mark as the end in and of itself is something that we can again trace to Georges Seurat (see pages 16–20). In his drawings, Seurat made images of everyday things with a certain tool (the conté crayon) on a certain paper (the textured Michallet paper). These three things—the common image, the blunt crayon, and the textured paper—all interconnect in such a way that his message, what he is communicating, is clearly a combination of the forms, the quality of light itself as depicted by the speckly, shimmering mark, and the interrelatedness of the mark with the surface. By making the quality of the mark interconnected with the nature of the surface, and by making the marks so distinctive and so obviously not just part of the subject matter, Seurat brought the mark into the open air of conscious thought and deliberate decision-making. Even though in his own work the message is a combination of the image and the mark, he opened the door to the idea of the mark being the message by itself.

The mark itself as the artistic end is something new to drawing, and having that as a possibility is one thing that distinguishes some modern and all contemporary drawing from everything that has come before. When, after Seurat, it became possible for the mark to be the end in and of itself, vast new artistic territory opened up for artists, in that their options tripled: the mark can deliver the message, the mark can *be* the message alone, or, as with Seurat himself, the mark and the image can combine together to deliver a layered message. We have just looked at the first of these three options, so now we will study the other two.

Many contemporary artists work with mark-making as the end in itself. Some go right to the heart of things, exploring the fundamental questions of drawing: What makes a line a line? How wide does a line have to be to stop being a line and start being something else? Does a line have to have an edge? Does a line even have to be drawn by hand? When I look at some of the drawings of Brice Marden and Sol LeWitt I find those questions occurring to me.

In one of Brice Marden's earlier drawings, *Untitled*, which is pastel, graphite, and wax on paper, three black rectangles line up side by side with the narrowest of narrow vertical white lines between them. The white lines are paper without the tonal media, the large black bands are paper with the tonal media. So the question is: Is this a drawing of three big black lines or two thin paper lines in a sea of black tone—or both? These wide black bands seem large and blockish at this scale, but would feel utterly linear if the paper were 100 times bigger. This drawing causes me to think about the nature of line itself, its width and bulk and the scale surrounding it.

OPPOSITE Brice Marden, *Untitled,* 1970, pastel, graphite, and wax on paper, 21 1/2 x 30 inches (55 x 76 cm)
© 2010 Brice Marden/Artists Rights Society (ARS), New York, NY
Courtesy Matthew Marks Gallery, New York, NY

This drawing calls to mind the purity of the mark itself, of line, tone, space, and edge.

For Helen B Marden 70

In pondering this, I remember how I once heard a quiz on the radio. The questioner asked if it was possible to draw a continuous line connecting all five dots in the five-dot pattern on a die (one dot in each of the four corners and one dot in the middle) without retracing one's steps. The conventional answer is no; however, one young girl sent in t he suggestion that you could succeed at this puzzle simply by laying a wide line, a line as wide as the whole five-dot pattern, down across the thing. No one had stated any rule about the width of the line. Seeing this loophole, the girl offered a simple, and brilliant solution. Lines can be different sizes; there are no rules about that. How we perceive lines is at the heart of drawing, and is explored by many artists. Marden continues to this day in exploring line, its movement, intensity, and meaning in his drawing, printmaking, and painting.

Sol LeWitt has spent his artistic career expanding and enlarging the possibilities of drawing and painting, and gently pushing past conventions. His folded paper drawing is an example of a drawing wherein nothing is drawn in the conventional way, but lines are put onto paper by the hands of an artist—and could be by anyone's hands, which is another of the conventions he has quietly strolled past, namely that art has to be made by specially labeled individuals. Anyone can do it, the artist need not be present, all one has to do is open one's mind and take the trouble to see. In this one simple piece LeWitt has both enlarged on what drawings are and challenged the preciousness and exclusivity of art.

When artists deliberately choose to draw certain kinds of marks for a specific look, they are bringing mark-making to the forefront, allowing it to deliver one message, while the images they create deliver another message. These two messages are often united, but are sometimes in conflict. This aspect of drawing—having the marks speak their own message that may or may not agree with the image—is particularly interesting in both modern and contemporary drawing. How do artists do this? I have chosen to break this information into four specific categories that are based, not on what tool makes the mark, but on what force produces the mark. In contemporary drawing, artists choose whether to be in charge of the mark, or whether to let another force be in control. I have put this choice into four categories: artist-induced marks, nature-induced marks, culture-induced marks, and marks that are self-governed but unforeseeable. The first category is the one we are most familiar with, the other three are newer, having derived from the concepts of Pop and Conceptual art of the 1960s and 1970s.

In this one simple piece LeWitt has both enlarged on what drawings are and challenged the preciousness and exclusivity of art.

What is a line—and what is a drawing? Both questions are presented here for each viewer to figure out.

The Artist-Induced Mark

When the mark is used as the means of communicating the message, the artist considers the other variables of surface and materials in light of what the message is, and in light of what the marks need to be to communicate that message. The artist sets the parameters of size, color, and composition, in order to help the mark deliver the message, and then sets to work creating the image by means of certain distinctive marks that will tell the story.

Several artists come to mind who have created art that communicates a storyline through the mark itself: Ralph Steadman and Alan Cober are two wonderful examples of artists whose pen and ink lines are drawn in ways that add emotion and meaning to their images. The artist I'd like to picture here, however, is Saul Steinberg. Steinberg's drawings are quietly sly, with the image saying one thing and the marks telling the real truth. His humor is almost entirely in the way he draws what he draws. Steinberg's drawing *Techniques at a Party* shows us a number of people at a cocktail party, each drawn with a different kind of mark. Some marks are forceful, some are timid, some are solid, and some dissolve into dots. Obviously, the marks describe the authentic personalities at this party, both humorously and succinctly.

ABOVE Saul Steinberg, *Techniques at a Party,* 1953, ink, colored pencil, and watercolor on paper, 14^1/$_2$ x 23 inches (36.8 x 58.4 cm) The Saul Steinberg Foundation, New York, NY © 2010 The Saul Steinberg Foundation/Artists Rights Society (ARS), New York, NY

Showing us how a single kind of mark can be more honest than the image it depicts is one of Steinberg's gifts.

OPPOSITE Piet Free, *An Exercise in Dichotomy,* 2008, pen and ink on paper, 9 x 12 inches (22.9 x 30.5 cm) © 2010 Piet Free

Free has used different marks to show us different mental states, not of the apples, but of the artist.

It is possible to set up a project in which you create drawings where the marks do all the communicating. One of my students, Piet Free, made these pen and ink drawings of apples. The assignment was to draw the apples, showing various dichotomies through the mark-making. The dichotomy depicted here is "decisive/indecisive." As you can see, one apple is drawn in a direct, straightforward way, while the other is drawn anxiously with many kinds of marks, as if the artist can't decide whether to hatch or stipple or shortline or . . . or

The Nature-Induced Mark

When mark-making itself is the focus of the drawing, and the mark itself is the message being created by the artist, then how the marks are produced becomes a significant and fascinating part of both the process and the finished piece. The next three discussions pertain to how the mark is created: nature-induced, culture-induced, and something that falls in between the two. In all three of these categories, the artist has to relinquish control somewhere in the process. This letting go is part of the difficulty of drawing this way, but also contributes to the work's authenticity and depth.

Nature-induced marks are those created by some force of nature. Forces such as gravity, propulsion, surface tension, and fire have all been used by artists who are interested in a result that cannot be predicted or heavily controlled, but that communicates something intense. The intensity comes from the unpredictability, the sheer chance of it all, and the surprising beauty that can occur when artists let the laws of the universe take over.

GRAVITY

Jackson Pollock made splatters and drips, which are just such a set of marks, created by gravity, not to mention by the various forces involved in liquidity and the chemical behaviors of pigments. Pollock's famous statement "I *am* nature" gets right to the point: No longer does the artist stand apart from nature and depict it, the artist is a part of nature, and is aware of, and governed by, the vehicle through which nature makes its mark, makes its particular presence known. Pollock recognized something that we perpetually forget—that human beings are part of it all, not separate overseers. His powerful work is the result that can be found in art made by handing much of the control over to the fundamental and ever-present force of gravity.

The drawing *Autumn* by Louise Kikuchi is composed of ninety Sumi ink droplets with added color (gansai), dropped onto a piece of absorbent rice paper, complete with attendant splatters, in a gridded pattern of seven across and thirteen down, with the bottom row having only six droplets. Gravity is everything here, even influencing how we are meant to look at this from top to bottom, with a very subtle color change going from warm to cool. Even though she organizes the results of gravity's pull, the feeling is that it is a force, huge and inevitable and not to be totally controlled.

The choice of rice paper is important to Kikuchi, as it responds to ink in its own soft-edged and subtle way. Try to imagine this image on any other paper, and you can recognize that her choice of rice paper is a deliberate one. Kikuchi works with a variety of papers, especially a variety of rice papers, and runs many tests to arrive at the right surface for each image. The softness, blur, and spread of wetness varies from

NATIONAL RIFLE ASSOCIATION
OFFICIAL 50 YD. SMALL BORE RIFLE TARGET
FOR PRACTICE ONLY. NOT FOR RECORD FIRING.

THIS TARGET IS OFFICIAL IN ALL DIMENSIONS BUT IS FOR PRACTICE ONLY. FOR
ALL OFFICIAL NATIONAL RIFLE ASSOCIATION COMPETITIONS, THE OFFICIAL N. R.
A. TARGET CONTAINING 2 BULLS AND LITHOGRAPHED ON SPECIAL TAGBOARD, TO-
GETHER WITH A BACKING TARGET IN A DOUBLE TARGET FRAME MUST BE USED.

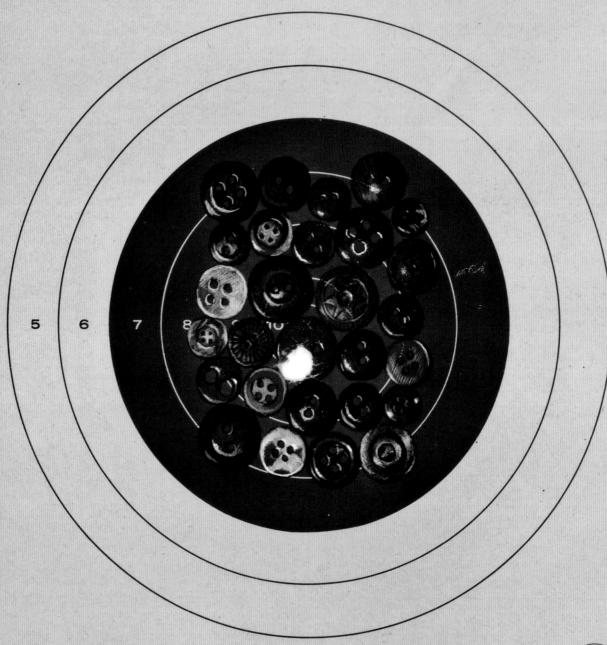

NONE OFFICIAL
WITHOUT THIS SEAL

Target-handgun Margaret Davidson 2006

Quality Gun Care Products

16 Industrial Pkwy., Easthampton, MA 01027 Tel. 413/527-0300

Made in U.S.A. - NRA License No. 42

A-9

paper to paper, and is an important decision in her images. With all her planning and control, the fact that the force of gravity is the reason these marks exist causes her drawings to be loose and free. Gravity being in control of Kikuchi's ink drops reminds us of how gravity also works on everything in this world, including weather, air, and even our own sense of the passage of time.

PROPULSION

Propulsion is a force of nature that can result in images either innocuous or frightening. This is because to propel something you need to use some sort of device, which can be as simple as a rubber band or as deadly as a gun. My pen and ink drawings on NRA-approved gun targets are two examples. The targets are certainly part of the message, as are my bullet holes. Targets are a given-paper surface, a commercially made and easily available pre-printed paper, and I found them both nondescript and threatening. The whole target image, the concentric circles with the powerful center, is an image that goes back several thousand years and is something we humans really focus on and are drawn to. I chose to draw on the targets and treat them like art, and then shoot the drawings, treating them like targets, thereby ending up with art wherein some of the marks are handmade, and some of the marks are the bullet holes.

For propulsion, one does not need to use real guns necessarily, as different kinds of guns are safe in more situations: squirt guns and water pistols come to mind. Other propulsion tools may include atomizers, spray bottles, and even toothbrushes. Anything that sends ink or pigment out with some modicum of force can engage in propulsion.

Another way to use propulsion is to be the propelling force yourself. Tom Marioni's drawings, as seen on the following pages, which are both drawings and performance pieces, communicate various kinds of movements—running, leaping, reaching, stretching—and he makes marks on paper while he is making those movements. Marioni chooses to make certain movements for certain spaces, on certain sizes of paper, in prescribed amounts of time, and then he inscribes marks on the paper, as he is moving, with specific tools. His marks are a direct record of his movements. By clamping down on all the variables of time, surface, space, and tools, Marioni opens up the field for the mark itself to do all the communicating about his movements, and about movement in and of itself.

SURFACE TENSION

The nature and behavior of bubbles depends on the surface tension of the soapy liquids used to make them. I can think of two artists, and maybe there are more, who work with

Forces such as gravity, propulsion, surface tension, and fire have all been used by artists who are interested in a result that cannot be predicted or heavily controlled, but that communicates something intense.

OPPOSITE Margaret Davidson, *Target—Handgun*, 2006, pen and ink drawing on commercial target, 9 x 7 inches (22.9 x 17.8 cm) © 2010 Margaret Davidson
Photo: Nancy Hines

I drew buttons onto the commercially printed target, and then shot it with a .357 magnum handgun. This piece rocks back and forth between being a drawing and a target, with the bullet-hole mark and the drawing marks each being at home in the one, and startlingly out of place in the other.

this very ephemeral natural force: Roland Flexner and Tara Donovan. Flexner adds soap to ink in some very careful proportion to blow singular ink bubbles that, with care, can be caught and popped on a sheet of paper. I say "with care" because it takes a lot of bubbles popping too soon and splattering all over the place before one gets one that lasts long enough to get it onto paper. The resulting images are stunning: The disc of marbleized tone with strings and splatters of ink at the edges look more like something you'd see at NASA than on the drawing table. The images (as seen on page 82) are equally believable as bubbles or as planets, and beautifully mysterious at either level.

Tara Donovan actually etches metal plates with bubbles, making wonderfully subtle prints. Donovan and Flexner have found two very different ways to do what seems impossible—capturing and solidly recording the presence of that most elusive thing, the bubble.

FIRE

I have tried working with soot and burnt paper a little because the results are so entirely and interestingly unpredictable. However, I have only even thought to try this out because of the work of the great musician, writer, and artist John Cage. Cage has made a number of monoprints and drawings using fire as one of his mark-making tools. He also draws directly on some of the images. Monoprints are images on paper that use printmaking technology to produce them, but also employ methods that result in unique and

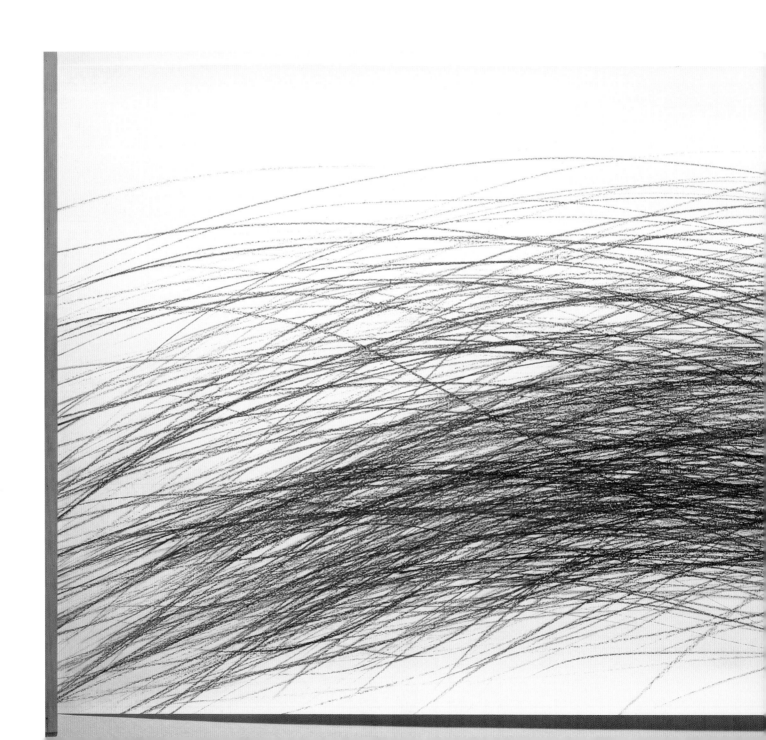

unreproducible marks. The results are both one-of-a-kind prints and drawings wherein printing presses were used. Cage's works use fire right when the paper is being cranked through the press, and also through techniques such as timed branding. The results, such as the image that appears on page 38, sometimes contain burnt holes, sometimes have burnt edges, and always feature smoky singed tonalities.

Another artist working with fire in a way is Etsuko Ichikawa. (See image on the following page.) Ichikawa draws onto paper with molten glass, which singes and burns the paper as her hand moves quickly and gesturally. The result is an image that is the immediate and utterly truthful record of her movement, with no changes or corrections and certainly no indecision allowed.

BELOW Tom Marioni, *Flying with Friends,* 1999, colored pencil on paper, 36 x 89 inches (91.4 x 336.1 cm) © 2010 Tom Marioni

Marioni is interested in the immediacy and truth of the mark. The marks in this drawing are made when he and his friends run up to, and then leap past the paper, marking it with the colored pencils they are holding.

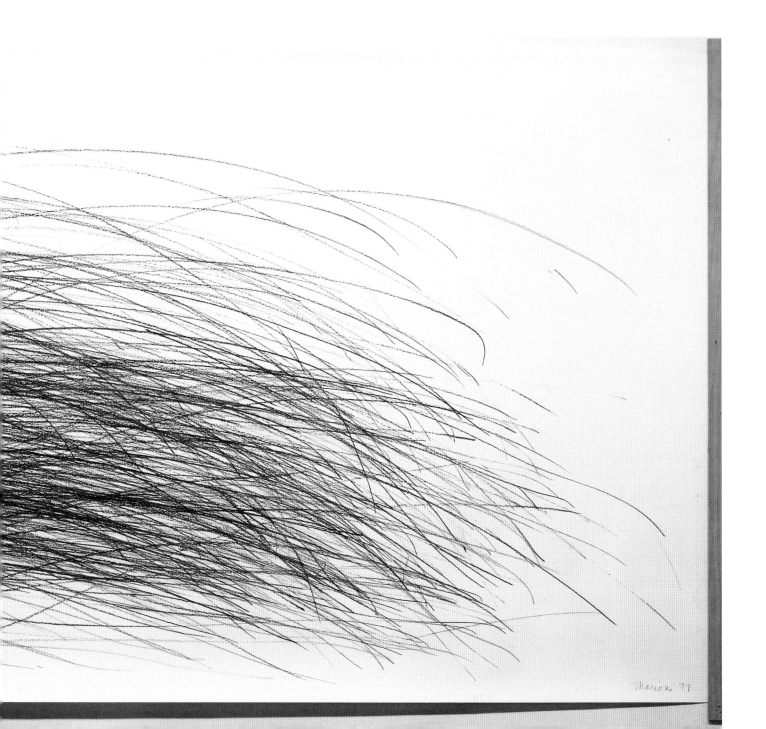

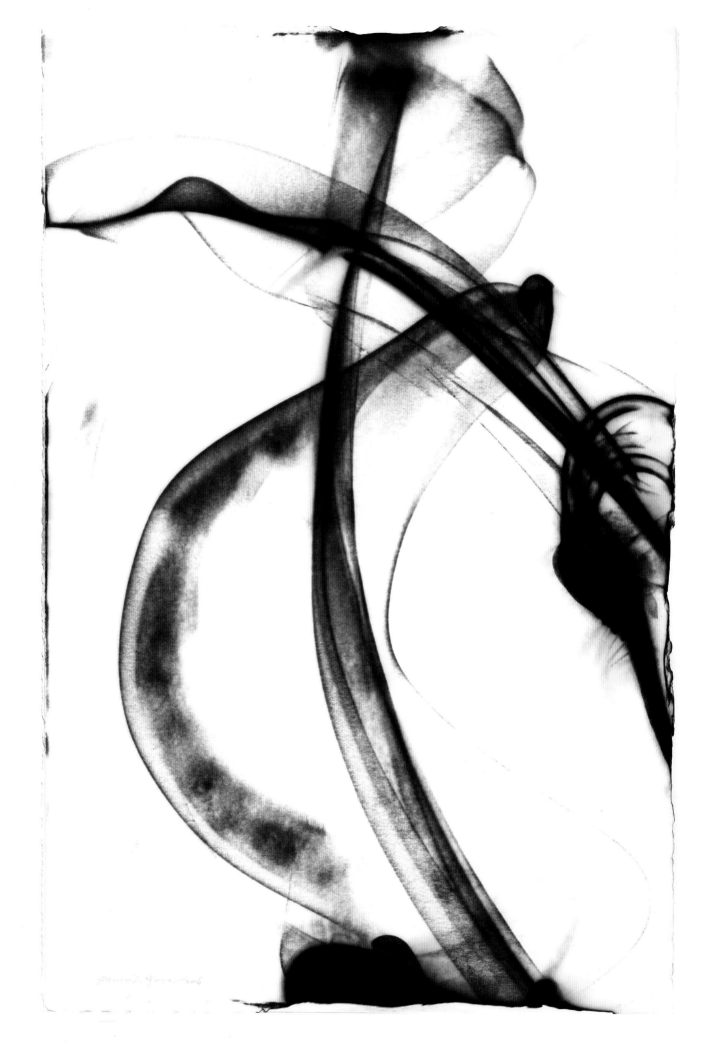

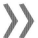

USING NATURE TO INDUCE MARKS

Forces of nature can take over your mark-making in any number of ways. Here are a few techniques you might want to experiment with:

GRAVITY Use an eyedropper to drop ink or watercolor onto various papers. The height you hold the eyedropper, the amount of liquid in the eyedropper, and the kind of paper are all variables you can adjust and play with.

PROPULSION Soak small pieces of sponge in brown ink and then throw them at the paper. The wetness and intensity of the ink, and the distance and force in the throwing, are all things you can alter and adjust for different effects.

SURFACE TENSION Mix drawing ink about 50:50 with bubble soap and blow ink bubbles. While creating the sample below, I ended up with more ink on my face than anywhere else, but I gained an even greater appreciation for Roland Flexner's work.

FIRE This technique is tricky because it is so potentially dangerous, so if you're going to work with fire, be careful and take precautions. Try using a candle to smoke part of a drawing. First, mask out the party you don't want to get sooty; liquid masking fluid works, as does a cardboard stencil. Then, stand outside and hold the unmasked part of the paper close to a lit candle, causing the candle to smoke and deposit soot on the drawing. (See image on title page spread.)

RIGHT Nature-induced mark-making techniques can include gravity (top), propulsion (middle), and surface tension (bottom). Photo: Nancy Hines

OPPOSITE Etsuko Ichikawa, *Trace No. 23706*, 2006, glass pyrograph (molten glass burn) on paper, 22 x 15 inches (55.9 x 38.1 cm) Courtesy Randall Scott Gallery, New York, NY © 2010 Etsuko Ichikawa

In Ichikawa's work, the marks, created by the heat of the molten glass and the speed of her hand, look both beautiful and pure.

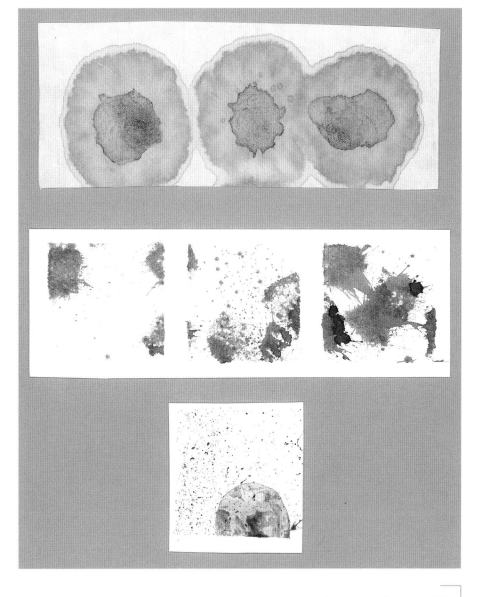

The Culture-Induced Mark

Drawings made by working with culture-induced mark-making are contemporary indeed. They are made by artists who have found ways to let various cultural forces direct and sometimes control their marks, and also by artists who use machines to make their marks. I will discuss three artists below. All three work with text as the cultural influence of their marks, with two using machines as well.

TEXT-BASED MARKS

Various artists today are using text-based cultural objects as the controlling force of their drawings. Some work on pre-printed papers, like newspapers and sheet music. Other pre-printed materials, such as maps and book pages, have been used by artists as the base image and surface for their contemporary drawings (see pages 31–33). Always the pre-printed marks have some say in what the finished image will look like and what it will be about. Sometimes these artists are working with the content of the text, but always they are working with the shapes the text makes, the blocks and ragged-edged rectangles that printed text forms. As with the artists working with nature-induced marks, those working with culture-induced marks know that they do not necessarily control the outcome.

Sally Schuh works with the text itself as her image. Schuh creates visual interpretations of Gertrude Stein's writing. As Schuh says: "Gertrude Stein used repetition to make auditory pattern out of sounds and oral patterns out of words. . . . Influenced by Minimalism and Conceptualism, I use this repetition to create a visual translation of what Stein created in literary form." In the image shown here, Schuh assigns each square of paper of her drawing to a sentence of Stein's writing. If the sentence consists of one phrase, Schuh types that phrase into a square with a manual typewriter. If the sentence has many repetitions of the phrase, she types all of them into a square. Visually, the squares vary in density and tonality, with the accumulation of typing sometimes breaking the paper apart. The phrases vary from legible to illegible, from light to dark, and from solid to lacey. Schuh then arranges the squares and delicately attaches them to each other.

LEFT *Detail of Sally Schuh's* She Was Beautiful. *Though the marks are machine-made, they have the very human qualities of being irregular, crooked, and indefinite.*

OPPOSITE Sally Schuh, *She Was Beautiful*, 2006, typewriter type, Japanese paper, and beeswax, 31 x 24 inches (78.7 x 61 cm)
© 2010 Sally Schuh; Photo: Arthur Aubry

This drawing is based on the text from Gertrude Stein's story "Many Many Women" from G.M.P. The text breaks, words are there and not there. Text is sometimes legible as text, but always legible as a variety of marks.

Louise Hopkins colors in areas of newspaper pages, leaving certain things exposed. In the case of the drawing pictured here, she has left visible the words "the" and "of" and "of the." She has colored in all the rest of the newspaper sheet in ink. The result is a tonal dark area with sprinklings of lighter spots. Their positions and groupings cannot be comprehended until the coloring in is done, and so the overall pattern is uncontrolled by any artistic compositional intent, unpredictable, and surprising in how balanced and interesting it is.

MACHINE-GENERATED MARKS

Machines are cultural tools, and contemporary drawing artists often use them as a way to create a mark that is *not* handmade, and therefore more impersonal and soul-less.

Sally Schuh uses a typewriter to arrive at text that is both legible and illegible, and surprising in its variability. Carl Andre uses a typewriter quite differently, exercising much more control. In the 1970s he used a typewriter equipped with the kind of ribbon that was half black and half red. He stacked words and spaced them in certain ways, shaping the words into red and black blocks that fit together sculpturally, creating certain patterns and positions, sometimes relating to the words used, sometimes not.

Other machines that artists are working with include the complex, such as computers and photocopiers, and the more simple, such as sanders, punches, and staplers, to name a few. The use of these machines is indicative of how contemporary drawing artists have expanded the possibilities of mark-making as they have expanded the nature of drawing.

LEFT Carl Andre, *Plan,* 1972, color photocopy on typewriter paper, 11 x 8 inches (27.9 x 20.3 cm)
© Carl Andre/Licensed by VAGA, New York, NY
Image courtesy of the Paula Cooper Gallery, New York, NY

Andre's typewriter text is built into blocks of red and black, with a sense that the composition is structured on the shape as well as the meaning of the words.

ABOVE Louise Hopkins, *Untitled (the, of, the),* 2002,
ink on newspaper, 24 x 29 ¹/₈ inches (61 x 74 cm)
© 2010 Louise Hopkins; Photo: Hyjdla Kosaniuk Innes
Courtesy of the artist and Mummery + Schnelle, London

*Hopkins has let the nature of the content of the text be
the deciding factor in her own compositional structure,
which is both daring and trusting. She has dared to
let go of control, and trusted that something of
interest will emerge.*

ABOVE Joseph Pentheroudakis, *Dear Diary,* 2009, pen and ink on paper,
22 1/2 x 22 1/2 inches (57.1 x 57.1 cm) © 2010 Joseph Pentheroudakis
Photo: Frank Huster

The collection of marks in this drawing work on the "cellular" level, in that they each relate and react to the marks directly adjacent to themselves when viewed up close, and then also coalesce into a greater whole when viewed from a distance. Pentheroudakis is interested in both, showing us unique individualism in the marks themselves, and the idea of united community in the drawing as a whole.

The Self-Governed but Unforeseeable Mark

In previous paragraphs I have talked about artists who control their marks to create a certain foreseeable image with its attendant message, and artists who have surrendered that control to outside forces, either generated by nature or by culture, to create an unforeseeable image with a different message. Here I would like to show the work of a few artists who have combined those two ways of creating. These artists decide on the rules for their mark-making, and are still doing the drawing with their own hands, but have set up parameters that cause the finished image to be unforeseeable.

Seattle artist Joseph Pentheroudakis creates pen and ink drawings wherein the marks all are made according to certain rules defined by Pentheroudakis himself. These parameters are such things as "the drawing will consist of short vertical strokes, arranged in horizontal but not straight lines that don't touch, and with occasional disruptions in the horizontal format," which is the set of rules for the drawing pictured here called *Dear Diary*. They act as both guidelines for him and controls on the movements of his hand. Although Pentheroudakis has a general idea what the finished drawing will look like, he cannot know for sure until it is done whether it will look the way he foresaw, or whether he will like it, or even whether he can do it without error. Part of the challenge that he creates for himself can be seen in the size and format of his drawings. Pentheroudakis chooses to make some of his drawings quite large, knowing that the size will make things difficult, and also that the finished piece will prove, by how it fills the eye and mind of each viewer, that the whole is greater than the sum of the parts. He also chooses his format with care, recognizing that whether something is rectangular or square has an immediate effect on its visual impact.

Walter Tandy Murch, discussed on page 26, is worth mentioning again. Murch's drawing pictured on page 81 shows objects in a bowl with other objects sitting nearby. The objects are mostly drawn showing their attendant lights and shadows, though not all are. The air is mostly drawn with transparent linear hatching, though not all of it is. The white, opaque marks are added to both air and object, just as the unmarked white paper is used for both air and form. Furthermore, the usual flatness of drawing is also altered, and just as the marks and thickening white break up and lighten the weighty objects, they simultaneously add weight and presence to the air and space that lies around and between the objects. The finished drawing presents to the viewer a whole set of artistic dichotomies—the objects are both weighty and light, the space is both airy and thickly textured, and the drawing is both illusion and reality. All of these things combine into a kind of art truth that Murch succeeds in creating, namely that drawing is both dimensional and flat, with the illusion of the image combined with the reality of the surface.

This kind of work has to be done almost gropingly. The artist must equalize every mark that indicates illusion with another that asserts flatness. There is no roadmap, no possibility at the beginning of the drawing of knowing what or where these opposing marks will be, and so the artist must continually shift and change, assessing each stroke and space in relation to every other, until balance is finally achieved.

> Although Pentheroudakis has a general idea what the finished drawing will look like, he cannot know for sure until it is done whether it will look the way he foresaw, or whether he will like it, or even whether he can do it without error.

THE MARK'S RELATION TO ALL ASPECTS OF DRAWING

Mark-making, and the decisions that artists have to make about mark-making, do not occur in a vacuum. As I said at the beginning of this chapter, marks do not stand alone. Marks are influenced by, and inflict their own influence on, surface, space, composition, and scale. All of this interconnectedness is governed by the intentionality of the artist. Every artist chooses and decides these various things, and those choices, paradoxically, include choosing not to decide, or deciding not to choose. All of it has some element of the intentional.

Relation to Surface

Every kind of paper, and every kind of other surface, influences drawing tools, and has a say in what the mark will look like. As was stated in the previous chapter, the nature of the surface will affect the nature of the mark. Also, another mark/surface relationship deserves mention: the nature of the feel of the surface, its touch, to the artist while he or she is drawing. Artists respond to the way the surface feels under their drawing tools. That is not necessarily something that is obvious in the marks, but if an artist is not happy with the touch of the surface, as well as with the way the marks look on it, the drawing will show that discontent and argument. Occasionally an artist wants that distress to be in the drawing, but not usually. Both the feel of the surface while drawing, and the way the mark looks on it, have to be right for the artist to consent to work with the surface, whatever it happens to be.

Relation to Space

Take a sheet of paper and draw a line on it anywhere. You now have a drawing that consists, not of one thing, but of two—the line and the space around it. These two things have a tight, reciprocal relationship. The space is made cogent by the line, and the line means nothing without the space. Line by itself has a relationship with space that is intense, and both real and symbolic.

It is easy and acceptable for the viewer to notice just the line itself and forget about the space that is surrounding and supporting it. But the drawing artist cannot forget the space for even a moment, as it is the mark's oxygen, the medium in which that line lives and breathes. Within the space of your sheet of paper, the line can be coming or going,

rising or falling, strengthening or fading—all activities that imply movement and are impossible without space. So, every student of drawing must become aware of, and work deliberately with, space as well as with the marks made in that space. As a drawing artist makes marks, he is literally carving into, and shaping, space. He is carving space with the marks and housing those marks within that space. The two are completely interdependent; every artist mentioned in this book works with that relationship consciously, in some kind of way, doing everything from keeping the space behind and the mark in front, to pushing them both into some kind of interchangeability.

Relation to Composition

How effective marks are has to do with how artists draw them, and where they put them. Composition is the positioning of marks with regards to the space, the boundary edge, and the other marks. Only through the effective and conscious use of composition can the artists' marks relate to the space they live and breathe in, and thereby work the way they are intended to work.

Relation to Scale

The size of a drawing—its scale—has a direct influence on the size and nature of the marks. A ballpoint pen line looks normal in a sketchbook, but miniscule on, say, a doorframe. Likewise a large tonal area of graphite drawn in a notebook looks fairly small on a wall. This relationship of scale—size of mark to size of mark's environment—greatly influences how artists decide to execute marks, what they use as tools and materials, and how they move their hands, arms, and bodies. That decision about scale, in turn, affects how the artist and the viewer see the drawing, how they experience it, and how they respond to it.

OPPOSITE Walter Tandy Murch, *Still Life with Bowl of Fruit,* 1965, ink, graphite, and gouache on paper, 23 $5/8$ x 17 $7/8$ inches (60.1 x 45.4 cm) Private Collection; Courtesy of Michael Rosenfeld Gallery, LLC, New York, NY; © 2010 Walter Tandy Murch

Murch approaches the depiction of the duality of illusion and reality through constant questioning and attentive mark-making. With the study of each mark, we are made keenly aware of every space, and when we look at the space, we cannot fail to see its interrelatedness with the marks.

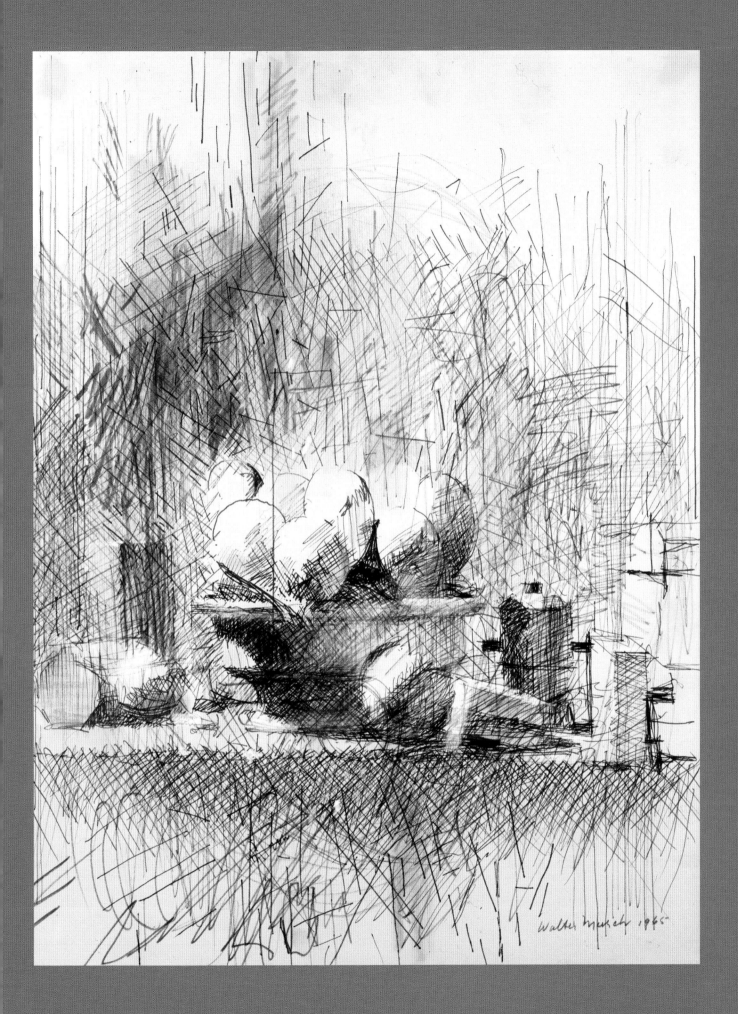

Walter Murich 1945

SUMMARY

Drawing is an area of art wherein the mark is of huge importance, and has a complex and essential relationship with all of drawing's various parts.

In contemporary drawing, the marks themselves are used by artists to communicate with the viewer, and to create whatever finished images they desire. Contemporary drawing artists communicate their various messages by considering both what marks the picture is made of, and what the picture is of. The choices available to the drawing artist today include drawings where the marks deliver the message, drawings where the marks are themselves the message, and drawings that combine both into the finished idea.

Furthermore, the possibilities in mark-making have increased hugely due to a change in the fundamental outlook of artists in the twentieth century. Artists have been influenced and inspired by the world of nature since the very beginning. We have used art to depict the world, classify the world, imagine other worlds, even explore the inner psychological world. This is what art has been for centuries, and is what art continues to be for many artists today. Starting in the twentieth century, however, some artists began to come at art from another direction. Instead of being inspired by landscape or the figure, namely nature, these artists were inspired by billboards, the written word, machinery, mass-produced things—in short, by culture. The Pop artists were in the forefront of this development—artists like Andy Warhol, Robert Rauschenberg, and Roy Lichtenstein who took culture, rather than nature, as their source.

This opened up new sources of inspiration for what the image could be, and it has also opened up new sources for what the mark could be. It has affected all contemporary drawing and how artists make marks, and has also added mark-making possibilities, with marks that are powered by natural forces and those created by cultural forces. Natural marks are, for the most part, untamed. Marks created by Pollock or Cage, using natural forces, make this very point—their marks are out of human control, wild, caught by accident, unpredictable. Cultural marks, for example those presented to us by Schuh or Hopkins, are still unpredictable, but in a more ironic way. Rather than turning to nature as nature, these artists look to the cultural doings of mankind as nature. Presenting culture as nature is fascinating, though sometimes touching on the cynical. But this is the way things are. Culture is now the artistic source for many artists, especially in highly industrialized countries. Some people bemoan this, but it is not necessarily a bad thing. Artists working with this point of view have opened up new territory with their imagery and ideas, and have certainly developed new realms of mark-making. In art, in my opinion, more choice is always better.

In addition, there are new ways of making marks. Machines of various kinds are being used to draw lines and tones, some within the artist's control and some outside of it. Of course, the artists today who use machines understand that it is not the machine, but rather their intentions in choosing machines, that makes their drawings contemporary. The possibilities in mark-making have increased dramatically in contemporary drawing, but are still corralled by the conscious choices artists must make, choices having to do with surface, space, composition, scale, and drawing materials and tools. Intentionality remains the number one principle for all drawing artists, regardless of the nature, relevance, or recognizability of their images.

In contemporary drawing, intentionality has to do with personalizing the image, and arriving at a personal truth. A personal truth is not necessarily the same as a universal truth, but it could be, and it is left up to time to decide that. All the subtlety and intimacy of drawing, whether by hand or with the aid of some machine, whether in the artist's control or in the realm of chance, is turned to by artists who seek to express something completely personal and honest. Drawing has always provided a direct path to this kind of truth, and contemporary drawing artists continue to work at finding new ways of arriving at it.

OPPOSITE Roland Flexner, *Untitled,* 2000, ink and soap on paper, 6 3/4 x 5 1/2 inches (17.1 x 14 cm) Courtesy d'Amelio/ Terras Gallery, New York, NY © 2010 Roland Flexner

Flexner's bubbles are unique. They are the product of, and even depict, several physical laws that control all things in the universe, including, we are startled to remember, us.

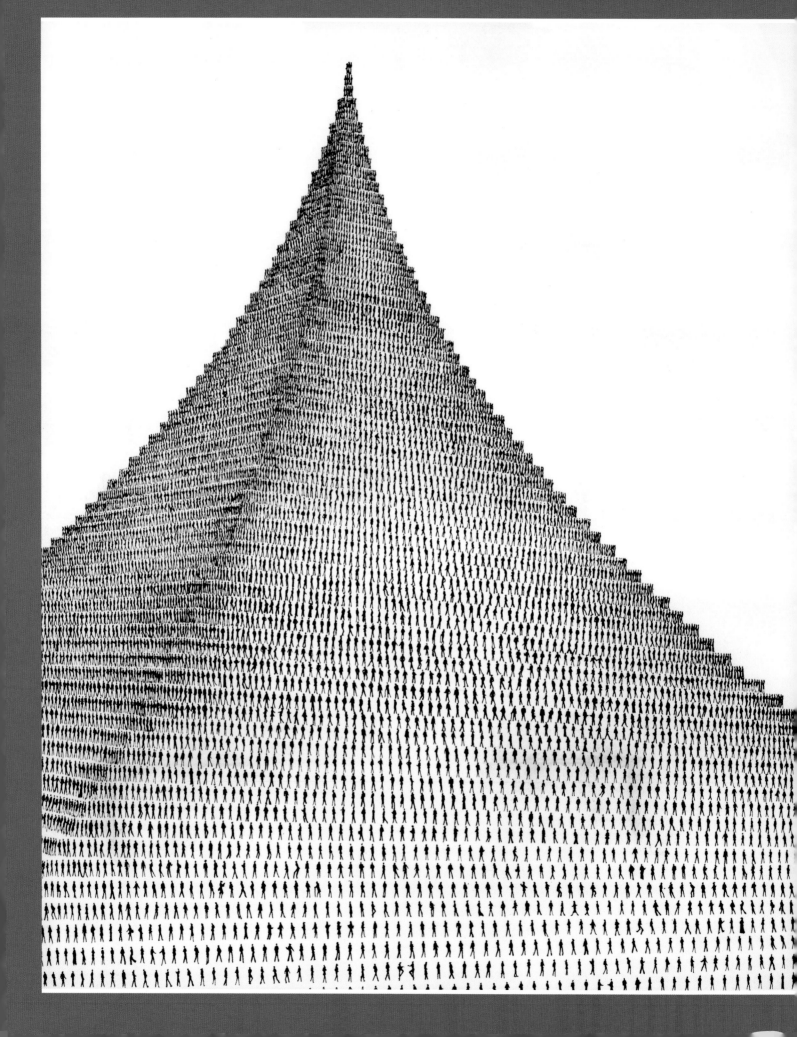

CHAPTER THREE

SPACE

I n real life, space is all around us. In art, as in reality, space is the stuff that is between, around, and behind things. However, unlike reality, where space is essentially intangible, in art, particularly in drawing and painting, space is visible, tangible stuff. And when something in art is visible and tangible, that means the artist must work with it consciously and intentionally.

In painting, space either is painted some sort of color with some amount and thickness of paint or is left to be the blank canvas, which is also a color and a texture. This is also the case in drawing, where space either is drawn in or is left to be blank support, either of which is some sort of color and texture that the artist has deliberately chosen.

OPPOSITE Agnes Denes, *Pascal's Perfect Probability Pyramid & The People Paradox—The Predicament* (detail), 1980, India ink on silk vellum, 32 x 43 inches (81.3 109.2 cm) © 2010 Agnes Denes, courtesy of the artist

This drawing contains more than 16,000 figures, and each is unique. The full image can be seen on pages 90 and 91.

SPACE IN DRAWING

Space in drawing is its own presence, either subtle or bold, depending on the surface and the intention of the artist. Space is also the medium that the mark exists in, the mark's oxygen, as I said before. Space is necessary for the existence of the mark, and likewise the mark is necessary for our realization of the presence of space. The two are essential to each other, and constantly play off of each other. Space is not evident until a mark has been made; in fact, that act of making a mark on a surface organizes everything immediately into the relationship of a drawing. What had been nothing is now the something of art. This is why when looking at a drawing of a single object, even of just a single mark, it is always actually two things: the object and the space it inhabits. This is true in all drawing, regardless of the nature of the imagery. All drawing artists, both past and contemporary, know that they must think about the relationship space has with their mark-making, and with the surface, and with all the other concepts discussed in this book. Contemporary drawing artists especially know that space in drawing is a touchable substance, one that must be worked with consciously, and deliberately molded.

Georges Seurat, as mentioned in the chapter on surface, made both drawings and paintings wherein the air is as tangible as the forms. The support used for drawings by Seurat was paper. Today in contemporary drawing the support can be such a variety of things—including paper, glass, wood, and cloth—any of which have color, texture, and some sort of specific physical presence. This presence can be loud or soft, obvious or subtle, demanding or retiring—but it is always there, and the drawing artist chooses that particular support because of that presence, that particular voice, which becomes an active, intentional part of the drawing. This voice, this presence of the support, is especially noticeable in the areas of space. This is true whether the artist leaves the space in the drawing blank, or whether he completely colors it in with hand-applied tone. In either case, the artist has chosen that support for how it looks alone, and how it influences the drawing marks as they are laid down. This is a key decision in any contemporary drawing, and for both the artist and the viewer, this decision is especially visible within the drawing in the areas of space. In art, space is tangible, and this fact can never be forgotten by the artist. In contemporary drawing, space is as intensely important as form, and thanks to artists like Seurat, can be interchangeable with it.

To assess the space within various drawings and the artists' intentions regarding it, we need to begin with an understanding of something that is basic, a key division in drawing, and that is the difference between a sketch and a drawing. That difference is, in fact, entirely a matter of the artist's intention with space. In a sketch the artist is not thinking about anything but the form he's trying to capture; he's not thinking about its relation to anything else on the page, he's just trying to get it down. However, in a drawing the artist is thinking about the entire page, about the spatial relationships of the forms to each other, to the air around them, and to the outer edge of the format, the whole page. One can see the artist's intentions when looking at a sketch or a drawing, and one can tell when he is thinking about just form, as in a sketch, and when he is thinking about form in

OPPOSITE Peter Sculthorpe, *Zimmerman Homestead, Lancaster, Pennsylvania,* 1987, graphite on paper, 6 1/2 x 12 inches (16.5 x 30.5 cm) © 2010 Peter Sculthorpe Courtesy of the Frye Art Museum, Seattle, WA

With the use of spaces as well as marks, Sculthorpe both states and infers this homestead. The areas empty of marks are sometimes the sky, sometimes the ground, sometimes part of the building— his use of these emptinesses deliberately balances the graphite tonalities and is quietly powerful.

relation to the space of the page, as in a drawing. Sketches do not show a relationship between the form sketched and the paper it is sketched on. Our interest here is in drawings, because they do show that the artist has worked on relating the forms to the space, the surface, and the edges of the page.

A drawing is, most basically, some sort of surface that includes areas of marks and, usually but not always, areas of no marks. These non-marked areas have the same importance as the marked areas, and are thought about and decided upon by the artist as much as the drawn areas are. The non-marked areas can depict either space or form, just as the marked areas can. The artist is intentional and deliberate about how the non-marked area is used, and how the paper or other support exerts its particular influence within that empty area. A drawing is also an image made by someone who is

deliberately positioning everything in relation to the edges of the format, an act of composition that immediately brings to the fore the concept of space. As soon as the edge of the page is considered by the artist, some kind of space is decided upon.

Contemporary drawing artists can depict different kinds of space. These can all be drawn on any kind of paper, or on any kind of surface whatsoever, because, in drawing, space is something the artist creates on purpose, and so can impose on any surface. The four main kinds of space that artists use include: depicting the illusion of three-dimensional space; promoting the truth of the flatness of the picture plane; working out a combination of both illusory dimension and actual flatness; and making actual three-dimensional drawings. Each of these approaches will be explored in turn on the pages that follow.

Everyone is most familiar with drawings that depict three-dimensional space. Every comic book or graphic novel does exactly this, and also every realistic drawing tries to picture recognizable forms in believable, three-dimensional space. Realist drawing is usually done on a flat surface, most often a piece of paper. To depict three-dimensional space on a flat two-dimensional surface means that you are creating an illusion. Several techniques are available; most drawings in which the artist is involved with illusory space incorporate more than one of these techniques at the same time. All of the techniques listed below come under the heading of perspective, and more detailed accounts of them can be found in books that are specifically about perspective in drawing. Here I will touch on the main ones used by contemporary drawing artists who are interested in depicting the illusion of three-dimensional space.

Overlap

When objects or forms overlap each other, the implication is clear—one thing is in front of the other. We immediately understand this to be an indication of spatial depth—that this thing is near us and the other thing, which is partially obstructed by the first thing, is further back. As soon as something seems to be *behind* something else, space is implied. Artists have used this technique for centuries, of course, and it is not exclusive to drawing, by any means. However, some artists today have done things with overlap that work better in drawing than in any other media. Robert Birmelin is an artist whose drawings show overlap combined with an interesting transparency. The result is a sense of speed and the flash of instantaneous peripheral comprehension we get out of the corners of our eyes or just when we turn our heads. He gives us this sense of speed and feeling of space and distance with his transparent overlapping of the figures. No one is truly solid; everyone is in flux. He seems to be giving us his mental images of one person who is just moving out of a certain place while another is just moving into it. He reinforces this with rapid strokes and human eye level, and with changing the size of the figures so that the largest are those closest and the smallest are those most distant—size changes that are consistent with our daily experiences.

Size Difference

Size difference is simple. We all know that larger things seem closer to us and smaller things seem farther away. This concept works in art very effectively, and even works without overlap. Agnes Denes's drawing *Pascal's Perfect Probability Pyramid & The People Paradox—The Predicament* (which appears on the pages that follow) shows thousands of little marks forming a curving pyramid. A closer look shows us the surprising truth—that all the little marks are silhouettes of people, more than 16,000 of them, in fact, each one unique, with larger figures forming the part of the pyramid that is closer to us, and figures getting progressively smaller and smaller to indicate the areas of the pyramid that angle away from us. These figures are not in any kind of regular, outlined interior space, but they find themselves to be the indicators of a three-dimensional spatial form, and Denes is using size difference to show us this. It is also important to note that as the figures change in size, so do the spaces between the figures. Spaces need to get smaller as they recede from us just as forms do. You need both to succeed in creating the sense of three-dimensional space through size difference.

ABOVE Robert Birmelin, *Study—Steps Series, Shoe*, 2005, black chalk, conté pencil, and acrylic wash on 90lb cold pressed Fabriano Classico, 22 x 30 inches (55.9 x 76.2 cm) © 2010 Robert Birmelin Collection of the artist

Birmelin has chosen to overlap images in the foreground here, though not in the background, thereby directing our attention past and through the overlapped faces and onto the leg with the yellow shoe.

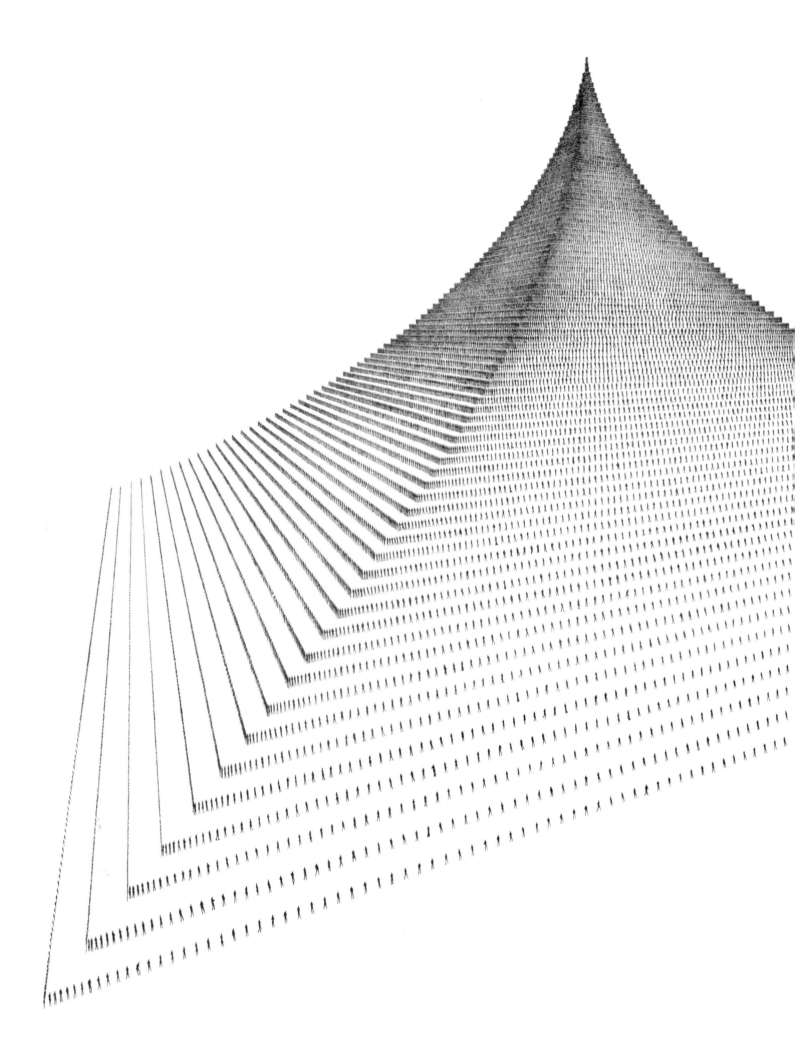

Pascal's Perfect Probability Pyramid & The People Paradox—
The Predicament *depicts a society composed of individuals
who stand in protected isolation, alone but without
privacy. They cannot escape the structure yet seem to be
fooled by illusions of freedom. Representing alienation in
togetherness and uniqueness in uniformity, they assume
the journey of living paradox. Although each figure is
different, carefully drawn to represent distinct individuals
acting out countless lives (there are over sixteen thousand
people in the drawing), ultimately they all seem identical
and indistinguishable. The dissimilarities are almost
imperceptible yet become quite noticeable at close scrutiny.
The pyramid they form is a society of visual mathematics
in which they are but patterns and processes, number
components of a mathematical system who believe they are
unique entities.*

*The endless contradictions they seem to accept into
their lives, their ability to know so much and understand
so little, makes them very endearing. They are emotionally
unstable yet manage complicated technological miracles
and do not seem to realize that their great advances have
interfered with their own evolution.*

*The magnificence of their collective accomplishments
and the insignificance of the individual component are
unmistakable. Not a single tiny figure can walk away
from the structure—they are the structure. They are the
anatomy and the form, and it is their illusions of freedom
and the inescapability of the system that forms the ultimate
paradox. They span a delicate balance between universals
and the self, between the moment and eternity, and with
great courage proceed to build the* Perfect Pyramids.
—Agnes Denes

Value Change and Contrast Change

Like size change, value change and contrast change are techniques that artists use to show the illusion of spatial depth. Both are ways of showing atmospheric perspective, which is the indication of spatial difference through tonal changes caused by the amount of atmosphere that exists between the viewer's eye and the object. In reality, forms that are close to us appear clear and in full color, while forms that are further away begin to get less distinct, losing color, contrast, and sharpness the further away they are. This is due to the particles of dust and moisture that are in the air—the further away something is, the more dust and moisture hangs between our eyes and the object. Those particles catch and reflect light, and thereby inhibit our ability to see the thing clearly. Knowing this, drawing artists draw forms that are meant to be understood as further away in a less distinct way than they draw the forms that are meant to be understood as closer to the viewer.

Value is a term that means how light or dark something is drawn. *Contrast* is a term that refers to two values that are right next to each other. *High contrast* means two values that are extreme, like white and black; whereas *low contrast* means two values that are close, like medium gray and dark gray. In drawing, high contrast visually advances and low contrast visually recedes, meaning anything that has high contrast values on it attracts our attention and we tend to visually pull it forward, while forms or spaces depicted in low contrast values do not immediately attract us, and tend to visually stay in the background.

There are subtle ways of taking advantage of these optical facts, and contemporary drawing artists who want to show the illusion of three-dimensional space use them all. To begin with, how the values change depends on the tonality of the background. If the background is light in tone, the objects and the space will lighten as they go back; if the background is dark in tone, the objects and the space will gradually darken. If the background is medium in tone, then the lighter things get darker and the darker things get lighter. This change, which is a function of atmospheric perspective, can be dramatic if the distance being depicted is huge, or it can be gentle, if the distance being depicted is small. James Valerio's drawing *Foxglove*, featured on page 102, shows all of this. Notice the changes of value and contrast; some leaves are darkened to show how they recede into the dark background, and others are lightened to indicate that they are more forward.

Another subtle way of showing atmospheric perspective is by drawing a delicate value change at the edges of objects. Just a hint of value change at the edge of, say, the objects in a still life, will make the objects look more dimensional themselves, and will add to the sense of three-dimensional space being created in the drawing. Again, the tonal change at the edges depends on the value of the space behind the objects. If it is lighter, then the objects lighten at the edges; if it is darker, then they darken at the edges. All of these changes in value and contrast contribute to the illusion of three-dimensional space, and are used by drawing artists who want to create a convincing sense of space.

Reflection

Reflections in realist drawings can be used to increase the spatial illusion greatly. By drawing a reflection on, say, a shiny bowl in a still life, the space is enlarged to include not just the area beside and above the bowl, but also that which is in front of it as seen in the reflection. The spatial illusion is increased, and also is thrust out into the air in front of the drawing; or maybe a better way to put it is that the viewer is pulled into the middle of the drawing's space, with the shiny bowl in front of him, and that which it is reflecting behind him.

OPPOSITE Margaret Davidson, *Reflecting Still Life*, 2010, graphite on rag paper, 14 x 11 inches (35.6 x 27.9 cm) © 2010 Margaret Davidson; Photo: Nancy Hines

Reflection is always in contradiction to reality. If you draw the reflection too prominently, you lose the form, and if you draw the form too well, you have to deny the reflection. The push/pull of this relationship is both challenging and fascinating.

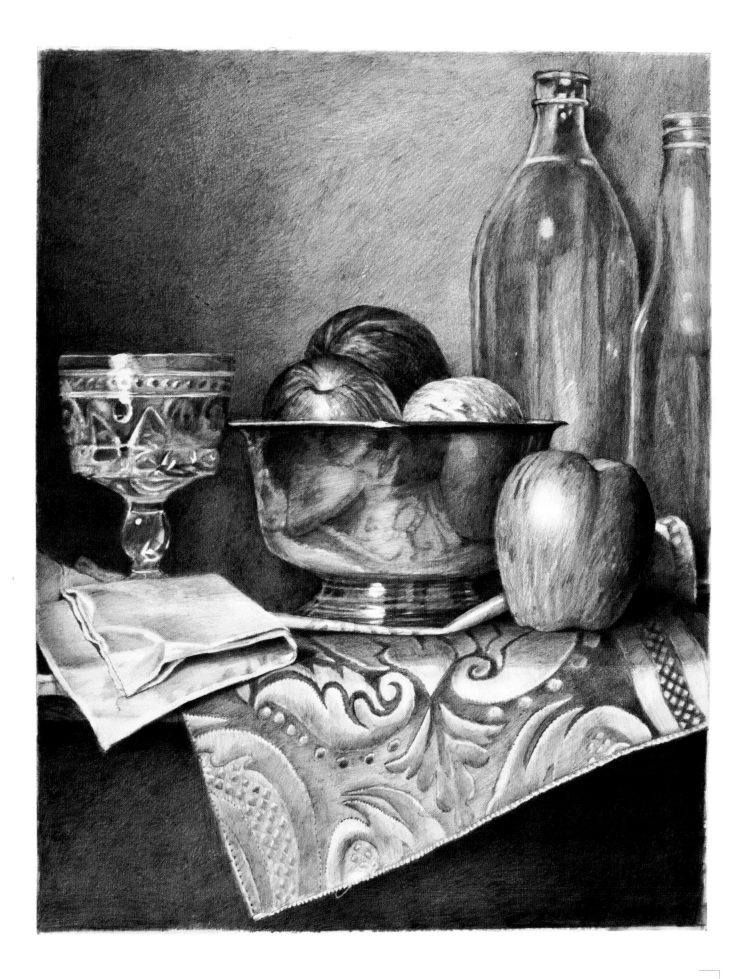

THE TRUTH OF THE FLATNESS OF THE SURFACE

Drawings are, in truth, flat things. Whether they are on paper or cloth or walls or floors, they are actually flat. Furthermore, even when the surface is a three-dimensional thing, a drawn image that is wrapped around it is made emphatically flat, by sheer contrast. Some contemporary drawing artists explore this flatness. To do so requires attention to the mark on the surface, and a constant awareness of the mark's relationship to the space implicit on the page. This is no easy thing, but the results, when this is carried out well, can be both austere and luminous. To focus on the mark and its relationship to the surface and the space is something akin to meditation and focusing on one's own breathing. Both are so fundamental, so easily taken for granted, that it is difficult to sustain any amount of thought just for them. However, in drawing, when this is achieved, once the eye and hand have been successfully focused, the mind is free to open to a new sense of space and time.

The artist Agnes Martin comes to mind when thinking about art that focuses on the true flatness of drawing. Martin's drawings are fields of hand-drawn grids, or sometimes just parallel lines forming a shape, that sort of floats and hums on the surface. They are also drawings that speak of infinite space. It isn't that she has drawn pictures *of* space, more that her lines and grids are conscious of the spaces around them, and we are somehow made aware of how the two are intertwined and interdependent. Her lines can be graphite or ink, sometimes alone and sometimes combined, and sometimes with a watercolor wash. She works on various papers, and also works drawing into her paintings on canvas. The image of a grid is abstract and inviting—we viewers are able to stay out or go in, hang in front or go behind—because she does not seek to control our response. This kind of drawing requires a certain honesty from the artist, and Martin gives us that. It also requires a new kind of looking from us—we must look slowly, absorbing only everything that is there.

To focus on the mark and its relationship to the surface and the space is something akin to meditation and focusing on one's own breathing.

Martin's drawing is lines crossing lines: many horizontal lines crossed by fewer vertical lines. We become aware of slight variations made by small gaps or different strengths of mark, all pertaining to nothing less than exactly what is in front of us.

"the city" 1962

Agnes Martin

A COMBINATION OF FLATNESS AND SPACE

Putting the two together—combining the truth of the flatness of the surface with the illusion of three-dimensional space—is one of the many legacies that have come down to us from Paul Cézanne. It is something that artists like Giorgio Morandi did in modern times, and is continued by some artists today in contemporary times. Artists who put these two ideas together often work with one or more of the techniques of illusion, combining them with issues of surface that insist on our recognizing the flatness presented to us.

The drawings of Peter Millett are a good example. Millett draws parallel lines with brush and ink on rice paper. It is a simple technique, but something else is happening here, something that goes beyond technique. Millett's drawings are of lines that lie parallel to each other within different outlined sections that are either triangles or parallelograms. These sections seem to be dimensional, folded over, or in front and behind each other, following a mathematical path and displaying a logical nature. His lines are casual, sometimes scruffy, bold, wavy, or thin, and all of them are alive. His ink lines are separated by paper lines of much the same width—his drawings are as much lines of paper as lines of ink—and they move with each other, shifting dimensionally and sliding tectonically. Look at the lines and the drawings are flat; look at the sections and the drawings are dimensional. A wonderful balance is achieved between flatness and space, between pattern and form, as the image moves back and forth between the two. Millett's drawings directly relate to his sculptures and the mathematics involved with them, and both, amazingly, visually "move" back and forth—between implied two-dimensionality and actual three-dimensionality in the sculptures, and real two-dimensionality and the illusion of three-dimensionality in the drawings.

RIGHT Peter Millett, *3/4, 4/4,* 2004, steel, 56 x 70 x 24 inches (142.2 x 177.8 x 61 cm)
© 2010 Peter Millett
Courtesy of Greg Kucera Gallery

The light, shadows, angles, and planes cause some parts of this bronze sculpture to appear flat, and other parts to show their actual dimensionality.

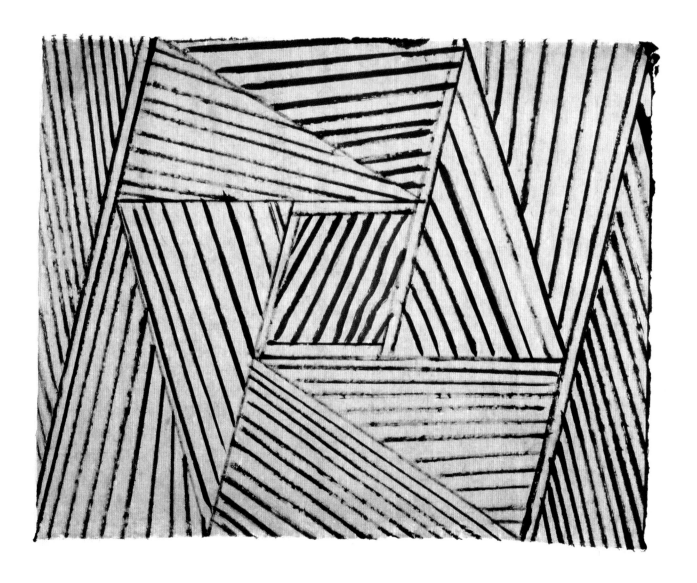

*Millett's loose, texturous, and even wavy lines actually
help us to see the forms shift from flat to dimensional
and then back to flat.*

There are several ways a drawing can be turned from a flat thing to a visually dimensional thing, but there are also ways drawings can be made to be actually dimensional. Dorothea Rockburne does this with her folded drawings on translucent papers, with some lines on top and some seen from within. Her drawings are slightly dimensional, enough to get you thinking about her space as well as her lines.

Russell Crotty draws and he draws a lot. Much of what he draws, from surfing patterns to star charts, is bound into books of various sizes. Recently he has been making drawings on fiberglass spheres coated with layers of paper. These spheres, the largest so far being six feet in diameter, are called globes by Crotty, as they map out views of earth and sky and celestial events. Crotty's hand-drawn marks on these large spheres stay at a human size, even though he is drawing the universe. His drawing marks keep him, and therefore us, connected to the idea that every person is connected to the universe; he needs only to remember this by thinking about it,

and depicting his thoughts with the simplest tools of pencil and paper.

The globes are shown suspended, giving the viewer the ability to walk all the way around them and look at our world and the stars and comets of our night sky from the outside. Crotty's use of space in these drawings is twofold in that he draws space on the globes in the form of skies and lands, and he places us in another space, outside the sky and land, looking in. We are accustomed to looking at globes of our planet from the outside, but . . . looking at the universe from the outside? Where, exactly, are we, then?

My own drawings on wooden cubes, as seen on page 100, have taught me some good lessons about real flatness versus illusory flatness, and real dimensionality versus the illusion of depth. These two opposites, namely the illusory buttons and the wooden cube with actual wood grain, cause the sense of space to repeatedly shift back and forth between the implied and the real.

DRAWING ON BOTH SIDES OF A TRANSLUCENT MATERIAL

Drawing on both the front and back of a translucent paper is one way of combining actual space with illusory space. Pictured below are three different papers that are translucent. No doubt there are more.

FROSTED ACETATE comes in various thicknesses and can be drawn or painted on both sides. The sample here is the thinnest: .003.

PERGAMENATA is an Italian paper made from 100% high alpha cellulose. It is meant to look like real calfskin vellum.

GAMPI is a plant from which a thin, strong, translucent silky paper is made in Japan.

Each paper sample has pen and ink layered lines on both sides, and a strip of colored paper on both sides. The clarity or lack of it varies from paper to paper.

RIGHT Three translucent papers: frosted acetate (top); Pergamenata (middle); and gampi (bottom). Notice the differences when drawn marks and tonal papers are positioned on the front and back side of each paper, on the left and right of each drawing respectively. Photo Credit: Nancy Hines

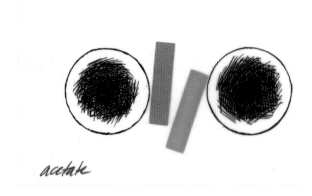

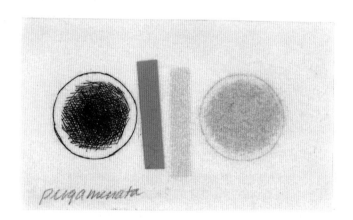

OPPOSITE Russell Crotty, *Looking for Baade's Window*, 2004, watercolor and archival India ink on fiberglass and paper, plywood rings, steel plate, 6 feet (1.8 m) in diameter © 2010 Russell Crotty Photo: Courtesy Shoshana Wayne Gallery/Gene Ogami

Crotty's marks are all the size that is normal for his hand to make, despite the large size of this globe. This human-sized mark-making adds depth and subtlety, especially in the large areas of carefully drawn land.

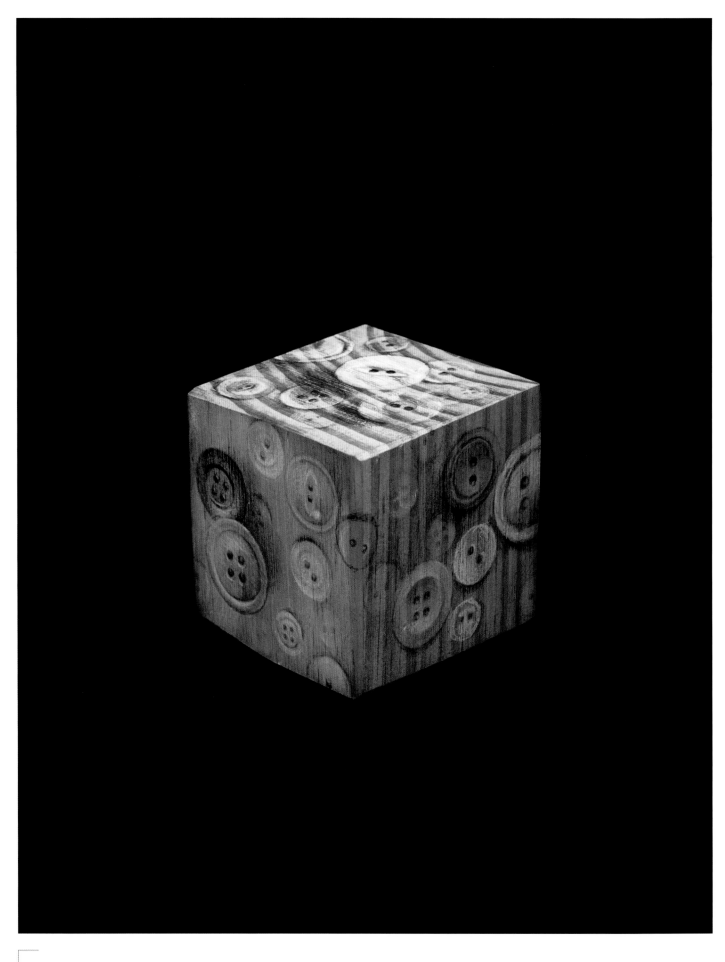

SUMMARY

Space is a complex concept that is dealt with by contemporary drawing artists in a variety of ways. Artists work consciously with the mark's relation to space, but must remember that there also needs to be emphasis made on space's relation to the mark. All contemporary drawing artists need to understand and work with the concept of space from both sides. Just as space is the oxygen for the mark, the mark is the thing that causes us to notice and experience space. Artists can work with space by creating the illusion of three-dimensional space, by acknowledging the reality of the flatness of space, by creating drawings that are deliberately and simultaneously dimensional and flat, or by pulling drawing itself into real space by folding the paper into dimensionality or by drawing on three-dimensional objects, come what may. All of these methods are happening today and all delve deeply into the concept of space. Suffice it to say that space continues to be a frontier in drawing, though maybe not the final one.

Contemporary drawing artists especially know that space in drawing is a touchable substance, one that must be worked with consciously, and deliberately molded.

OPPOSITE Margaret Davidson, *Shadows Block,* 2004, colored pencil on wooden cube, 2 1/$_2$ x 2 1/$_2$ x 2 1/$_2$ inches (6.4 x 6.4 x 6.4 cm) © 2010 Margaret Davidson
Photo: Nancy Hines

The reality of the cube shape and the power of the actual wood grain are in competition with the illusion of the drawn buttons and the drawn spatial depth.

CHAPTER FOUR

COMPOSITION

C omposition in contemporary drawing is often the same as composition in traditional drawing. The two share such things as power centers, pathways for the eye, and, above all, balance. There is also a new compositional structure, one that started in modern times and has been developed even further by contemporary artists. Those following this new plan occasionally employ the grid, though that is not a necessity. What is essential, again, is balance.

Balance creates a unity within the structure, and makes possible a relationship between the drawing and the viewer. The real or abstract nature of the image is beside the point here; the underlying strength of the composition is key to whether the drawing succeeds in communicating the artist's message, or fails in that task.

OPPOSITE James Valerio, *Foxglove,* 2000, graphite pencil on paper,
33 x 28 ¾ inches (83.8 x 73 cm) © James Valerio
Image courtesy of George Adams Gallery, New York, NY
Collection of the Columbus Museum, Columbus, GA

UNIVERSAL FUNDAMENTALS OF COMPOSITION

Artists who work with either the traditional or contemporary compositional structures share two basic approaches—a connection with the format and the significant use of eye level. These two issues are so essential to all composition in all drawing that they can be considered universals.

Format

The format, which is the shape, is the outer boundary edge of the drawing, and what shape artists choose will strongly influence the way they draw and the way the drawing is seen. As I said in the chapter on space, the difference between a drawing and a sketch is that in a drawing the artist is relating all the marks and all his decisions to the edge, seeking to compose his marks and unite them in some kind of way within, and with, the format. A fundamental question every contemporary drawing artist must ask, and then answer, therefore, is what shape is the drawing going to be. If it is going to be two-dimensional, as most drawings are, then the shape possibilities become very important. (If the drawing is going to be three-dimensional, then it has certain compositional issues that pertain to positioning the work in three-dimensional space, information that I cannot cover here, but that can be found in books on sculpture.)

Two-dimensional shapes are traditionally the horizontal or vertical rectangle, or the square, with artists occasionally working with ovals (horizontal or vertical), circles, or diamonds. Other shapes—torn-edged trapezoids and such—are seen as contrary to the traditional shapes, and so are understood in opposition to, but still in relation to, the usual format shapes. The two rectangles (and the very similar ovals) have other, more descriptive, names as well: The horizontal rectangle is the landscape format, and the vertical rectangle is the portrait format. Both of those names imply what that shape has traditionally been used for, but also what kind of space that particular orientation of the rectangle is capable of offering—the former a vast, deep space; the latter a closer, more shallow space. This inference of the kind of space being made available by the kind of format is interesting. Artists today work with every format in every way using every kind of space, but they all are aware of the spatial implications of portrait or landscape formats, and they all decide whether to work with the implied space or ignore it.

Eye Level

The eye level in a drawing is an intriguing thing—one that is always telling us something important. The eye level adopted by the artist becomes the eye level from which the viewers must look at the art. The artist, therefore, can make the viewer be above the subject and looking down at it, directly in front of it and looking at it straight on, or lower down and looking up at the subject.

The interesting and important information that comes with that is why. *Why* are we above and looking down (or below and looking up)? *Why* has the artist placed us in this

ABOVE Ellen Gallagher, *Watery Ecstatic Series,* 2003, watercolor, pencil,
varnish and cut paper on paper, 27 ¹/₂ x 40 ¹/₂ inches (69.8 x 102.9 cm)
GALLA 2003.0024 © 2010 Ellen Gallagher
Photo: Rob McKeever, courtesy Gagosian Gallery

*Gallagher's drawing provides us with a solid, straight-on eye level that lets
us see and experience everything, without fear of falling or being crushed.*

ABOVE Zhi Lin, *A Tied-Up Man on the Ground (Study for Firing Squad)*, 1995, graphite on paper, 17 x 19 inches (43.2 x 48.3 cm) © 2010 Zhi Lin Courtesy of Koplin Del Rio Gallery, Culver City, CA

The eye level in this drawing puts us above the bound man, and forces us to participate in his plight. We are reminded that, as we ourselves are not bound and on the ground, then we must be among those who did this to him.

position? Because that is indeed what has happened—we have been consciously placed, deliberately manipulated by the artist. There is always a reason, one that can usually be understood within the context and meaning of the drawing. It is something that must be thought about, both by the artist and by the viewers. Eye level is a factor in both traditional and contemporary composition, and is something all artists use as a way of putting the viewer into a certain position relative to the drawing and thereby contributing to the mood and message of it.

STRAIGHT-ON POSITION

Ellen Gallagher's *Watery Ecstatic Series,* shown on page 105, utilizes a straight-on eye level, easily discerned by how we can see the underside of the ribbony forms near the top of the drawing, and the upper side of those near the bottom. This puts our eye at a level in the middle, even with these forms twisting and curling everywhere. Gallagher's eye level allows us to stand up and be comfortable on our own two feet, and therefore enjoy her drawing face to face.

LOWER POSITION

Creating a drawing wherein the eye level is lower than the subject matter is only occasionally done, and then usually for certain dramatic effects. When the eye level is in a lower position, the viewer is below or beneath the subject, making it possible for the subject to tower over and either impress or intimidate. The resulting feeling in the viewer can be one of delight, as from looking up at a tall monument, or one of dread, cowering below a rearing monster.

HIGHER POSITION

Zhi Lin's drawing *A Tied-Up Man on the Ground (Study for Firing Squad)* puts us above the subject and looking down on it. We can tell because we see the top of the figure, and also because Lin shows us shadows on both sides of the figure, a device that contributes to our understanding of our eye level being above and looking down. Lin's eye level elevates us and puts us in the position of power over this man. We are, in fact, put in the same position and at the same eye level as his tormentor.

The eye level in a drawing is an intriguing thing—one that is always telling us something important. The eye level adopted by the artist becomes the eye level from which the viewers must look at the art.

In traditional compositional structure, the aim, within any format, is to arrive at balance and a sense of unity. The artist intends the elements of the drawing to work together to create a whole, and intends that whole to arrive at an equilibrium in some way, and keep the viewers' attention.

Balance

Balance can be either symmetrical or asymmetrical. Symmetrical balance is most often seen in pattern, with each side a mirror image of the other. Think of the spirals and interlaces that decorate Celtic manuscripts of the Middle Ages. Though symmetrical balance works well for that purpose, it is a still sort of balance, and so is not often used in drawing. Rather, asymmetrical balance is frequently used in drawing, wherein artists balance elements of different sizes with each other by working them together with the spaces between them, making the spaces larger or smaller depending on the size of the element.

ASYMMETRICAL BALANCE

Imagine a seesaw, which is simply a plank balancing on a fulcrum in the middle. If two people who are the same weight are on either end, then the seesaw balances. If one person weighs more than the other, then the plank has to shift off center to bring the heavier person closer to the fulcrum. This gives the lighter person more of the plank to add to his collective weight, and balance is again achieved. In drawing, empty space can be used like the plank of the seesaw—greater amounts of space can be added to smaller forms to make them balance with larger forms.

Balance has nothing to do with the type of imagery involved, and so this is a technique artists use in abstract work as well as in realism. Other "pieces" of space—intangibles like cast shadows or shafts of light, or even just an abstract mark on the page—can also be used as compositional tools for arriving at asymmetrical balance. Remember that in art, all things are made of a tangible substance, both the surface and the mark-making material. Nothing in art is actually intangible. Everything has some kind of tonality and/or texture, and so everything has enough presence to be useful for compositional balance.

BALANCE OF CUBICAL SPACE

Henry Rankin Poore, in his book *Composition in Art,* discusses another kind of balance, a balance in cubical space from front to back—a balance on something that, remembering high school geometry, is called the z-axis. (The x-axis is horizontal, the y-axis is vertical, and the z-axis comes toward you and moves away from you, on that plane that implies three-dimensional space.) Poore points out that, just as artists seek to achieve a lateral balance across the plane of the image, there must also be some kind of balance between

the foreground and the background, provided, of course, that space rather than flatness is the intention. For instance, a high-contrast foreground is balanced by a low-contrast background—and vice versa. The same is also true for in-focus and out-of-focus things being at opposite ends of the z-axis, and for large forms and small forms. Again, this is true only when artists wish to depict the illusion of spatial depth. Artists who are working with deliberately flat imagery will be deliberately leaving out the z-axis as one of their flattening devices.

BELOW Graham Little, *Untitled*, 2005, colored pencil and gouache on paper, framed with den glass, 21 x 38 inches (53.4 x 96.7 cm)
Courtesy of the Artist and Alison Jacques Gallery
© 2010 Graham Little

There are many systems of balance in this drawing, the three most obvious being a balance of light areas, a balance of forms, and a balance of shimmering color. All of these work to provide viewers with a beautiful, complex, and satisfying visual experience.

Eye Pathways

There is, of course, more to creating unity in a drawing than setting up seesaw-like relationships with marks, forms, and space. Balance is a more subtle and difficult thing to achieve because it is constantly being tested and pushed at by the artist's, and also the viewer's, eye. So artists further control the composition by organizing the various pictorial elements into a visual pathway that follows a unified shape or structure.

Anyone looking at a drawing is looking at things in a certain order. For example, the eye might notice a big contrast point first, then move laterally to a smaller dark area, then travel up to something else. This "eye pathway" is a collection of points of interest that artists consciously and deliberately work to arrange, organize, and control. This is true of the careful realist artist and of the artist working to achieve carefree randomness. Both are thinking about the eye pathway—the former to map it out, and the latter to deliberately *not* map it out.

In traditional compositional drawing, the eye pathway is something that artists must relate to the format and incorporate into their plans for balance. Most often artists use a structure or shape upon which they organize the elements of the drawing. This means that the forms *and spaces* are organized to provide points of interest that the eye starts at, and then travels to, one after another, in a fairly organized order. For instance, in the still life, one of the most common shapes used as a compositional structure is the triangle.

However, artists use other shapes as well, shapes like rectangles, diamonds, horizontal lines, vertical lines, zigzags, and starbursts. These shapes have more than three points the eye must go to, and some are easier than others, but what they all have in common is that they help the artist keep the viewer's eye in the picture, and keep the picture in a state of balance.

Certain things strongly affect the eye pathway, and must be taken into account when working out the composition. These are faces, vectors, high-contrast points, power centers, and focal points. Artists who work with these factors must be sure to be aware of how they function within a drawing, so as to position them according to the particular eye pathway being used.

FACES

Anything with a face, be it a person, an animal, a toy, or even a picture of a face, will pull the viewer to it first. Humans relate to faces on a primal level, so if any face is in the drawing, we will connect with it first, and return to it often. Graham Little's drawing *Untitled*, shown on pages 108 and 109, is a case in point. The face in this drawing pulls us to look at it first, and though our eyes travel with pleasure over the whole drawing, we return to the face repeatedly.

VECTORS

Arrows, pointing fingers, even the direction a pitcher or cup seems to face is a vector, and acts as a strong directional signal. The eye will go to where the vector points.

HIGH-CONTRAST POINTS

A contrast point in a drawing is a place where two values are side by side and in some kind of relationship. A high-contrast point is a place where black is right next to white, or colors equating to those values are right next to each other. A high-contrast point is especially noticeable in a drawing composed mostly of middle tones, and so is effective in such a drawing as a part of the eye pathway.

POWER CENTERS

Power centers are an idea put forth by Rudolf Arnheim in his book *The Power of the Center*. Arnheim states that different formats have, intrinsically, areas of power built into them. These power centers exist, regardless of what artists do, and so it behooves artists to pay attention to them and use them to the advantage of the art. Power centers are used in abstract work as well as realist, exerting their influence on every kind of imagery.

The vertical rectangle has a power center just above the middle. The horizontal rectangle has two power centers, one on either side of the middle. And the square has a power center exactly in the middle. Only the square has a power center that aligns with the geographic center, the other two do not. How do artists work with this? There are several ways to work with power centers. You can put the important thing in them, or you can use them as a balancing space with the important thing outside of them. You can even deliberately face away from a power center, and access it by ignoring it.

FOCAL POINTS

A focal point is the place the artist wants the viewer to look at the most, maybe look at first and then return to repeatedly. It is usually the place where the viewer visually enters the picture, the place around which the composition is built. A focal point in realist work is usually the main subject; in abstract work it is an area of visual interest the viewer looks at often. It is also possible in some drawings to deliberately have no focal point.

This drawing has a central image, along with ancillary focal points to keep your eye moving across, around, and into the image. Fisher's contrast points guide your eye and also balance his composition.

ABOVE Margaret Davidson, *Gravel Ratio*, 2006, graphite on rag paper,
27 x 28 inches (68.6 x 71.1 cm) © 2010 Margaret Davidson; Photo: Nancy Hines

*Each stone was drawn, one at a time, and the entire gravel area is
laid out in the golden ratio. The individual and the collective are
both here, and are both important.*

The Golden Section

I feel obliged to talk a little about the golden section as a traditional compositional structure, but must hasten to say that I know only a little about it. I will say here what I can, and then urge any who want to go deeper to seek out the books that go into it in depth, which I've listed in the bibliography. I feel obliged because this structure has been around for a very long time, and has been used by artists since ancient times to create a dynamic balance in their compositions. I would also add that in certain periods of art, such as the Middle Ages, the golden section was used for symbolic reasons, as well as reasons of balance and beauty, and was deeply meaningful. The structure of the individual pages of such illuminated books as the *Lindisfarne Gospels* (circa 698 CE) and the *Book of Durrow* (circa 720 CE) is based on the golden section as well as other Pythagorean-based geometry, believing as the Irish monks did, in the symbolic divinity of such proportions.[1]

The golden section, also known as the golden mean and the golden ratio, is a proportion, around which much in the natural world is organized, and with which many artists over the centuries have composed. This proportion is depicted, in its most basic state, by a line with a point off-center on it, where the smaller segment of the line is in the same ratio with the larger segment, as the larger segment is with the whole line. This boils down to the ratio of 1.618031 . . . to 1, or very roughly, 8 to 5. When you expand this proportion from a line to a plane, the result is a golden rectangle. A golden rectangle is a rectangle, regardless of size, whose long side is in the golden ratio to its short side, like the one pictured on page 114.

This golden rectangle, either vertical or horizontal, has been used by artists for centuries as a structure that is understood to have built-in balance, harmony, and beauty. Look around you today and you will see this ratio everywhere in the natural world—the structure of shells, the veins of leaves, the proportions of trees—and everywhere in the world of manmade things—credit cards, candy bars, pop cans—many are configured on this ratio.

There is much, much more, but this is as far as I can go here. There are several books that cover the golden section as it applies to science and art. Of those listed in the bibliography, I especially recommend Robert Stevick's *The Earliest Irish and English Book Arts,* Charles Bouleau's *The Painter's Secret Geometry,* and Juliette Aristides's *Classical Drawing Atelier.*

1 Throughout the book BCE (Before the Common Era) and CE (Common Era) are used in lieu of BC and AD respectively.

The golden section, also known as the golden mean and the golden ratio, is a proportion, around which much in the natural world is organized, and with which many artists over the centuries have composed.

WORKING WITH A GOLDEN RECTANGLE

First, draw a horizontal line of any length and label it AB. To find the center point of this line, place the point of the compass at one end of the line and stretch the compass out until it measures more than half the line. Inscribe arcs above and below the line. Then, without changing the length of the compass, place the point at the other end of the line and inscribe arcs above and below. Draw a line between the two points where these arcs intersect each other; this line will bisect your original line at point X.

Next, inscribe a circle by putting the point of the compass at X and setting the width of the compass to touch either A or B. Inscribe the circle. Keeping the compass at the same setting, put the point of the compass where the circle intersects the vertical line at the top and inscribe arcs to the upper left and upper right. Do the same at the point where the circle intersects the vertical line at the bottom, and at points A and B. Where these new arcs intersect you have points C, D, E, and F, and if you draw lines between these points, you will have inscribed a square around the circle, labeled CDFE.

To make this square golden, first extend lines CE and DF downward. Place the point of the compass at B and stretch the compass out to E. Inscribe an arc downward until it crosses the extension of DF. Label that point H. Then place the point of the compass at A and stretch it out to F. Inscribe an arc downward until it crosses the extension of CE. Label that point G. Draw a line connecting the two points G and H. You now have a golden rectangle, CDHG, whose long side is in the golden ratio to its short side.

On the right is a drawing that uses the lines and arc of the creation of a vertical golden rectangle to plot where the still life objects go. The objects all rest within the square, with the handle of the pitcher and the lower curve on the left side of the vase following the lines of the original circle around which the square was inscribed. As shown in the illustration below, to make the square into a golden rectangle, a diagonal was drawn from the center of the right side of the square (a point behind the handle of the pitcher) to the lower left corner. This diagonal line was then inscribed down to the lower right, drawing an arc in the process. Hanging over the edge of the table that the objects sit on, the striped cloth was arranged to follow the curve of this arc.

OPPOSITE Margaret Davidson, *Golden Still Life,* 2008, graphite on Strathmore multimedia aquarelle paper, 10 x 9 inches (25.4 x 22.9 cm) © 2010 Margaret Davidson Photo: Nancy Hines

The objects in this simple still life are all guided by the Pythagorean structure of the circle, square, diagonal, and arc, and they also all guide the viewer's eye to those elements of the structure. See also Golden Button Mean, *page 9, which is composed with the same mathematical structure, positioned horizontally.*

RIGHT Construction of a golden rectangle (here defined as CDHG and shown in three stages) requires only a straight edge and a compass. Photo: Nancy Hines

FAR RIGHT *Golden Still Life* with mathematical diagram overlaid. This shows the mathematical structure and how it was used as a positioning guide for the objects. Photo: Christina Olsen Burtner

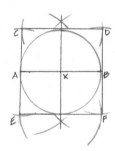
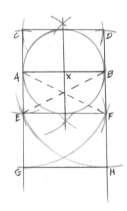
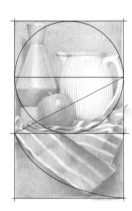

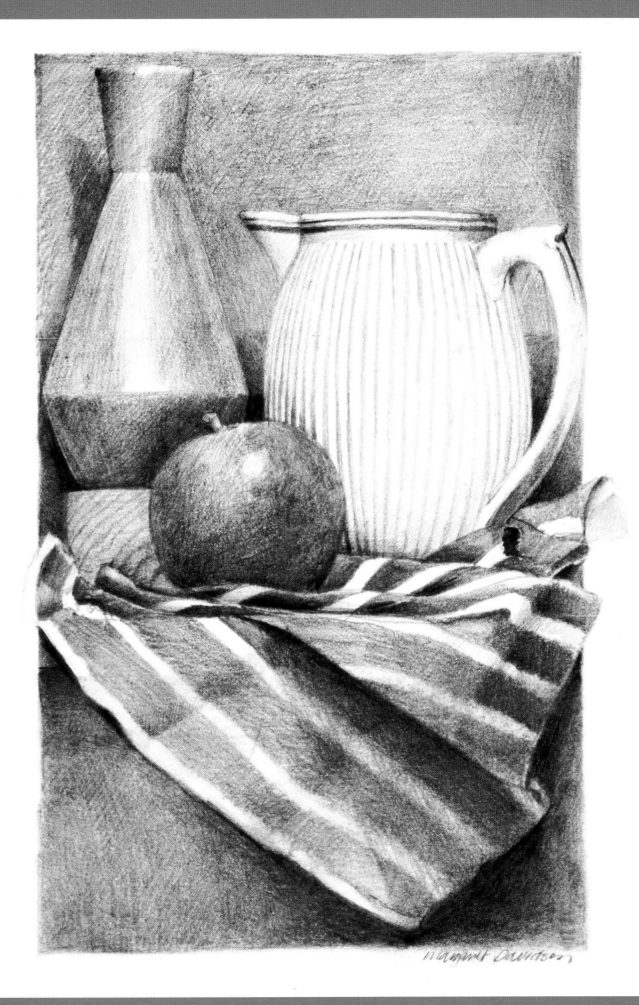

Margaret Davidson

MODERN/CONTEMPORARY COMPOSITIONAL STRUCTURES

By the early part of the twentieth century big changes were happening in art. Artists were beginning to think about the underlying structure of Nature, how they saw the underlying structure of Nature, and how they painted the underlying structure of Nature.

What was painted underwent several changes, with new subject matter added to the existing content; to pictures of Nature were added pictures of light and color effects, pictures of dreams, and pictures of spatial planes, for example.

How pictures were painted became the focus for some artists, who came to emphasize such things as the nature of color, the fact of the flatness of the canvas, or the structure of paint. Artists have always had to understand how paint works in order to successfully paint something. How paint works is an abstract issue, having to do with chemistry and optics and things that in traditional work are not directly related to the subject matter of the picture. However, by making the *how* of paint the main subject, artists opened the door for all the abstract issues to be the subjects of art, and for art thinking to include the how of it as acceptable subject matter.

In drawing this has proved to be especially revolutionary, as there are more abstract issues to focus on. Composition is one of the abstract issues that contemporary drawing artists have explored with these new thoughts in mind, and in so doing they have arrived at a new compositional structure, one that is markedly different from the traditional model.

Overallness

The new compositional structure, which was begun in modern times and is being carried further in contemporary times, is one that deliberately has no focal point or eye pathway, but an overall evenness of mark-making and of tone, an *overallness*. Joseph Pentheroudakis's *So Many Places to Hide* utilizes this concept: The overall structure of this image arrives at unity and balance in a new way.

An analogy might be found in music: A melody is linear and travels a certain path from note to note, starting at one place and ending at another, whereas a chord is a single sound composed of several different notes that blend harmoniously all at the same time. Traditional compositional structure is like the melody, and the contemporary overall compositional structure is like the chord. Both give us something wonderful, in quite different ways.

How overallness works with the format is interesting. Often, though certainly not always, drawings having this compositional structure are square. This format's power center is directly in the middle, which helps the artist keep the energy of the marks evenly spread over the surface. A square format is like a target, with a center that pulls us in, and at the same time radiates an energy outward, helping to spread the various drawing forces evenly.

> Traditional compositional structure is like the melody, and the contemporary overall compositional structure is like the chord. Both give us something wonderful, in quite different ways.

ABOVE Joseph Pentheroudakis, *So Many Places to Hide*, 2007,
pen and ink on paper, 27 $^1/_2$ x 27 $^1/_2$ inches (69.9 x 69.9 cm)
© 2010 Joseph Pentheroudakis; Photo: Frank Huster

The intensity of the black and white, along with the square format,
cause us to experience a sense of compressed energy.
This image is quiet but not still.

The Grid

The grid is a mathematical structure that invites overallness, in that it is even and unchanging everywhere. Many contemporary artists working within this new compositional structure work with grids, artists such as Bridget Riley, Eva Hesse, and Agnes Martin.

The drawings of Agnes Martin often use a grid within a square format, in that, working on a rectangular sheet of paper, she tones a square format in, and then draws a grid on top. (See page 95, as example.) She has found it a subtle and exacting construct and has written:

My formats are square, but the grids never are absolutely square; they are rectangles, a little bit off the square, making a sort of contradiction, a dissonance, though I didn't set out to do it that way. When I cover the square surface with rectangles, it lightens the weight of the square, destroys its power.[1]

Martin's work, both drawings and paintings, are meant to be experienced wordlessly, and so for me to write on and on about them feels foolish. She simply means for us to look at them, and feel the act of looking as completely as we can.

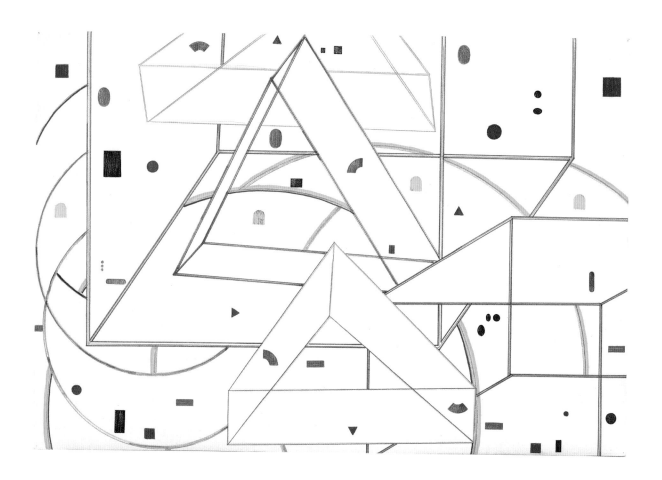

The grid is not a necessity when working with an overall compositional structure. The drawing *76 C-7* by Al Held is a case in point. No grid is used, but the eye moves over the entire drawing evenly, taking everything in with the same level of interest. He has an architecture of some kind, but every indication of space is immediately negated by an equal indication of flatness, and every time you feel an inclination to rest your eye on one contrast point, you are instantly pulled to many other equally strong (and evenly placed) contrast points. Contrary to being frustrating, the result, for me, is invigorating. My eye is free from Held's control, and I can roam at will in his drawing.

1 Schwarz, Dieter, editor, *Agnes Martin*: Writings (Stuttgart, Germany: Hetje Cantz Publishers, 1992), page 29.

SUMMARY

Composition in contemporary drawing comes in two basic structures: traditional and overall. Both are intended to arrive at balance and some kind of visual unity.

Both work, both are good, and both are used today with realist and abstract imagery. Both traditional and overall compositional structures have a relationship with the format, whatever shape that format may be, and depend on it to be a fundamental factor in the compositional decisions. A drawing artist today is free to work within any structure that was developed in traditional drawing, as well as the newer overall kind. If there is any restriction at all, it is that contemporary drawing artists must choose something, exercising free will and, of course, intentionality.

No grid is used, but the eye moves over the entire drawing evenly, taking everything in with the same level of interest.

OPPOSITE Al Held, *76 C-7*, 1976, colored pencil, graphite pencil, wax crayon, and fiber-tipped pen on paper, 27 1/8 x 39 15/16 inches (68.9 x 101.4 cm) Whitney Museum of American Art, New York; Purchased with funds from the Drawing Committee, accession #86.2 Photography by Gamma One Conversions © Al Held Foundation/Licensed by VAGA, New York, NY

Held's drawing shows us an overallness of placement, and a balance arrived at by meeting every force with its exact counterforce.

CHAPTER FIVE

SCALE

Scale is a term that is used to refer to the size of the art. Drawings can be large-scale or small-scale or "normal" in size—something that can be held in two hands and looked at easily. An image can be "scaled up," meaning enlarged, or "scaled down," meaning reduced in size.

Today, artists have greater choice as to the size of the sheet of paper they can work on. This expansion of choice requires artists to really think about scale, and have solid reasons why they are choosing one scale or another. Artists need to think about how the scale will affect them as they work on the drawing, how it will affect the size and nature of the mark within the drawing, and how it will affect the viewers as they look at the finished piece. In this chapter, I want to look into the nature of scale and how it relates to those three things: the artist who is making the work, the marks being used, and, ultimately, the viewers as they look at the finished drawing.

OPPOSITE Jill O'Bryan, *7200 Breaths between October 1 and October 21, 2007,* graphite on paper, 60 x 40 inches (152.4 x 101.6 cm)
Collection of the artist; © 2010 Jill O'Bryan; Photo: Jill O'Bryan

In the twentieth century a significant change in the size of drawings came about, one that has continued into the twenty-first. Simply put, many artists are now making large drawings. By large I mean drawings on paper or other surfaces that are bigger than the human body, taller and wider than a standing figure, taller and wider than the artists themselves.

Relationship to the Artist

To do big drawings artists must work on some kind of large surface. Big papers, popular with many artists, are available in rolls. Other artists work on canvas, large panels, or directly on walls, floors, and even sidewalks. The artists making big drawings must also consider the following three things, all of which are different from those things thought about by artists working at a normal size.

First, artists working large must decide whether they are drawing one big image or tiling together several smaller ones. The two choices have very different compositional structures and spatial implications, and so this decision must be made early on in the drawing process. To draw one big image allows the artist to work seamlessly and develop the form and space relationships in traditional or modern ways without interruption. When tiling separate images together, the artist must always remember the seams, and take them into account. The seams, or the spaces between the tiled smaller pictures, cause the artist to have to work with at least two spatial relationships: the one created by the image, and the one created by the fact that there are two surfaces involved in the drawing, and not just one. The former is illusory, or at least has illusory elements, and the latter is actual. Illusion can exist side by side with actual, but there must be a recognition of this relationship—the artist must give a nod toward the fact that two separate and opposite truths are being presented to the viewer.

Second, artists making big drawings need to move their bodies differently from those who sit at a table, even differently from those who stand at an easel. Big drawings often require that artists climb on scaffolding, lie on the floor, swing, sway, and walk distances while making a mark, and always, always stand back far enough to take in the entire image to assess it. This movement influences the marks and has an impact on the image, message, and even the artists' health, and so must also be taken into account when making decisions about scale.

Jill O'Bryan works with her whole body on large sheets of paper, sometimes rubbing and drawing actual rocky landscape, and sometimes leaning on and recording the

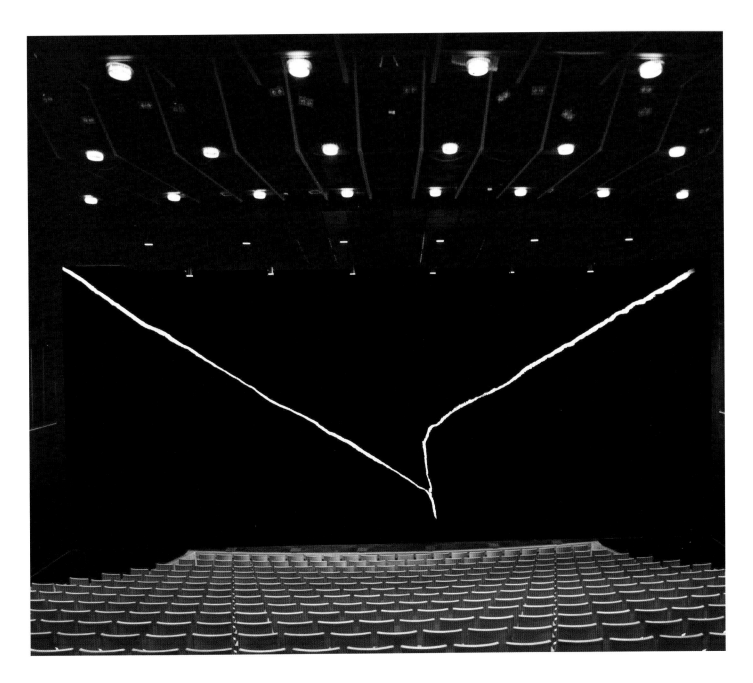

ABOVE Jan Groth, Stage Curtain, Det Norske Teatret, Oslo, Norway, embroidery on cotton duck, 374 x 866 ¹/₈ inches (9.5 x 22 m)
Photo: Teigens Fotoatelier Courtesy Galleri Riis, Oslo, Norway
© 2010 Artists Rights Society (ARS), New York, NY/BONO, Oslo

Groth has found that a manmade line greatly enlarged can still give us that exciting and electric sense of the human touch.

OPPOSITE Jan Groth, *Sign,* 2000, wool on cotton warp, 114 ³/₄ x 145 ⁵/₈ inches (290 x 370 cm) Courtesy Galleri Riis, Oslo, Norway © 2010 Artists Rights Society (ARS), New York, NY/BONO, Oslo

This weaving, created from a reversed drawing, shows Groth's mastery of everything I talk about in this book. The white line crackles in the deep black space; both black and white have form, texture, and presence; and all of it is made intensely significant by his use of scale.

fundamental intimacy of her own breaths. Breathing is organic but record-keeping doesn't have to be; O'Bryan strives to keep her records of her breathing organic as well, with pencil marks that quiver and tones that vary with her own volume. The drawings can take months, and provide her and her viewers an accounting of her life that is both mathematical and contemplative. The drawing that appears on page 120 is immediacy itself. O'Bryan has recorded her breathing across a span of many days, creating an image that, for something so focused on time, is timeless.

A third thing drawing artists must consider when planning a big drawing is whether they want to work alone, or collaboratively. Large-scale drawing opens up the possibility of working with a group of people, thereby enlarging the scope of the drawing, and opening the door to other ideas brought to the drawing by other participants. There can be a certain surrendering of control by the artist, where he lets unscripted and unexpected things happen, or there can be a tightening of control, with the artist organizing and closely supervising the work of the others. Scandinavian artist Jan Groth starts with normal-sized drawings of a single, or a few, charcoal lines on white paper. This image is then reversed to become a white line on a black background, which dramatizes the line and makes the sense of the touch of the artist's hand more emphatic. The image is then handed over to the Gobelin Tapestry Works, where it is enlarged, sometimes greatly, and translated into a weaving or embroidery. Groth supervises

the progress of his drawing through this process, but accepts the changes to his image that the weaving process inevitably brings about. By working with craftspeople and technicians from Gobelin, Groth can have his images made into textiles that can hang on a wall like a painting, or hang as functional art—for example, as the curtain at the Norwegian National Theater in Oslo, seen on page 123. The enlarging of his image is thus made into something grand but still accessible, touchable, and connected to people.

Artist Sol LeWitt has taken collaboration to another level by creating large drawings that he himself does not draw. LeWitt has created wall drawings himself, and then written out the process so that others can follow his directions and reproduce the image on their own walls. The drawing pictured here was done directly onto a wall at Studio G7 gallery in Bologna, Italy by a group of people who worked from written instructions created by LeWitt. LeWitt leaves it to the group to follow the instructions as they see fit, and to execute the wall drawing as his and also theirs, in that he is the artist and they are the draughtsmen. What I derive from this is a great sense of inclusiveness. LeWitt is throwing open the doors and letting everyone in to be in on the whole drawing creation process. Art becomes participatory, the viewer is as much a part of the art as the artist, and the image grows in meaning, importance, and even joy when it stops being the precious object by one person, and becomes something available to, and created by, everyone.

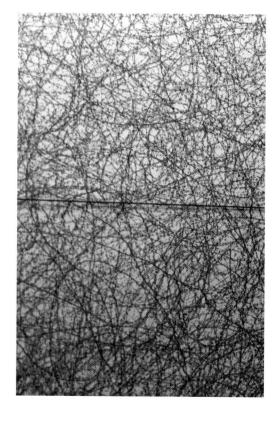

RIGHT Detail of Sol LeWitt's #1187 Scribbles, Inverted Curve. This close-up shows how, during production, several strings were stretched across the wall, indicating the different parallel bands. The drawing participants knew to begin changing the density of their scribbles at the areas near the strings. This results in the humming gradation seen on the completed wall.

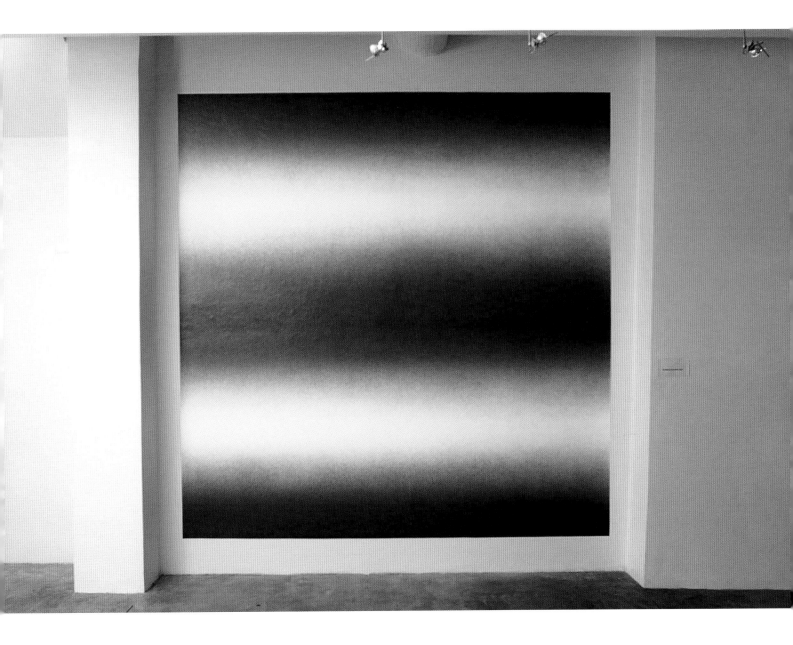

*This wall drawing, done by several people following LeWitt's
written instructions, is composed of an uncountable number
of overlapping curly lines, with many layers in the dark areas,
and fewer layers in the lighter areas.*

Relationship to the Mark

When a drawing is big, the marks can be any size, from mammoth to miniscule. Large marks that look incomprehensible on smaller paper make sense in this larger context, while small marks have the opportunity to look even smaller because of their proximity to big marks, big spaces, and the big format. Large-scale works present an opportunity for a great range in the sizes of marks in between large and small. In fact, there is greater opportunity for a large range of mark sizes in big drawings than in small drawings.

Sometimes in big drawings, though the image is huge, the artist does not enlarge the marks themselves, but keeps them at a normal width. By working this way, artists can create greater interior space—more depth can be created by adding more marks and more layers of marks. At other times in big drawings, the artist wants the marks to be as enlarged as the format, a decision that allows the marks to be commanding, intense, and even overwhelming. In short, the size of the mark in relation to the size of the whole drawing is a critically important thing. A big, wide mark in a big drawing says something completely different from a smaller mark in the same place in that same drawing. The former is bold and can be seen from a distance, while the latter is subtle and invites the viewer closer. Large marks are taken in quickly, while small marks take more time to see. At all times, contemporary drawing artists decide what the scale of the marks will be, as well as what the scale of the image will be.

Relationship to the Viewer

Drawing artists make big drawings for a variety of reasons, but always consider the effect on the viewer. This effect has everything to do with the message of the drawing, and with the artist's ability to communicate that message. For instance, some big drawings are meant to be imposing. They need big spaces in which to be seen, and they command a lot of attention in that space. The viewer has to be able to stand back far enough to take in the whole thing, and then discern its meaning or message from there. Other big drawings are meant to communicate vastness, but not necessarily anything grand. These drawings are taken in at a distance but then are meant to be looked at again by the viewer more closely. This up-close look is encouraged by great detail and smaller marks, both of which pull the viewer close, and at the same time contribute to the sense of vast space within the large size of the drawing.

Big drawings often require that artists climb on scaffolding, lie on the floor, swing, sway, and walk distances while making a mark, and always, always stand back far enough to take in the entire image to assess it.

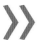

SCALING UP AN IMAGE

When working on a drawing that you plan to enlarge, there are two possible ways to go about it. The first way is to make everything bigger. The format scales up, the image gets bigger, and the mark gets bigger. When you enlarge this way, you must remember that if the format gets, say, ten times bigger, and the image gets ten times bigger, then the mark must also get ten times bigger. Pencil lines look thick enough to be charcoal lines, charcoal lines look wide enough to be a paint stroke—the increase in mark size makes a powerful change in the nature of the drawing that you need to be prepared for.

Another way to scale up is to only enlarge the format, but not the image or the mark. This creates a completely different situation: The small drawing is now set into a much larger format, and so it must have much more drawing added to it to fill it out. This new, added drawing is in the small mark size but on a great deal more paper acreage. This approach requires a lot of work, but will result in an image that is not startlingly different—like what happens when the mark size is increased, but is more elaborate and complex than the original small drawing.

ABOVE *You can enlarge a small drawing in two ways, either by making everything proportionally bigger, or by keeping the drawing the same size and placing it in a proportionally enlarged format and then adding more to the drawing. This image shows a small drawing next to those two options.*
Photo: Nancy Hines

Small drawings are very interesting because they are so completely about their size. Regardless of subject matter, the first issue they present is how much smaller they are than normal. Large drawings must be seen from a distance for the entire image to be taken in; small drawings, on the other hand, must be approached closely to do the same thing. This closeness is something the artist must do as well as the viewer, and makes the small drawing intimate, even private.

Relationship to the Artist

Artists who work small do not need large studios, nor do they need to use large, sweeping movements with their arms. On the contrary, they do need to develop a tolerance for sitting and working closely with small movements and even, sometimes, magnification.

The history of working small goes back at least to the fourteenth and fifteenth centuries, when tiny books of hours, books that fit easily into the palm of the hand, were made for ladies' daily contemplation and prayer. These books communicated a sense of preciousness as well as a sense of private devotion, and were as much talisman as book. Contemporary drawing that is small also has that sense of preciousness, a quality that some artists like to work with, and some like to work against. An example of this can be seen in the work of Gala Bent, who draws tiny, gentle peculiarities, forms that are maybe real in another world, or symbolic in this one. Her small size of drawing and paleness of tones work to subtly counterbalance the fascinating intensity and weirdness she depicts.

Contemporary drawing that is small also has that sense of preciousness, a quality that some artists like to work with, and some like to work against.

*Bent's drawing is sharply focused and full of intense
detail. The curious being is both two and one, and the
tightly drawn detail is set off by the loosely watery pink
atmosphere that surrounds it/them.*

Relationship to the Mark

The small size in drawing tends to restrict the size of mark: Large marks don't fit into small spaces, so only marks that are average or smaller can be used. Some artists choose to develop an array of increasingly thinner and thinner lines, like micro-artist Daniel Zeller. Zeller's work currently contrasts his extremely tiny marks with normal rather than small sizes of formats, causing a sense of wonder at his level of detail as well as at his patience with covering so much ground. We viewers still peer closely, though the formats are average in size.

Relationship to the Viewer

Small drawings are almost automatically intimate. The size makes them something that usually can be viewed by only one person at a time, increasing the sense of privacy of the experience.

When framed, small drawings are often matted with very large margins around the image, giving them air and room to breathe, enhancing the opportunity for the viewer to look closely without distractions. Small drawings are also sometimes presented outside the frame to give us the opportunity to see, up close and personal, how tiny they are, how they fit in the hand, and how big we are in relation to them. That is one of the main things about small drawings—how small they are relative to the viewer's body. Unlike the images in large drawings, the images in small drawings cannot overwhelm or impress a roomful of people. Instead they are easy to overlook, even vulnerable; but if you do notice them and take the trouble to look closely at them, then you may be rewarded with a particularly intense experience.

SUMMARY

Scale is something that contemporary drawing artists are exploring in all its variations. Some drawings are as big as auditoriums, others smaller than playing cards. This exuberant range of scale shows how today's drawing artists are exploring new surfaces and new imagery, secure in the understanding that drawing can pretty much go anywhere and do anything.

The variations in mark size relative to format size cover every combination, and artists are pushing the boundaries at both the micro and the macro ends. Scale is another method drawing artists have for communicating very intense things, and for seeking a particular response from the viewer. In addition, variations in scale require artists to use their bodies differently, and for viewers to be willing to experience drawings while being conscious of their own bodies—to understand themselves as either the little thing in relation to a big drawing, or the big thing in relation to a tiny one.

OPPOSITE Daniel Zeller, *Reductive Cluster,* 2009, ink on paper, 13^1/$_2$ x 11 inches (34.3 x 27.9 cm) Courtesy of the artist and Pierogi © 2010 Daniel Zeller

Zeller's forms burrow in, as he seeks ways to draw greater and greater detail. Chaos theory and the repetition of pattern at different scales comes to mind, and you cannot do other than look very deeply into his drawing.

CHAPTER SIX

MATERIALS

I n this chapter, I want to divide things up into two sections: materials used to draw *with,* and materials used to draw *on.* Both of these subjects are complicated and interesting. Drawing artists relate to this information in every kind of way, from wanting to know the ingredients of everything they use, to deliberately choosing not to know. I fall into the former category, so I want to provide the information; everyone else can pick and choose through it all and take what is wanted.

OPPOSITE Paul Fabozzi, *Spectral Variant #1 .8 (Stripe),* 2010, colored pencil on Mylar, 38 x 29 ¹/₂ inches (96.5 x 74.9 cm)
© 2010 Paul Fabozzi; Photo: Michael Marfione

Drawing tools fall into two categories—those that are used to create dry marks, and those that are used to make wet ones. Information about these materials tends to be scattered all over the place, and so my goal here is to collect from a variety of sources and put it together in one place.

Tools and Materials for Dry Marks

The dry mark-making materials and tools are, perhaps, the most common and familiar of the drawing materials out there. They are the things most readily available today, and are easiest to use.

GRAPHITE

Graphite is a substance that is mined from underground and has been since the sixteenth century. Graphite was used for drawing as early as the 1680s, but was not really made into the wood-encased form we know today until around a century later. Today we can get loose graphite in jars and apply it straight, or we can buy graphite in stick or pencil form. The graphite pencils we know today are made by combining various amounts of powdered graphite with a powdered clay, forming them into sticks, and then encasing the sticks in wood, usually cedar.

Graphite pencils are either the regular yellow pencil, which is very cheap, or the art pencil, which costs about ten times more. The art pencils come in labeled categories: B, 2B, 3B, etc. (up to 9B) are progressively darker and *blacker* (hence the B); whereas H, 2H, 3H, etc. (up to 9H) are progressively lighter and *harder* (hence the H). There exists also an HB, which falls between H and B, and an F, which stands for "fine." The tones made with graphite, from various grays to black, are transparent but with a shininess that causes even the darkest 9B black to appear slightly lighter. Graphite lays down on every kind of paper, and also on other surfaces like wood and cloth and walls.

LEFT Graphite comes in various forms (from left to right): stick, woodless pencil, regular pencil, graphite lead held in a mechanical pencil, and powdered graphite. Photo: Nancy Hines

BELOW This chart shows the range of values achievable with graphite pencils—from light (9H) to dark (9B). Photo: Nancy Hines

F

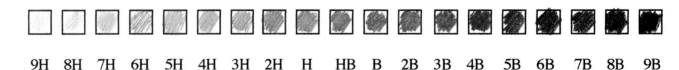

9H 8H 7H 6H 5H 4H 3H 2H H HB B 2B 3B 4B 5B 6B 7B 8B 9B

CONTÉ CRAYON

The first conté crayon, invented by Nicholás-Jacques Conté in 1795, was a combination of ground up French graphite mixed with powdered clay and encased in wood—France's answer to the English graphite pencil. Subsequent to this was a second invention with two variations, where the graphite and clay were mixed with tallow, and the graphite and clay were mixed with carbon black. These are the first versions of conté crayons, and by 1895 were offered in four colors: black, bister (brown), sanguine (reddish brown), and white.

Conté crayon lays down unshiny black marks, very rich, and not particularly moveable, meaning you can't blend them much, and you can't erase them much. The material is just slightly gooey, and so it draws differently from charcoal or carbon pencils. Today conté comes in sticks and in pencil form in the standard four colors of black, brown (called bister), sanguine, and white, made more elaborate by having four grades of sanguine, three grades of white, three of black, and the addition of a mixed gray. Conté will draw down on most, if not all, papers, and will also lay down on wood, cloth, stone, plaster walls, and glass.

ABOVE The three most standard conté crayon colors are (from left to right) black, white, and sanguine. Photo: Nancy Hines

CHARCOAL

This is perhaps the oldest of drawing materials, going back at least 30,000 years to the prehistoric cave art found in France and Spain. Charcoal today comes in two forms: the vine charcoal, which is burnt twigs of willow or some other wood, and the compressed charcoal, which is charcoal powder mixed with a binder of some sort and compressed into sticks or pencils. The vine charcoal is soft and powdery and will not yield a tone darker than a mid gray. The compressed charcoal is made to produce the darker tones, and because of the binder, it will adhere to the surface more solidly than the vine. The tones made by either form of charcoal range from grays to blacks and are transparent and matte, i.e., unshiny. Charcoal comes in three varieties (soft, medium, and hard), and works best on papers that have slight texture. It also draws well on smooth wood.

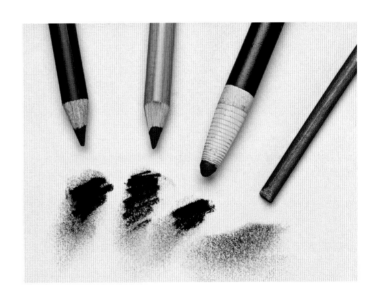

ABOVE Charcoal comes in two basic varieties: vine charcoal (on the far right) and compressed charcoal, shown in various pencil forms. Photo: Nancy Hines

CARBON PENCILS

These drawing tools are often mixed up with compressed charcoal pencils, and some stores even mix them in with the compressed charcoal. However, they are different—both in content and in their behavior on paper. Carbon pencils are made of charcoal powder and binder with the addition of soot, or lampblack. This soot makes carbon pencils draw differently, in that the black is stickier, less smudgy, and less erasable. Carbon pencils can be used alone, or, because they make a transparent matte black, they can be used with charcoal. However, because they are less easily blended, I always recommend that when using carbon pencils within a charcoal drawing, they be used especially for fine lines and detail work.

Carbon pencils come in more measured amounts than do compressed charcoal pencils. Where charcoal often just comes in three varieties, carbon pencils come in seven varieties (including 2H, H, HB, B, and up to 4B). In addition to drawing with them directly, artists use carbon pencils as their source for carbon dust, grinding the carbon in the pencils to dust, and then painting the dust through stencils onto paper with soft brushes. (See page 55 for one example of this technique.) Like charcoal, carbon pencils work best on slightly textured papers, and also on smooth wood.

ABOVE Here is an array of most carbon pencils, lacking only the 2H. Photo: Nancy Hines

COLORED PENCILS

When drawing in black and white many choices of materials are available, but when drawing with color there are fewer. One of these color drawing choices is colored pencils. Colored pencils are pigments mixed with a binder and various other ingredients and then encased in a wooden tube to make a pencil. Prismacolors have a composition of pigment (25%), methylcellulose gum, wax, and clay. This formula has been used since 1931, with here and there a variation in the kind of wax or type of pigment. Prismacolors are creamy and smooth to work with, and have rich colors with dense coverage. Other brands have the same general composition but with different binding ingredients. Along with Prismacolor, Rembrandt Lyra, Derwent, Faber-Castell, and Caran d'Ache all seek to appeal to the professional artist by using good-quality pigments. Pencils made by these companies all draw well, though I find some are smoother than others, and some seem less generous with their pigments than others. Artists choose which brand according to how it feels, what it costs, and whether it is easily available. Currently Prismacolor offers 132 colors; other brands offer as many as 120. Usually you can buy just one or two pencils to try them out before buying a large set. All the brands I have tried mix easily with each other, and so I often have more than one brand represented in a drawing. Currently I work with the Pablo series from Caran d'Ache with various pencils from all of the other brands listed above mixed in.

Colored pencils are most often used on papers and mat boards of various kinds. I also find them easy to use on wood and sometimes on cloth. Some artists also draw on slate with them. Because they have such a soft, buttery touch, colored pencils can be used on papers that do not take kindly to a harder material, including various rice papers and waterleaf papers.

As with any color medium, lightfastness is a pressing issue with colored pencils. Manufacturers publish their own lightfast test results, but I always do my own. After creating a row of swatches of every color I have bought, I cover up half of each swatch with a strip of thick cardboard. This array is then taped to the inside of a south- or west-facing window and left there for at least six weeks. At the end of this period, I remove the test from the window and take off the cardboard, uncovering the protected parts of the color swatches. If any color has faded or shifted its temperature, it is not lightfast.

PASTELS

Pastels are sticks of powdered pigments—some with an additional binder and some without—and are considered by some to be one of the purest forms of color drawing in existence. Like charcoal, pastels trace their ancestry back to the prehistoric caves, where the images were made with red ocher, white chalk, and yellow ocher, along with black charcoal. Those ancient colors were dug out of the ground and are the first use of pigments in drawing that we know of. Today many more pigments than those first four are used. Many pastels are on the market, and drawing artists are ferociously partisan about their preferred brands.

To navigate these waters, here are some basic facts. Whether binders are used or not is one differentiating feature of pastels. The way they are rolled into sticks is another. The larger companies, like Sennelier and Schmincke, roll their pastels by machine, producing sets of colors with an even consistency. Smaller businesses that specialize in hand-rolling have sprung up, producing sticks that vary in consistency in order to remain true to the variations in pigments. The hand-rolled pastels have the advantage of containing few (or sometimes even no) binders, but are more expensive, whereas the machine-rolled pastels have the advantage of being less expensive but do have binders.

Pastels come in two categories: dry pastels and wet pastels. The dry pastels are further subdivided into soft pastels, hard pastels, and pastel pencils. Soft pastels are the sticks with paper wrapped around them. They have more pigment and fewer binders, making them brilliant but very smudgy and easily crumbly, hence the paper casing. Hard pastels have more binders and less pigment, allowing them

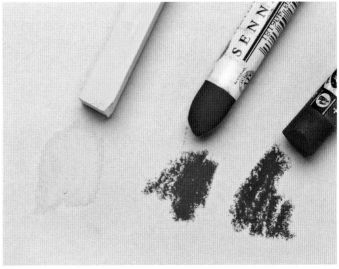

to be used for sharper drawing marks but with a little less blending ability. Pastel pencils are essentially hard pastels in a wooden pencil casing.

"Wet" pastels are not actually wet to the touch but have a wet ingredient. There are two kinds of wet pastels: oil pastels and water-soluble pastels. Oil pastels are pigments mixed with a little oil and formed into sticks. They are buttery and gooey, and can be thinned with turpentine or mineral spirits. They can be worked alone on paper or added to oil paintings. Water-soluble pastels are pigments and a binder with an added water-soluble ingredient, so they can be thinned with water; these are sometimes added to watercolor paintings, or they can be worked alone on paper. Both categories of pastels—dry and wet—are best used on papers that have some texture.

WAX CRAYONS

I know this is a kid's drawing medium, but some of us adults still use crayons occasionally. There is just something about them. Wax crayons are exactly that: paraffin mixed with colored pigments. The first company to make these was Crayola (formerly Binney and Smith), and their first box of eight colors came out in 1903. Today you can get dozens of colors, and most are pretty good, in that they have stood up to my lightfastness testing. Because of the paraffin, crayons do not stand up to intense sun or high heat; but with due care you can still draw with them and have fun. I have mostly used crayons on paper, though I did color what I considered to be a beautiful drawing on a pillowcase when I was three. Oddly, my mother did not share my opinion, and I think various other parents of small children can attest to the ability of wax crayons to make intense marks on walls and upholstery.

METALPOINT STYLUSES

Metalpoint is the general term for drawings that are made with metal tools, usually silver wire set into a holder; sometimes gold or other metals such as copper or brass are used. Metalpoint drawing goes back to late medieval times, but was done extensively in the Renaissance by such artists as Leonardo da Vinci and Albrecht Dürer. As silver is the most common of the metalpoint choices, I will talk about that in particular.

The silverpoint drawing technique involves drawing lines with silver wire onto a stiff, prepared support. The support can be wood or paper or cardboard, but it must be fairly inflexible, and it must be prepared by being coated with a few layers of a ground of some kind. The grounds are white and are similar in composition to an old-fashioned (i.e., non-acrylic) gesso. Various grounds recipes have come down to us from medieval times, some of which are fairly simple and some of which are almost impossible for us today ("grind up the old chicken bones you can find under your table"). Silverpoint, however, will not work without the use of some sort of ground. Today, Golden carries a silverpoint ground, a white opaque liquid formulation that is ready to be painted onto the support. Another easy possibility is to draw on Color-aid paper, which is a paper that has had matte color silkscreened onto it. I have only worked on white Color-aid, though it would be possible to work on many of the lighter colors.

Silverpoint drawing is subtle, delicate, and quite linear. Solid tones can only be made by building up several layers of overlapping lines. The range of tonalities you can get in silverpoint is narrow—light to medium dark—with no chance of getting really dark tones. Silverpoint drawings are, therefore, gray marks on white. You can achieve variations in this, however, by tinting the white ground with watercolor or gouache paint. Tinted grounds can be anything from pastel shades to medium tonalities. Working on a tinted ground opens up the possibility of adding white highlights with white paint or chalk.

To make a silverpoint tool, I buy 12-gauge silver wire, cut it into one-inch lengths, and house one piece in a mechanical lead-holder, the kind that holds bigger leads. After putting a point on the silver with a file, I am ready to draw. In the same way, you can make metalpoint tools with other metals, like gold, copper, and brass. To make a gold tool, gold being the expensive metal that it is, I buy very tiny wire, and jam it into the end of a wooden dowel.

ERASERS

Dry drawing marks can be eradicated or at least lightened with erasers. Tones and lines can also be smeared and moved around with erasers, so that erasers have become very much a part of the drawing artist's tools, both for mark-eliminating and mark-making. In other words, erasers are good tools to draw with as well as to erase with. Just as charcoal or graphite is used to create dark tones and lines, an eraser can be dragged through a tonal area to create a white line.

Erasers are made of just a few different things, most typically plastic or vinyl or rubber. However, they come in a wide variety of shapes, from rectangular blocks to novelty shapes. (I was recently given one in the shape of a peanut, which has turned out to work very well.)

The Staedtler Mars white plastic eraser is ubiquitous and comes in various shapes—from a small block to a clutch pencil to the eraser cylinders in electric models. It is a good all-purpose eraser that can also be cut with a mat knife to make sharp edges for crisper erasing.

The Design Kneaded Rubber eraser is a squishy gray lump that can be squeezed to fit any size, and then kneaded like taffy to distribute the grime within and keep its outside clean. The kneaded eraser leaves no crumbs, and is especially good for working on softer surfaces that can't take too much abrasion.

The Faber-Castell Pink Pearl eraser is harder and slightly more abrasive than the others on this list, and so is a good choice for getting dark marks off of strong, firm papers. It is most like the erasers that come on the ends of pencils.

The Design Artgum eraser is very crumbly, which does two things—one, its softness allows you to erase delicate surfaces with it, and two, the crumbs help pick up stray dirt and dust.

This is a general list, and I have probably left out a few. I have, and use, most of these erasers.

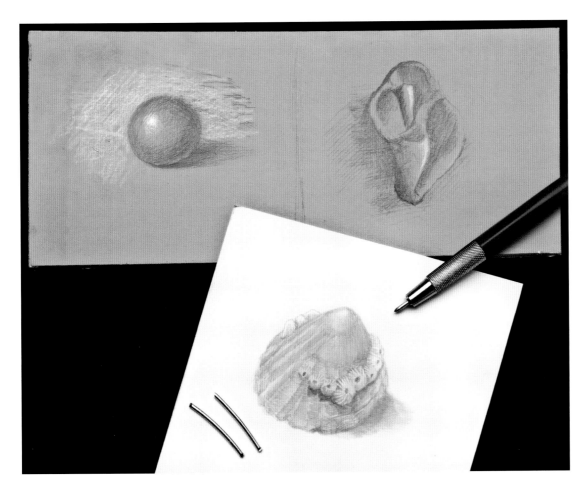

LEFT The two upper images were drawn with silver wire onto a ground tinted with a mixture of oxide of chromium green and thio violet watercolor. The white background and highlights on these images were created with white chalk (left image) and opaque white watercolor (right image). The drawing of the limpet shell is a plain silverpoint drawing done on white Color-aid paper. Lying across the drawings is the metalpoint tool and two extra pieces of silver wire.
Photo: Nancy Hines

Tools and Materials for Wet Marks

Today, wet marks in drawing are made by artists using inks.[1] Historically, it is likely that ink was not invented until people needed to write and draw, and they could not do that unless they had something to write and draw with, some sort of writing instrument. Therefore, the discussions that follow—about inks, brushes, pens, and pen nibs—are closely intertwined.

INKS

Many different kinds of ink are available, and the differences are subtle and interesting. Inks are made in various ways to do various things: Some are thicker, which provides more intensity when a brush is used; some are thinner, which facilitates flow through a fountain or mechanical pen; some are different colors; some change color; some are true to medieval recipes; and on and on. In short, there's a lot of variation in inks, and it is worthwhile for contemporary drawing artists to know the options.

Ink is a wonderful material—quick-drying, easy to work with, and responsive to the artist's touch. Ink was invented in many parts of the world, and has been made of many things, including berry juice, cuttlefish parts, and soot. It first appeared in China and Egypt, around 2500 BCE.[2] By 1200 BCE, the Chinese had developed a soot-based ink that is similar to what we use today, and by 300 CE they had invented the ink cake or stick, a solid ink that was easy to store and ship, and that could be reconstituted by grinding with water in an inkstone. Ink has been in use in India since at least the fourth century BCE (though what we call "India ink" today is usually Chinese). Early European ink recipes used oak galls, barks, iron salts, and wine in complex processes that took many days, even weeks, to complete.[3]

The inks available to artists today include many of those old recipes. One can buy Chinese and Japanese ink sticks; bister, an ink made from birch soot; genuine irongall ink like that used in medieval manuscripts; and even true sepia ink made from a cuttlefish ink bladder. Happily for the cuttlefish, true sepia fades and is not permanent. Today, many new kinds of ink are also available, including various blacks, browns, and colored inks.

In the black inks, subtle variations have to do with the blacking agent used (burnt wood, burnt bone, soot, etc.) and the binder used. Some inks have shellac as a binder, some lacquer, and some other chemicals. Artists choose according to density, ease of flow, whether the ink is waterproof or not, and what kind of wash the ink makes when mixed with water. Some inks simply go gray when watered down, and some, like the French ink *perle noire* by J. Herbin, separate out into colors when diluted. I am fond of using a wide variety of inks, and have had different favorites at different times. The Higgins Eternal ink and its waterproof cousin, Engrossing, have had a place in my studio for some years now, along with Pelikan black drawing ink, the *perle noir* ink mentioned above, and various Chinese ink sticks.

Brown inks are not as numerous as black inks. They are often called walnut inks, though I have not been able to find any ink made from walnut shells for a few years now. There is an ink called Walnut Drawing Ink that is a beautiful transparent medium brown color, and, though it is not itself made from walnut shells, is meant to replicate that warm color. The other brown inks I have found are bister, made by Kremer Pigments, and a walnut brown ink derived from peat, found in the Paper and Ink Arts catalog. Bister is more of a blackish brown and smells smokey. Because it has shellac as its binder, it evaporates somewhat quickly, and gets too thick too soon for me, and so application with a brush is better than with a nib. The peat-based walnut ink is useful because it comes in a powdered or crystal form, and so you can mix lighter or darker variations depending on how much water you add.

Colored inks come in two ways: either as dyes (Sennelier color inks, for example) or as pigmented inks (Daler-Rowney FW, for example). Dyes are dissolved colors. Pigmented inks, however, are like paints, in that the finely ground granules of pigment are not dissolved, but are held in suspension. The reason they need to be stirred so often is that the pigment grains readily separate out of suspension and must be mixed back in. There are pluses and minuses about each. The dye inks flow well, but might not be lightfast; the pigmented inks are lightfast but do not flow as well and must constantly be stirred. Don't forget that black and brown are included among the colors of these inks, so you can also find those colors with the particular properties discussed.

1 I have chosen to leave watercolor out of this book, though some contemporary artists do use this medium in their drawings. This is because the subject is too vast to handle here, and also it tends to get more painting-based than drawing-based. Instead, I will just point the reader toward *The Wilcox Guide to the Best Watercolor Paints* by Michael Wilcox.

2 Henning, Fritz. *Drawing and Painting with Ink* (Cincinnati, OH: North Light, 1986), page 17.

3 Huntington, Sharon J. "Think Ink!" *The Christian Science Monitor*, September 21, 2004, np (online article).

SOME INK SAMPLES

Higgins Eternal ink

Pelikan drawing ink

J. Herbin *perle noire* ink

Pro Art India ink

Walnut Drawing Ink

Paper And Ink Arts
Walnut Ink (*peat-based*)

Kremer Pigments bister ink

ABOVE I have laid out some of the inks I currently use
in this chart. The ink is painted in solidly, and then, while
still wet, pulled to the right into a watered-down wash.
Photo: Nancy Hines

BRUSHES

Although artists today can use any kind of brush they want, and are not limited by what the brush was originally made for, I want say a few words about Asian brushes, which were made for working with ink. Today Chinese and Japanese brushes are made from various animal hairs. Brushes are usually composed of an inner short hair that forms the belly of the brush, with a longer outer hair that curves in to form the tip. There are, basically, three kinds: a white-haired brush, a brown-haired brush, and a brush that is a mixture of the two. The white-haired brush is called a goat's hair brush, but can be made from the hair of sheep, deer, or cats as well. It is soft and supple. The brown-haired brush is called a wolf's hair brush, but actually uses the hair of martens, horses, weasels, and rabbits. It is stiff and springy. Some brushes combine these two hairs, with one on the inside and the other on the outside to form the tip.

Knowing all this helps you decide whether you want your brush to have a soft touch or a springy one. When drawing with a brush, you can get very fine lines using just the tip, and arrive at thicker, heavier lines simply by pressing a little harder. The brown-haired brushes spring back into shape after this maneuver a little better that the white-haired brushes, though I find that they both tend to stay somewhat bent over. They can be easily straightened when you recharge them with ink, however. The calligraphy technique of holding the brush almost vertical to the paper gives you the most flexibility in stroke thickness and direction.

Asian brushes come in a huge variety of shapes (from round to flat, from angled to straight) as well as sizes (from being as large as the thickness of your arm to being as tiny as a few hairs). In addition, other kinds of Asian brushes do not use hair at all. I have seen ones made from clumped rooster feathers, and also have one made from a single stick of bamboo where one end has been split into tiny, flexible strands.

NON-METAL PENS

Pens were originally devised out of things like sticks, reeds, and bamboo. Today I carve my own pens in a way similar to the way reed pens were made in the old days, but, as I don't live where reed grows naturally, I have learned that you can use anything that has a hollow stem and is fairly strong. So I use forsythia sticks, and carve pens that can be used and re-sharpened easily. I have also added a thin ink regulator using a metal strip cut from a soda pop can.

In early medieval times in Europe, the quills of certain bird feathers were sharpened to a point and then dipped in ink for writing. Some centuries later metal was used to create pen nibs that could be put into a holder, dipped in ink, and then used for writing or drawing.

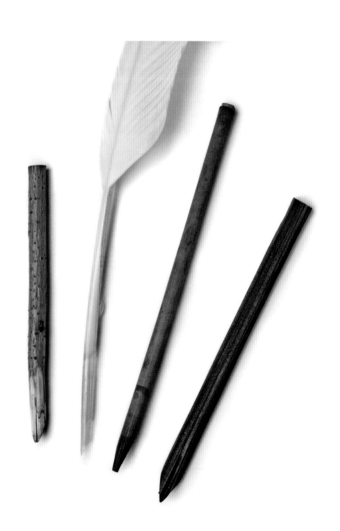

ABOVE Various non-metal pens, including (from left to right): forsythia pen, bird quill pen, reed pen, and black bamboo pen. The bird quill pen was cured and carved by Denny Rudd, and is available through the catalog *Paper & Ink Arts*. Photo: Nancy Hines.

When drawing with a brush, you can get very fine lines using just the tip, and arrive at thicker, heavier lines simply by pressing a little harder.

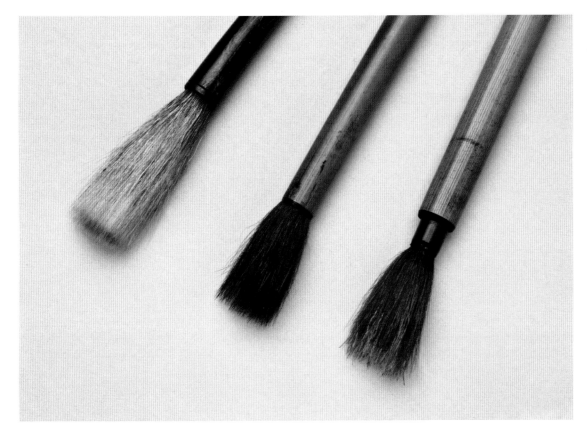

LEFT Standard Asian brushes (*from left to right*): goat's hair brush, wolf's hair brush, and a mixed hair brush.
Photo: Nancy Hines

METAL PEN NIBS

Pen nibs made of metal are many and various. Most draw a single thin line, but some create multiple lines at once, and others create very thick, wide lines. Pen nibs can be friendly or fussy, accommodating themselves to your hand movements, or stiffly requiring you to yield to their needs. There are so many nibs out there that a little guidance might be useful.

Pen nibs fall into the two general categories I just mentioned: those that produce a single line, and those that produce multiple lines. The first category is the bigger one, and can be further subdivided into nibs that make a line that varies, and nibs that make a line that does not vary. The nibs that make a varied line are calligraphy nibs with tips that are either straight or slanted; these come in various widths. When the pens are pulled in one direction the nibs make a wide line, and when they are pulled in a different direction they make a narrow line.

The other nibs, those that don't make a varied line, are the ones drawing artists turn to most often. These nibs make a single, unvarying line, and there are lots to choose from. Some are larger and make a thicker line, some are smaller and make a finer line, some go in any direction, and some work comfortably in only one direction. It's worth it to get a few nibs and try them out. Since nibs are not expensive at all, it's possible to buy a few and experiment, play with them, see what they will do.

To use a nib you need a nib holder, and there are basically two kinds. For the nibs that are tubular in shape, like the Hunt Crowquill (102), you need a special holder. For all other nibs, the regular holders work. Once the nib selection is organized into these various categories, based on what the nibs do, it's easier to decide what to buy.

CONTEMPORARY PENS

In addition to all of the traditional drawing tools, loads of new pens are on the market: felt-tip pens, markers, rollerball pens, ballpoint pens, gel pens, Asian brush pens, water pens, mechanical pens—there seem to be more arriving on the market every day. These pens have all been designed to deliver an ink of some kind automatically, so you don't have to dip into an ink bottle.

The variations have to do with the kind of the ink being delivered and the nature of the tip of the pen. The tips are either hard or soft: Ballpoint pens, rollerball pens, mechanical pens, and gel pens all have hard tips of metal or ceramic that deliver a crisp line; while felt-tip pens, markers, water pens, and Asian brush pens have soft tips made of felt or artificial hair that produce a fuzzier line. The inks range from traditional black to pearlescent color. Some are more watery than bottled ink, some are gooier, and many are not lightfast. So it is worth it to play with them, try them out on various papers, and see what you think of them. Artists choose according to how the pens feel in their hands as well as by what kind of marks they make, so what suits me would not necessarily appeal to you. Talk to other artists, try out different kinds, and then when you find something that you like, buy ten of them. You can be pretty confident that the ever-changing market will shift again soon, and your favorite pen just might disappear.

CHART OF METAL NIBS

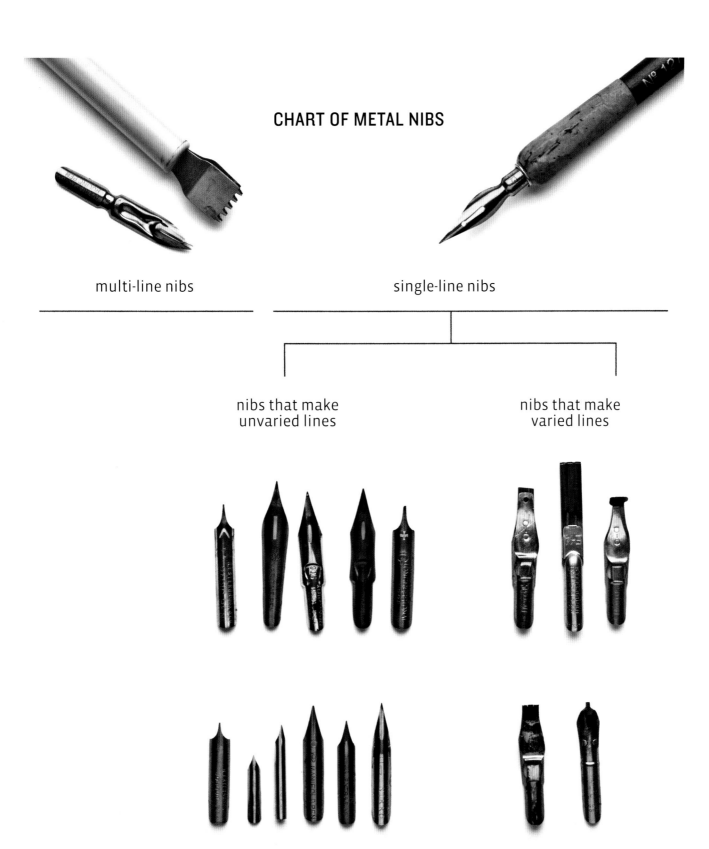

multi-line nibs

single-line nibs

nibs that make
unvaried lines

nibs that make
varied lines

This is just a sample. There are many more.

TESTING PEN NIBS

To test a nib, put it into its holder, dip it into a bottle of drawing ink (so that the nib has ink on it but not the holder), and then draw, first making straight lines, and then making curved lines. Make sure to have your paper on a board that is propped up slightly at the back, so that you are drawing on a slanted surface. This slant is important for how the ink flows out of the nib. If your paper is flat, the pen has to be held at a steep angle to the paper, and thus the ink will spill out too fast. With your paper on a slant, the angle of the pen is less steep, and the ink flows more slowly and comfortably. Now experiment, and try all kinds of marks.

Some nibs will do everything: straight, curved, and even looped lines. The old-school writing nibs are good for that, like the Hunt Globe (513), or the Bowl-pointed (512), or the Hunt Crowquill (102). I am also fond of the vintage Esterbrook Jonquil. Some nibs are very particular and delicate, and will only do one thing. The Gillott lithographic pen (290) and the Gillott mapping pen (291) are such nibs. They are delicate, easily damaged nibs made from a very springy metal, allowing them to be quite flexible. This flexibility is necessary for the thick/thin line this nib is known for. This line is created by slightly varying the pressure when drawing, and is used by many artists, from cartoonists to medical illustrators, who want that expressive and informative stroke.

Most nibs have names: Crow quill, hawk quill, and mapping are three currently made nibs. Vintage nibs that are not being made anymore but that are still on the market have names like Spencerian Subway Stub and Esterbrook Bronze Falcon. Other nibs are identified by the maker's name and a number, like the Hunt 104 or the above-mentioned Gillott 291.

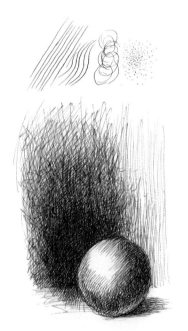
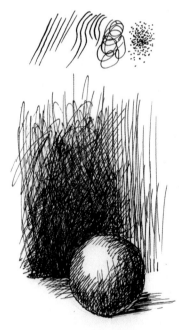
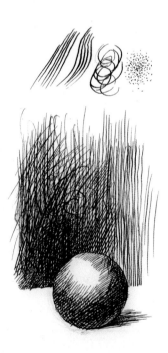

ABOVE Three nibs have been put through their paces here: the Hunt 104, the Hunt Globe (513), and the Gillott 291. They each draw very differently, and have different qualities to offer. Photo: Nancy Hines

The materials discussed on the previous pages—both those that create dry marks and those that create wet marks—can be applied to a wide variety of surfaces, depending on what tools you are using. Ink draws down well on all papers, as well as on wood, plant materials, cloth, stone, and plaster walls. Felt-tip pens draw on all papers, as well as on glass, ceramic, and metal. In short, the options for the drawing artist of materials that can be drawn on are, quite literally, innumerable. Covering them all would be impossible indeed, so for the rest of the chapter I'm going to stay focused on the support favored by the vast majority of drawing artists—paper.

Paper

Although many contemporary drawing artists work on unusual surfaces, most all of us have worked, and still do work, on paper. True paper, as defined by Dard Hunter, author of *Papermaking: The History and Technique of an Ancient Craft*, is made from a pulp that consists of water combined with fibers of some sort that have been broken apart and beaten down to separate and individual filaments. (Hence the phrase "beaten to a pulp.") Then some of the pulp is lifted from its vat with a framed screen. The water drains away, leaving a thin layer of filaments matted together on the screen. This thin layer is a sheet of paper.

Technically, only true papers come out of this pulp process; other surfaces, like Egyptian papyrus, made by pounding strips of reed together, or the new product called Yupo, made from extruded polypropylene pellets, are made differently and so don't qualify as true papers. Whatever the technical differences, we all, artists and non-artists alike, use the term "paper" to apply to all these products. This is because they share the significant characteristics of paper— they are flat, flexible, and able to be cut or torn into different sizes and shapes.

Today artists have an overwhelming array of papers to choose from—papers from Asia, Africa, the Americas, Europe, and the Middle East. To know how to choose, it's necessary to know a little something about what the papers are made of, and especially what their properties are.

A BRIEF HISTORY OF PAPER

Papyrus has been around for about 6,000 years, and, though we in the West do not use it much, its name has provided us with the root of our word "paper."

The first true paper made from a wet pulp was invented in China by a court official named Ts'ai-Lun, around 105 CE, using mulberry bark, along with other things such as fish nets and hemp. Chinese bureaucrats began to use Ts'ai-Lun's invention for their official written documents, and by the tenth century, paper was being used for all sorts of things, including money.

The manufacturing of paper spread from China to Korea and then to Japan (610 CE), and then into the rest of Asia and the Middle East (Baghdad 795). Arabs took the craft to Spain (Cordoba 1036) and Egypt (1100). It reached France in 1189 and it came to Italy, possibly with the help of Crusaders. The first mention of paper production in Italy is in 1260 in the town of Fabriano, a name still recognized and famous today, among artists, for its art paper production.

The Fabriano mill introduced rags as a material for papermaking, and the process of sizing with animal glues. This technique, especially the sizing, produced a heavier paper with a harder surface suitable for writing with a quill pen. Just as Ts'ai-Lun's technique made paper suitable for Chinese calligraphy written with a brush, the Fabriano mill customized their paper for European writing needs. Here you can see the reason for the fundamental change from Asian paper (which is softer, thinner, lighter, and good for brush writing) to a European paper (which is thicker, harder, heavier, and good for quill writing). This is the first big division in papers that artists today need to think about when choosing paper: Eastern or Western.

Papermaking moved into Germany in the fourteenth century, became established in Switzerland, Portugal, and Holland in the fifteenth, first appeared in England around 1490, and continued more or less north with mills established in Denmark (1540), Scotland (1590), Russia (1690), Sweden (1693), Norway (1698), and Finland (1818). The Spanish brought papermaking to Mexico around 1580. The first mill in North America was in 1690, in Pennsylvania. All these mills made paper by hand, sheet by sheet.

Papermaking became mechanized in the nineteenth century, and the established mills went over to machine-made production. Handmade paper has continued in many places, so both handmade and machine-made paper are available today. Thus, the second big division that artists have to think about when choosing paper is whether to use machine-made or

handmade paper. This is not a two-way choice, but actually a three-way one. There are two sorts of machine-made papers: those made on a cylinder-mould machine, known as mouldmade papers, and those made on the Fourdrinier machine, known as machine-made papers. The former produces paper that more closely resembles handmade sheets (examples are Arches Cover, Fabriano Artistico, and Rives BFK), and the latter produces the papers needed for commercial, industrial, and lower-priced paper markets (examples are graph papers, bond paper, and bristol). I am indebted to Silvie Turner's book *Which Paper?* for much of the above information, and for a very interesting trip into the subtleties of the world of paper. As a drawing artist, I have worked on many kinds of papers, and now know that I have worked on all three kinds listed by Turner: handmade, mouldmade, and machine-made. All have worked beautifully and provided a wonderful variety
of surfaces.

Today artists have an overwhelming array of papers to choose from—papers from Asia, Africa, the Americas, Europe, and the Middle East. To know how to choose, it's necessary to know a little something about what the papers are made of, and especially what their properties are. In this next section I'll give you the basics on the types of papers that are out there, what their properties are, and some of the terminology that is used when talking about paper. Knowing this terminology will help when buying your paper, so you can be sure to get what you really want and need.

Art papers can be put into just four categories: rag papers, rice papers, tree pulp papers, and other papers. As you can tell, these labels give the first piece of information you need: what the paper is made of.

RAG PAPERS

Rag papers are made from cotton fiber, hence the name. However, "rag" can mean cotton rags or cotton linters, which is cotton fiber too short to be spun into cloth. This is not a distinction I have worried about, but it may make a difference in the surface, so is worth knowing about. Some have other fibers in them as well, such as linen or hemp. Rag papers are considered to be high in quality and archival, meaning they will not change color or turn brittle and disintegrate with age.

Rag papers can be either handmade or mouldmade, and a few are machine-made. The handmade papers have a deckle on all four sides; the mouldmade and machine-made papers have a deckle on only two sides, or sometimes no deckle at all. The deckle is the natural uncut edge of the paper, formed by the rag pulp thinning out at the outer edge of the screen, making a slightly rippled edge when dry. I know of one well-established paper mill in the United States from which artists can buy handmade paper: Twinrocker. Their paper is wonderful, and their website is listed in sources at the end of this book.

Rag papers come in a variety of thicknesses, with a variety of surface textures, and may be sized or waterleaf (paper that has not been sized). Sizing is a glue or starch that is added to the pulp before the sheet is made, and/or is also coated onto the surface after the sheet is made. This glue helps the paper absorb liquids slowly, giving the artist time to move the paint or ink around on the surface before it is absorbed into the paper.

Watercolor papers are often rag papers, and are the papers that have weight numbers attached to them. For example, you can buy a sheet of 90lb watercolor paper, or 140lb, or 220lb, or 300lb. This term stands for what 100 sheets of that paper weighs. So 100 sheets of the thinnest watercolor paper weighs 90 pounds, whereas 100 sheets of a thicker one weighs 300 pounds. There is also a 600lb watercolor paper.

Watercolor paper is also the paper with a surface term attached to it: either hot pressed, smooth pressed, cold pressed, or rough. Hot pressed is very smooth watercolor paper, smooth pressed has a little more texture, cold pressed even more, and rough the most texture of all.

Other rag papers do not have poundage data or those particular surface terms attached to their names. Some have their own terminology attached, like bristol. Bristol paper terminology refers to its thicknesses, which are called "ply." "One-ply" is very thin and "five-ply" is quite thick and stiff. Bristol also has two surface terms: plate (also called "smooth") and vellum (also called "regular"). The vellum is very slightly textured, while the plate is exactly that: smooth as glass.

RIGHT A few rag papers (from top to bottom): Rives BFK (tan); Arches 88; Strathmore 500 plate bristol; Arches Text Wove; and Arches watercolor paper (rough). Photo: Nancy Hines

Rag papers do not usually come in bound pads, but must be bought by individual sheets. The exception that I know of is the Strathmore 500 series, a 100% rag bristol that can be bought in pads of either plate or vellum surface. You can always tell what the content of the paper in a pad is by what is said on the cover. Pad covers will say whether the paper inside is acid-free, or pH neutral, or recycled. If the paper is rag, it will say "100% cotton" or "100% rag" on the cover.

RICE PAPERS

The papers in this category are not, and never have been, made from rice or the rice plant. Instead they are made from various vegetable fibers, called bast fibers, that include kozo (mulberry), flax, gampi, hemp, jute, and mitsumata. They all come from Asia, and are soft but quite strong. Usually these papers are only lightly sized with a vegetable starch painted on just one side of the finished sheet. This makes them very absorbent, with only a little less absorbency on the sized side. A wide variety of rice papers are available, some plain, some in colors, some with lace-like textures, and some with things like flower petals or butterfly wings embedded in them.

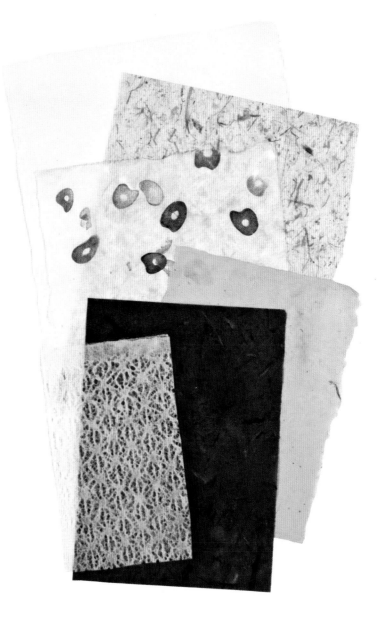

RIGHT A few rice papers (from top to bottom): mulberry; mulberry with bamboo; mulberry with sliced water hyacinth root; Nepalese lokta fiber paper called Lami Li (chartreuse); dark mulberry with bamboo; and Japanese kozo (mulberry) lace paper. Photo: Nancy Hines

TREE PULP PAPERS

Most of the papers you have daily contact with are tree papers, meaning they are made from tree pulp. Books, newspapers, computer printouts, all are tree papers, as well as most sketchbooks and art papers that come in pads. Tree papers are made by a process that uses a lot of acid, and so are usually non-archival. However, most sketchbook papers and art papers that come in pads have gone through a buffering process that neutralizes the acids, and so are considered acid-free, or at least pH neutral. Acid-free is not the same as archival, but is close. This information will be spelled out on the pad cover.

Some papers are labeled "100% high alpha cellulose," which means they are made from wood pulp that has been cooked with either calcium bisulphate or sodium sulphite to break the wood down to the cellulose fibers and remove the resins. These papers also are buffered and so are acid neutral, and are considered archival.

OTHER PAPERS

This category is always changing, as people around the world try new materials for making paper. The variety of plant fibers used in Africa and Asia are interesting and worth checking out. Papers are being made from bamboo, elephant grass, and even grass-filled white spotted rhino dung, to name just a few.

Papyrus, the oldest paper in the world I think, going back to about 4,000 BCE, is still being made and still available. Papyrus is made from a kind of freshwater reed with a triangular stem. Its scientific name is *Cyperus papyrus,* but it is known, not surprisingly, as the "papyrus plant." This paper is made by cutting thin slices from the core of the stalk, soaking and pounding them, and then laying them east to west, side by side, slightly overlapped, and then placing another layer north to south on top. These two layers are pounded together, and then left to dry under a heavy weight. The result is a yellowish sheet with obvious ridges and an overall plaid look.

In America new papers are being made from petroleum-based plastics. Yupo, which is smooth, white, and opaque, is such a paper made from pellets of polypropylene.

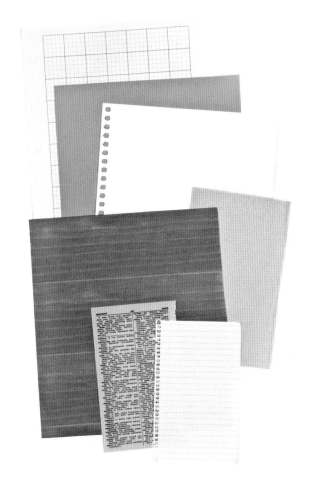

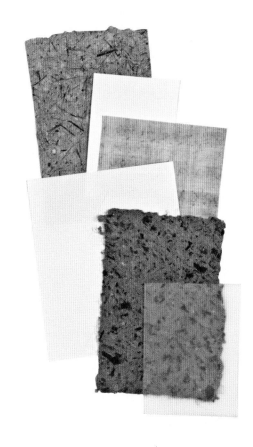

ABOVE Tree pulp papers (from top to bottom): graph paper; colored paper; sketchbook paper; Nideggen, which is high alpha cellulose; actual wood veneer paper; printed paper; and lined notebook paper.
Photo: Nancy Hines

ABOVE Other papers (from top to bottom): white spotted rhino paper; Yupo; papyrus; Duralene Mylar; savannah spotted leopard paper; and frosted acetate.
Photo: Nancy Hines

PAPER OPTIONS

All these variations in paper provide artists with a tremendous range of options. So, how does one go about choosing the right paper? Here are some guidelines.

I have already talked about how papers are made, and what they are made of. These two things are an artist's main consideration, because they determine what the surface is going to be like, and the surface is where drawing happens. Other paper properties are listed below, followed by a list of paper terminology on pages 158–160. These distinctions and terms will help you when reading or talking about the papers you are thinking of buying.

HARD OR SOFT

The difference in hardness or softness of papers is mostly due to the sizing. Heavily sized papers are harder, and less heavily sized papers are softer. You can check the quantity of sizing when reading about a paper in any art catalog.

Papers that have a hard surface do so because of what the paper is made of, how the paper is formed from the pulp, and especially how much sizing is used. Hard papers will accept things like ink very well. Hard papers will also erase well, in that the eraser will not disturb or tear up the surface. However, some hard papers do not seem to hang onto as much dry material like graphite or charcoal as softer papers do, and so artists find it difficult to make the blacks as dark as they would like. Hard papers include such papers as the various bristols, Lennox 100, Canson Mi-Teintes, Yupo, and most machine-made papers like sketchbook papers found in pads. Many handmade papers are also heavily sized, and so qualify as hard papers.

Softness in papers is due to what the paper is made of, how it is made, and again how much sizing is used. Soft papers include many rag papers and most rice papers. The softer surface is more absorbent of liquids like ink, and is also not very erasable. The eraser will disturb the surface, tearing up little threads, and so will show if drawing is then laid down on a previously erased area. Rag papers that are waterleaf are also soft. Arches 88 is the one I am most familiar with.

SMOOTH OR TEXTURED

The difference between smooth papers and textured papers is surface, which is created by the nature of the pulp and the texture or smoothness of the screen used. Paper that is really smooth has usually been calendered, which is to say it has been pressed smooth by a calendering machine. If you are buying handmade paper, you can often request your sheets to be calendered on one or both sides.

Smooth papers can be found in all the paper categories: rag, rice, tree pulp, and other. Catalogs will tell you whether a sheet is smooth or not, and stores that have the paper out will let you touch it. There is more to smoothness than that, however. To draw happily, many artists like to erase. Lots of papers take erasing easily, but many do not. Most rice papers, smooth or otherwise, do not take kindly to erasing, as it tears the surface apart. Rag papers that are labeled "waterleaf" will also tear when erased, and rag papers that are only lightly sized also have a sensitive surface easily destroyed by erasing. Smooth papers that can be easily erased include both handmade and mouldmade rag papers that are fully sized like hot pressed watercolor paper, and machine-made papers like plate-finish bristol, graph paper, and bond paper. Another smooth paper is Yupo, from the "other" category. This paper is both smooth and nonabsorbent, and so dry materials slide quickly across the surface, and wet things like ink washes are free to swirl and form into patterns before finally drying. This lack of absorbency also allows the colors in colored pencils and watercolors to stay on the surface and remain brighter, rather than be absorbed and thus lose a little brilliance.

Smoothness matters to realist artists because the smoother the paper, the more detail can be drawn in; texture inhibits detail by interrupting the line. Smoothness also matters to pen and ink artists because smoother paper is easier to draw on than rougher paper; rougher paper snags the pen nib and causes the ink to splatter. Some artists like this and deliberately choose it, but many do not. Smooth papers include any plate-finish bristol, Arches Platine, and Pentalic Paper for Pens.

Textured papers are papers that have what is called "tooth." Tooth can be light, medium, or heavy, and is a principle influence on the nature of the mark. A heavy tooth breaks up the mark significantly, while a light tooth will only texture it slightly. Another kind of texture is found on laid papers—papers with a surface that is lightly textured with rows of parallel lines with laddering ridges in between.

A rough texture and heavily sized surface is useful to watercolor artists because the texture, the bumps and crevices in the paper, will wick the watercolor wash across the surface evenly, making a smooth tonality that is highly prized. The heavy sizing will slow down absorption, giving the artist time to move and spread the paint to where he wants it. Rough texture is also useful for showing broken strokes, wilder lines, and more energetic strokes in either wet or dry materials.

Light texture can be found in most of the rice papers, including Kitakata and those made from mitsumata and kozo fibers; most of the rag papers are lightly textured, like Arches Cover, Arches Text Laid or Wove, any vellum bristol, and any smooth pressed watercolor paper. Medium textures are found in the cold pressed watercolor papers (Arches, Fabriano, Strathmore) and some handmade papers, like Twinrocker Cripple Creek. Heavy texture can be easily found in rough watercolor paper and much of the newer, experimental papers coming from Africa and India, like Khadi Indian bagasse and Khadi Indian wool, the white spotted rhino dung paper, and

BELOW Fabriano Artistico hotpress watercolor paper (left) is smooth and Khadi Indian wool paper (right) is textured. Photo: Nancy Hines

Egyptian papyrus. Papers with inclusions (such as sliced water hyacinth root, as shown on page 151) also behave like textured surfaces.

THICK OR THIN

This paper property is determined by how the paper is made. Thickness or thinness is not so much a matter of what the paper is made of, but of how many layers are involved.

Thick papers are those that are heavier, denser, and fairly opaque. Artists choose these for their strength and for the certainty that they will not be folded, cockled, or damaged as easily as thinner papers. The higher weights in watercolor papers, e.g., 300lb or 600lb, are thick and heavy and will stand up to watercolor activity without warping or rippling, and do not need to be stretched first onto a board. Artists also draw on four-ply cotton rag mat board because of its strength. Along with the papers mentioned above, thick papers include four-ply and five-ply bristol, and many handmade papers.

Thin papers are those that have the fewest layers or the least amount of pulp per sheet. These papers tend to be translucent and are very delicate. Some are too fragile for drawing and so are used for collage. One-ply bristol is a thin paper, still strong enough to draw on. Many machine-made papers are thin, like graph papers, notebook papers, and copier papers. The thinnest rice paper that I know of is one of the gampi papers, made in Japan from the gampi plant: Gampi Tissue A3. This paper is gossamer-thin but strong, and so can be drawn on. I have used pencil, ink wash, and colored pencil on it, albeit carefully, and it has held up well.

BELOW Lanaquarelle 300lb watercolor paper (left) is thick and Arches Text Wove (right) is thin. Photo: Nancy Hines

OPAQUE OR TRANSLUCENT

Paper either allows light to shine through it (i.e., is translucent) or it doesn't (i.e., is opaque). This property is determined by what the paper is made of and how thick it is. Opaque papers are useful for not allowing light, plus whatever might be drawn on the back, to show through them. But why would someone want translucence? It is for exactly that quality: showing what is on the back, or on another sheet underneath.

Many, maybe most, rag papers are somewhat opaque. However, if you hold a sheet of, say, Fabriano Roma up to the window to look at its nifty watermark, the light will show through. For true and total opacity you need to buy heavy, thick watercolor papers, 300lb or more, four-ply mat boards or illustration boards, or Yupo. This plastic paper is thin but completely opaque.

Translucent papers are more readily available. Many of the rice papers are translucent, but are sometimes hard to draw on; their surfaces do not erase easily, and their thinness makes them delicate. Films like acetate or Mylar can be drawn on. Mylar frosted on one side makes a surface that can be drawn on with dry media as well as wet; furthermore, Mylar will not shrink or expand with the heat of your desk lamp, whereas acetate will. Certain tracing papers and layout papers are designed to be translucent, some with a pre-printed grid and some without. Another good translucent paper is something called Pergamenata. This paper is meant to look and act like calfskin vellum, and so is somewhat thick, either white or yellowish, and translucent. I like working with Pergamenata when I want to draw on both sides and have things show through.

BELOW Arches Platine (left) is opaque and Clearprint Vellum (right) with a grid is translucent.
Photo: Nancy Hines

PAPER TERMINOLOGY
Now armed with information about what papers are made of, and what qualities different papers have, you are just about ready to shop for paper fearlessly.

Last of all, though, you might find it helpful to know some paper terminology, which is especially useful when looking at paper choices is art supply catalogs. Below are three lists of paper terms that will help you decipher what the catalogs say.

WHAT IT IS MADE OF
Below is a list of terms that refer to the contents of the paper.

Acid Free A paper that is made from cotton rag or 100% high alpha cellulose is almost entirely acid free, which means it will not degenerate with time, and is archival. Papers that have a neutral pH are called "acid neutral," which is not exactly the same as acid free, but is close.

Archival This term refers to a paper's ability to resist aging. Archival papers are not supposed to yellow, shrink, disintegrate, or change with age.

Bast Fibers These are the fibers used in what are commonly called "rice papers." Three common bast fibers are:

GAMPI—a fiber from the gampi plant, a shrub that grows in various parts of Asia.

KOZO—a fiber from the mulberry plant.

MITSUMATA—another plant fiber, shorter than kozo, used by Japanese papermakers.

Hemp Fiber from the cannabis plant, which is native to China. It can be used to make a strong, but coarse, paper.

High Alpha Cellulose A wood pulp that is cooked down and chemically altered, rendering it resin-free, acid free, and archival.

Jute A plant native to India and Asia that is used to make a hard paper.

Linen Fiber from the flax plant, which makes a strong, somewhat hard, paper.

pH A measurement of the acidity or alkalinity of a substance. 0 pH is highly acidic; 14 pH is highly alkaline; 7 pH is considered the point halfway between, and so is called "acid neutral."

Rag A term that indicates the use of cotton rags or cotton linters in the papermaking process. The quantity used is given in percentages (e.g., 100%, 50%, etc.).

HOW IT IS MADE

Below is a list of terms that refer to aspects of the production process.

Deckle Edge The wavy edge of paper, made when the pulp thins out at the border of the frame. Handmade papers have deckles on all four sides, mouldmade papers usually have two deckles and two torn edges, and machine-made papers usually have no deckles, but four cut edges.

Grain A characteristic found on mouldmade and machine-made papers, but not on handmade papers. It refers to the alignment of the fibers during the making of the paper. "Long grain" refers to fibers that run parallel to the long side of the sheet, and "short grain" refers to fibers that run parallel to the short side of the sheet. Grain direction is a consideration when folding, tearing, and printing papers. All those activities should be done with the grain, rather than against it.

Gm² An abbreviation that stands for grammage, which is the weight of paper in metric terms, namely grams per square meter. By looking at this number in a catalog, you can get a sense of the thickness of a paper.

Handmade A process by which paper is made by hand, sheet by sheet.

Machine-made A process by which paper is made on a Fourdrinier machine, usually for commercial and industrial purposes.

Mouldmade A process by which paper is made on a cylinder-mould machine. This creates paper in a long web, which is then torn into separate sheets; hence the deckle on two sides and the torn edges on the other two sides.

Ply The thickness of certain papers. For instance, one-ply bristol is thin and five-ply bristol is thick.

Watermark An insignia, indicating the mill and the kind of paper. It can be found on each sheet, usually in a corner. The watermark is either formed in the sheet during the pulp stage, or embossed into the sheet after it is formed.

ABOVE LEFT Pictured (*from top to bottom*) are: the torn edge of Arches Cover (buff); the regular deckle of Fabriano Roma (gray); and the "Feather" deckle of Twinrocker watercolor paper (white).
Photo: Nancy Hines

ABOVE RIGHT The laid paper Michelangelo (*left*) has visible horizontal ridges, while the Arches Text Wove paper (*right*) has none.
Photo: Nancy Hines

SURFACE PROPERTIES

Below is a list of terms used to describe the surface properties.

Cold Pressed A term, applied to watercolor papers, that identifies a surface with medium, even bumpiness. *See also* Hot Pressed; Smooth Pressed; *and* Rough.

Hot Pressed A term, applied to watercolor papers, that identifies a very smooth surface. *See also* Cold Pressed; Rough; *and* Smooth Pressed.

Internal Sizing A process by which sizing is added to the paper at the pulp stage. *See also* Sizing *and* Tub Sizing.

Laid A term used to describe a surface texture of certain papers, generally characterized by parallel ridges with laddering ridges between them. Usually the parallel lines run the longer direction of the paper, and the laddering lines run the shorter direction. *See also* Wove.

Plate A term, usually applied to bristol, that identifies a very smooth surface. This effect is created by sending the paper through the calendering process. *See also* Vellum.

Rough A term, applied to watercolor papers only, that identifies a surface with heaviest texture, characterized by a larger bumpiness with deeper valleys than is found in cold-pressed papers. *See also* Cold Pressed; Hot Pressed; *and* Smooth Pressed.

Sizing The chemicals, glues, or starches added to paper to make it less absorbent to moisture. Sizing can be added at various stages of the papermaking process. *See also* Internal Sizing *and* Tub Sizing.

Smooth Pressed A term, applied to watercolor papers only, that identifies a surface with light texture. This is a fairly new surface, meant to fall between hot pressed and cold pressed. *See also* Cold Pressed; Hot Pressed; *and* Rough.

Tooth A term used to refer to the texture of a paper. Tooth can be light, medium, or heavy.

Tub Sizing A process by which sizing is added after the paper is made. After being formed and dried, paper is passed through a tub containing some kind of size, which allows it to be added to the surface of the paper. *See also* Internal Sizing *and* Sizing.

Vellum A term, usually applied to bristol, that identifies a surface with a slight, even texture. *See also* Plate.

Waterleaf A term used to refer to papers that have not been sized at all, and so are very absorbent.

Wove The opposite of laid; papers without the laid pattern in them. For example, the paper called Arches Text can be found either Arches Text Laid or Arches Text Wove.

SUMMARY

This chapter on materials is meant to provide you with two somewhat opposite and contrary things: first, an understanding of various materials and their traditional uses, and second, a belief that with that knowledge you can do something different or opposite with that material if your art ideas take you in that direction.

Contemporary drawing artists work in all realms of contemporary thinking, from celebrating the traditional to breaking all the rules. Art materials are tools for both, and information about these materials can be helpful to either kind of artistic thinking. So learn what has worked, experiment with new things, and question, always question, any material that seems to hold you back. There is, no doubt, a way around or through to where you want to go, something else that will help make your ideas work.

CHAPTER **BREAKING** SEVEN

BARRIERS

I n this chapter I would like to put forth an observation: There are several important contemporary

artists who have either taken drawing into other artistic fields or brought other artistic fields into

the area of drawing. These artists are mixing it up—aware of the traditional boundaries that separate

one artistic discipline from another, but not interested in being restricted by them.

The first six chapters of this book outline drawing concepts, meaning essential things for

contemporary drawing artists to do. I'm calling the subject of this chapter an "observation" rather

than a "concept" because it is not an essential activity inherent to the practice of making art. Rather,

it is something that is happening now, and, I think, is unprecedented and exciting. The following

pages feature four of these barrier-breaking artists, though as you look around, you'll see more.

OPPOSITE Gego, *Paperless Drawing 85/12,* 1985, iron rods, steel wires
and beads of metal assemblies, plus shadow, 41.6 x 40.4 x .8 inches
(104 x 101 x 2 cm) © 2010 Gego Foundation, Collection of the Museum
of Fine Arts, Houston; Photo: Reinaldo Armas Ponce

WILLIAM KENTRIDGE

Among the many things William Kentridge does, are his stop-action animated films of his own charcoal drawings. The human touch, a universal characteristic evident in all drawings, is something that Kentridge is able to enlarge upon and enhance by making these drawings move. You can sense his hand rubbing out and shifting charcoal lines, and you can see the charcoal dust shift and move, even in small things like the hands of a wall clock that turn around its face.

The narrative messages of his films rely on the fact that the images are drawings, as much as they rely on the fact that the images move. Both media are essential to each other and vital to his message. Kentridge has given us something new here, a combination that is both personal and universal, a combination that dissolves and makes irrelevant the barriers between drawing and film.

BELOW Willliam Kentridge, drawing from *Tide Table,* 2003, charcoal on paper, 32 x 48 inches (81.3 x 121.9 cm) Inv. #9179 © 2010 William Kentridge

Kentridge's loose style of charcoal drawing gives us a sense of life and movement even before the drawings are animated.

LEFT William Kentridge, drawing from *Tide Table,* 2003, charcoal on paper, 31 3/4 x 33 3/4 inches (80.6 x 75.7 cm) Inv. #9187 © 2010 William Kentridge

The drawing lines here include black lines, white lines created with the eraser, and rubbed and partially erased gray lines—all contributing to the sense that the form lives and breathes.

BELOW William Kentridge, drawing from *Tide Table,* 2003, charcoal on paper, 32 x 48 inches Inv. #9179 © 2010 William Kentridge

The ghost images in this drawing are important and intriguing.

GERTRUDE GOLDSCHMIDT (GEGO)

Gertrude Goldschmidt, known as Gego, was an artist born in Germany and raised in Venezuela. Gego spent her artistic life seeking a way to show us light and space and transparency, not so much by representing it, or even by making art that embodies it, but by creating work that points to those aspects of light, space, and transparency that are already there in front of us. In particular, she created line drawings with ink on paper, and line sculptures with wire constructions that hang in the air. Both ways of working address the issue of form plus formlessness, and also how line and space each have the capacity to be either opaque or transparent, solid or vapor. In her search, Gego arrived at what Mari Carmen Ramírez calls an "in-between dimension," a place where "the image and the ground of Gego's drawings and constructions challenge each other in an ambiguous perceptual realm that straddles flatness and three-dimensionality."[1]

Gego's pen and ink drawing pictured here shows overlapping planes, some indicated with partial outlines, and some with fields of parallel or hatched lines. All these planes float, and demonstrate transparency, translucency, or opacity. The planes even seem to shift slightly, changing their configurations and their properties, as air or light moves across them. Gego's drawn lines work in concert with her un-drawn lines, namely the spaces between and around the ink marks. They are equally significant, with each involved in the weightlessness and movement of the other.

Gego produced a series of pieces she called "drawings without paper," composed of hanging wire structures *plus* the shadows they cast on the wall (such as the one shown on page 162). The two together, along with the space in between them, come the closest to her artistic goal, and present to us art that is more than sculpture, more than drawing, more than a combination of the two: Gego's art is completed by the thinking of those looking at it. Just as part of her art is the air in between hanging wire and its cast shadow, the completion of her work is the experiencing and understanding of light and space and transparency by her viewers.

1 Ramírez, Mari Carmen, "Between Transparency and the Invisible: Gego's In-Between Dimension," *Gego, Between Transparency and the Invisible* (Houston, TX: Museum of Fine Arts, 2005), page 23.

Gego's drawn lines work in concert with her un-drawn lines, namely the spaces between and around the ink marks.

OPPOSITE Gego, *Untitled,* 1963, ink on paper, 11.32 x 11.40 inches (28.3 x 28.5 cm) © 2010 Gego Foundation Collection at the Museum of Fine Arts, Houston Photo: Reinaldo Armas Ponce

This drawing is worth looking at a long time, to see Gego's layering, and to understand how weightless everything is. Her forms transcend gravity, floating forward and back, and moving in and out of states of transparency and opacity. She has made ink and paper become air.

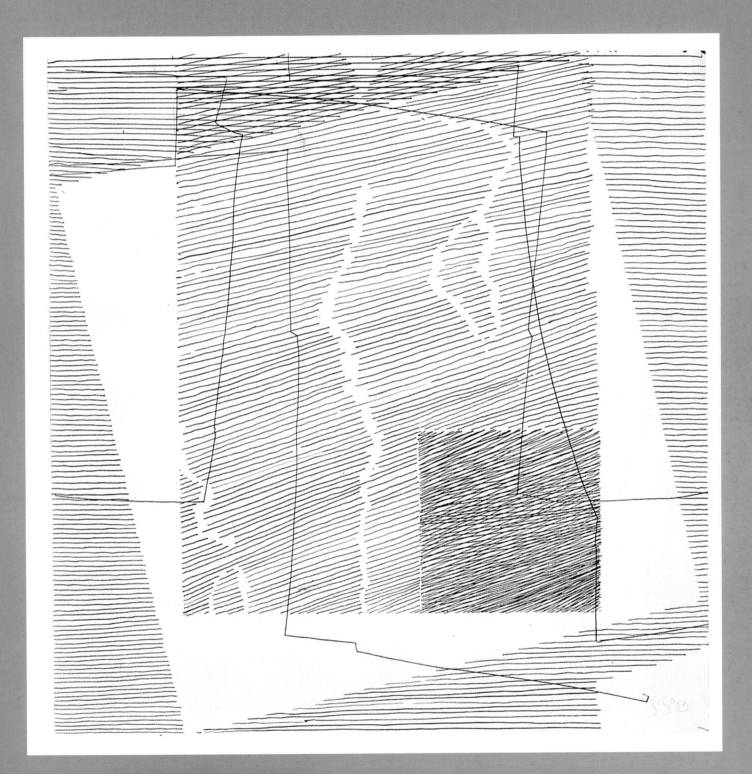

BARBARA ROBERTSON

Barbara Robertson can be called a printmaker, as she has her college degree in that discipline. However, her art goes beyond the confines of printmaking in that she makes one-of-a-kind works on paper that use multiple techniques, including drawing.

Roberston combines and layers images and forms, working with drawing, printmaking, photography, painting, and, most recently, video. Like many artists mentioned in this book, Kentridge and Cage, for example, Robertson uses technology as one of her tools to arrive at her particular vision, which I take to be an exploration of how deeply and how far humans have probed into the earth, into space, and into ourselves. That machines have been used to do that

probing, and that machines contribute to her multilayered images, is something Robertson recognizes and uses. The printed image and the hand-drawn marks enhance and contrast with each other, and her hand-carved woodblock images work as a combination of the two: obviously handmade, but printed using a press.

This mixture of approaches, the combinations and contrasts of the marks themselves, as well as of the images, is what gives her work its depth and power. No single technique can provide that; the marks and images need to be coming from multiple sources—camera, computer, drawing pencils, brushes, woodblocks—for them to be rich enough, and for her message to come through and be clear to us.

Various devices, like layers of lines getting progressively paler, and objects being larger and smaller or sharp-edged and soft, take us into this image, and then pull us back out, giving us a chance to visually shift and bounce and zoom in and out.

In her work, Robertson gives us a view in; our eyes travel in and out, as well as across and around. In this drawing, we are given the sense of crystalline structures with here and there openings into deep, deep space.

NANCY RUBINS

The art of Nancy Rubins is large, intense, and mind-blowing. She fills your vision with constructions built of modern-day castoffs: old TVs, broken appliances, trailer parts, pieces of wrecked airplanes, rusted water heaters. These structures sit, hang, balance, and counterbalance, changing back and forth between a disparate collection of parts and a unified whole.

Into this gravity-defying sculptural abundance Rubins has sometimes introduced the art of drawing. She draws with graphite on things like big slabs of broken chipboard or large sheets of paper. The paper drawings are completely and solidly covered with graphite, and are then draped over things, like sawhorses or water heaters, or accumulate and pile together, sliding down a wall onto the floor, or they hang in midair, wadded up and torn.

Rubins's drawings are sculptural, grandiose, and intimate. The graphite sometimes seems to stand alone, to just hang there being shiny and reflective, rather than being attached to the paper. When they hang I think of space, air, and floating, and when they drape over something I think of weight, groundedness, and protection. Furthermore, Rubins's drawings don't just exist, they *act*—they hang and swirl, they slide, they cover—and they do all of this dimensionally. By making her drawings behave in this manner, by creating drawings that can be said to "behave" in any kind of way, Rubins has greatly expanded what drawing is.

BELOW Nancy Rubins, *Drawings,* 2000–2001, graphite pencil on paper, 168 x 288 x 36 inches (426.7 x 731.5 x 91.4 cm)
© 2010 Nancy Rubins

Rubins's drawing is a huge and spectacular constrast. The act of covering paper with graphite is so sedentary, and then the way this drawing is on the wall—climbing, flinging, and flying up—is completely active. The two ideas pull at each other and also enlarge and enhance each other.

SUMMARY

Crossing media boundaries is not what any of the previously discussed artists are *about*, it just happens to be what they do in order to create their work. They are, simply, artists. They pursue their ideas to whatever ends, and are not deflected by any of the media barriers they may come across. I would love to be able to say here that drawing lends itself particularly well to this cross-cultural work, as it has such a variety of surfaces and materials to choose from. Although all that might be true, it misses the point, alas. And the point is that the art is what matters, not media one-upmanship. Here in this contemporary drawing book, I just want to say that if your art takes you out of drawing and into some other medium, follow it. You need to unhesitatingly go where the ideas and imagery take you. Don't worry about it, and don't look back.

INTENTIONALITY

H ere we are at the final concept: intentionality. As I said in the introduction, intentionality is the over-arching concept in contemporary drawing. It is the one main concept that every contemporary drawing artist needs to understand and use. It is what makes the difference between art with thought and meaning, and something soulless.

OPPOSITE Louise Kikuchi, *Las Meninas,* 2004, Sumi ink and gansai on paper, 34^1/$_2$ x 27 1/$_2$ inches (87.6 x 69.9 cm) Photo: Spike Mafford

Kikuchi did this drawing after having seen Velazquez's most famous painting of the same name. The references she makes to it are subtle and symbolic.

WHAT IS INTENTIONALITY?

Intentionality has to do with making decisions on purpose, and with being aware of all the things that have to be decided upon. Each of the previous chapters is about a facet of contemporary drawing. Every drawing artist must decide on what surface to use, with what materials, at what scale, involving what compositional structure, indicating what kind of space, and exhibiting what kind of marks. Furthermore, all these decisions are crucial to the meaning and message of the drawing, and so must be made within that context. Drawing artists must also, of course, decide why. The artist's intentionality unites all these concepts into the cogent whole of the finished drawing.

For those who are already consciously and intentionally making their artistic decisions, this chapter may seem obvious, or even superfluous. After all, don't all artists know what they're doing? Doesn't everyone already decide these things? Well, not exactly. What I am talking about here is not just deciding, but *consciously* deciding, not just choosing,

say, one paper over another, but being fully aware of the implications of that choice to all the other aspects of the drawing, and ultimately to the meaning you intend the drawing to present to the viewer.

I am also talking here about how every drawing is more than the subject matter. Every drawing is, in fact, a combination of what the drawing is of, and both how and why the drawing is made. All three of those things are what make the finished drawing, all strongly affect the message of the drawing, and all must be consciously thought about and decided upon. The student of drawing tends to think only of the subject matter. To advance an understanding of drawing, both the student of drawing and the drawing appreciator need to learn to understand the how and why of drawing, as well as the what.

I would also like to say this to the art student in particular: Intentionality teaches you how to work. I do not mean that it teaches you how to make a smooth tone, or

Every drawing is, in fact, a combination of what the drawing is of,
and both how and why the drawing is made.

ABOVE Stephen Fisher, *World of Wonders*, 1991,
graphite on heavy wove paper, 26 x 31 inches (66 x 78.4 cm)
© 2010 Stephen Fisher Photo: Susan Dirk, Under the Light
Courtesy the Frye Art Museum, Seattle, WA

*The realistic drawing technique, the tabletop display
of seemingly disparate objects with the shallow space
almost bending at the edges, the carefully positioned
focal points—we are in Fisher's control at all times, as he
presents us with questions about the truth of drawing.*

a skillful gestural line. What I mean is that intentionality teaches you how to put your drawing skills to work, and to work hard, in the service of your ideas. To make art is to pursue an idea in a visual way down a kind of a logical path to whatever end happens to be there. As a student in an art class, you learn techniques and hone skills, but that is just the beginning. You must also be able to follow an idea, through many drawings, to its conclusion. To do this well, you need to be intentional. You must question your work in each drawing. Does the surface you chose help or hinder the tools you chose? How does the mark-making contribute to your idea? What does the space do? Does the composition move your eye the way you want it to? What does the scale you chose say about the meaning? And finally, is your idea being presented clearly?

These questions cause you to deal deliberately and *intentionally* with the abstract issues of your drawing. Whether you are trying to make a picture *of* something, or whether you are trying to have some part of the act of drawing be the picture, you must deal intentionally with the abstract issues of surface, mark, space, composition, scale, and materials. When you ask each of these questions while looking at the first drawing of your idea, the answers will show you what the problems are, and how to pursue solving them in your second drawing. And when you ask these questions of your second drawing, the answers will guide your third, and so on. Each drawing will be different and each will open doors of understanding. You will find yourself making ten drawings where you would previously have only made one, but you will also find yourself working with a specific purpose in mind, toward the defined goal of solving the problems of the various abstract issues—a goal that, when reached, will make you a better artist. The quantity of drawings will depend on the quality of the idea. If it is a good one, many drawings will grow out of it. If it is not so good, then you will feel the idea wither under this scrutiny, and dry up before long. Chances are, however, that a better idea will have presented itself in the meantime.

Look at the work of mature contemporary drawing artists and you will see this very process. *How is it,* you may wonder, *that anyone can do so many drawings of that one thing, be it night skies, or grids, or, dare I say it, buttons?* The answer is that all these artists are pursuing and questioning abstract ideas through the vehicle of those images, and so when you look more closely, you will see beyond the images and into the variations of those internal ideas.

The cat is surrounded on three sides by flowers that repeat in patterns and cadences. The variations in color and density of the wrinkled papers and the drawing lines lead our eyes across and around, ending, for me anyway, with pleasure in the symmetry of the cat's position, and the comfortable square balance of the entire composition.

Intentionality means working on your art consciously. Consciousness in drawing calls upon the artist to think holistically about the drawing, to continuously think of all the concepts and how they interrelate, and to remember that every decision has a reason behind it, a reason that pertains to the meaning of the drawing. It takes practice to become conscious of things previously done unconsciously, and it takes practice to assess those things and then choose to either continue them or change them. Those are, in fact, the two steps you need to take to arrive at intentionality: step one, become aware of what is being done, and step two, decide whether to continue or to change what's being done. Consciousness in drawing is one of those states of mind that, once you reach it, you can't imagine the time before reaching it. Once you know it, you can't return to not knowing it. When you become conscious and intentional, you cross over from some realm of ignorance to true awareness.

There are simple ways to see this in drawing. When looking at a drawing, just ask yourself if the artist is being intentional, is making decisions on purpose about certain materials, surface, scale, composition, space, and mark-making. Does the title help you discern what's going on? By learning to see intentionality in the work of other artists, you can learn to arrive at it in your own work. The methods I'll describe here seem almost too simple, but I think they work, and will help.

Look at Art

To start with, look at a drawing with pencil and paper in hand, and make a list of everything, absolutely everything, that you see. Then ask the following questions, which all boil down to why the artist is doing what he or she is doing.

- Has the artist shown a relationship between the negative spaces and the forms?

- Has the artist shown a relationship between the surface and the mark?

- Is it clear to you why the artist has chosen certain materials and a certain surface?

- Does the scale tell you anything?

- Has the artist been clear in how space is depicted? For instance, is the space illusional or flat or both, and does it seem to be on purpose?

- What is the eye level?

- What is the message, and is the message clear?

- What helps, or hurts, the clarity of the message?

By making the list and asking the questions, the first thing you will notice is that you are spending much more time looking at and studying a single drawing than you ever did before. This is helpful to your understanding of contemporary drawing, of course, and is certainly beneficial to your own work, and so is worth doing. This process is especially helpful when you are looking at a show of someone's drawings, so you can see more than one piece. When you have the chance to see more than one, then it becomes even easier to discern what is done intentionally, and what is not.

OPPOSITE Margaret Davidson, *Breathing,* 2004, colored pencil on Twinrocker Cripple Creek paper, 17 x 14 inches (43.2 x 35.6 cm)
© 2010 Margaret Davidson; Photo: Nancy Hines

I critique this work on the following pages.

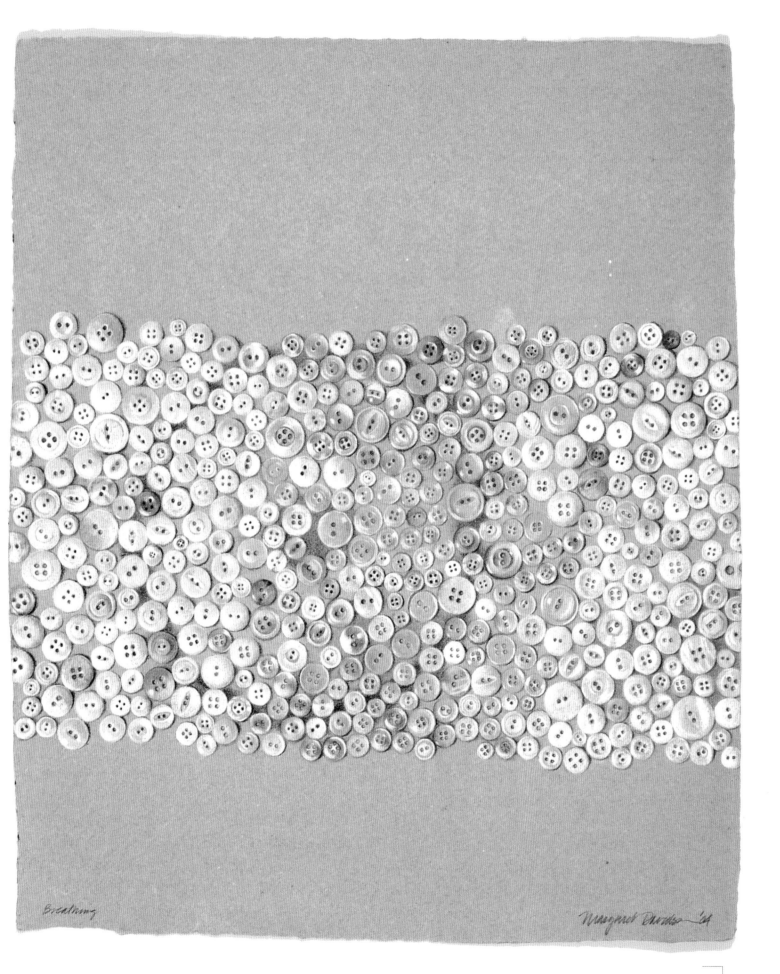

Breathing

Margaret Davis '04

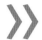

USING A CHECKLIST

To learn intentionality it is helpful to apply a checklist of questions when looking at other people's art, and also when looking at your own work. I put one of my own drawings on page 179 as a test case. This is a drawing that I think has some good qualities and also some problems. By running it through the process described on page 178—listing everything in the image, and then asking the questions—I hope to discover the solution to the problems here.

FIRST, THE LIST:

- Gray handmade paper that is almost, but not quite, square. Format is vertical rectangle.

- Buttons drawn in a band across the drawing, touching at each side.

- Band of buttons is about half the height of the paper.

- Band of buttons is positioned below center, so there is an area of gray paper above and another area of gray paper below the band of buttons.

- The upper area of gray paper is larger than the lower one.

- The buttons are all shirt buttons, in that they all have holes.

- Many buttons are white and opaque; some are clear and transparent; and a few are slightly colored.

- Each button casts a slight shadow to our right.

- There is some sort of tonal pattern under some of the buttons.

- The tonal pattern appears to be a large circle, almost as high as the height of the button band, with a dark spot in the middle of it.

- This tonal circle is off center, more to our left.

- The buttons seem to fall into a color pattern, with white and opaque buttons on the left and right of the band, and clear buttons more or less in the middle of the band, and then more opaque buttons on the right.

- The clear buttons are positioned over the right half of the circular tonal pattern.

- Title: *Breathing*.

NEXT, THE QUESTIONS:

Has the artist shown a relationship between the negative spaces and the forms?

Actually, I have not done this very well. It is true, the band of buttons show gray paper in between each button and also as part of some buttons, so within the button band there is a good interrelationship between the positive and negative; however, the whole button band does not relate well with the upper and lower bands of paper.

Has the artist shown a relationship between the surface and the mark?

Yes. The gray of the paper works as both background and button, and the colored pencil works as both button and shadow.

Is it clear to you why the artist has chosen a certain material and a certain surface?

Yes. It's clear that a tonal paper is better for drawing white and clear things on, and it is clear that a smooth paper is better for clean edges and smooth tones.

Does the scale tell you anything?

The scale seems to need to be actual size for the buttons to be believable. The believability of the buttons appears to be important.

Has the artist been clear in how space is depicted? For instance, is the space illusional or flat or both, and does it seem to be on purpose?

The space is supposed to be both flat and dimensional, but this image does not show enough flatness.

What is the eye level?

The eye level is straight on.

What is the message, and is the message clear?

Here, at last, is when the title of the drawing is considered. The title is *Breathing*. This should provide a clue. However, what the message is, with the underlying circular pattern, is not clear.

What helps, or hurts, the clarity of the message?

The title suggests the sequence of breathing in and breathing out, so positioning the buttons in a band to be read from left to right was meant to suggest that. Therefore, the composition was supposed to help in delivering the message of the drawing, but I don't think it is very clear. In addition, the underlying circle pattern is not made clear at all. It's true, sometimes the meaning is intended to be hidden, but then *that* idea should be clear. In this drawing, it is not clear if the meaning is supposed to be hidden or not.

From this assessment I have learned what I did not know before about this drawing. I now see that I have not fulfilled two goals: one, to be both flat and dimensional, and two, to be clear in my message. Knowing that, I can now work further on this drawing and try to solve both of those issues. This knowledge is extremely helpful for this drawing, and also for future ones.

Apply This Process

By applying the process—first introduced on page 178 and explored in depth on pages 180 and 181—when looking at other art, you can then learn to do it with your own work. When drawing, we develop blind spots, problems we stop being able to see, and other areas we love too much to judge fairly. By looking at and studying your own work this closely, and by asking yourself these questions, you can push your work, and yourself, closer toward two things: discovering ideas you want to draw, and depicting those ideas more clearly. When you arrive at that state of mind, then you will find that you can trust yourself to be honest and open about your own drawing, and thus able to move forward and improve. Agnes Martin said it best:

> If you want to know the truth you will know it. The manipulation of materials in art work is a result of this state of mind. The artist works by awareness of his own state of mind.[1]

1 Agnes Martin: *Writings,* page 93.

SUMMARY

Intentionality is a state of mind wherein decisions about drawing are made consciously, in full awareness of the effects every decision has on every other decision. It is possible to learn intentionality by studying other artist's drawings and doing two things: listing everything in the drawing, and asking the questions listed here. At the same time as studying the drawings of others, assess your own work. Looking, making the list, and asking the questions will immeasurably help you toward arriving at intentionality and thus improving your art.

Intentionality is a state of mind wherein decisions about drawing are made consciously, in full awareness of the effects every decision has on every other decision.

OPPOSITE Agnes Martin, *Untitled,* 1963, ink and graphite on paper, 9 x 8 $^{15}/_{16}$ inches (22.9 x 22.7 cm) Courtesy of the Seattle Art Museum, Gift of Margaret Smith © 2010 Agnes Martin/Artists Rights Society (ARS), New York, NY

In this drawing, Martin's grid is not a grid, causing us to look at it with no assumptions, and just see the lines—how they cross or connect, and how they relate to the underlying tonality.

67

a·martin '63

AFTERWORD
CONSCIOUS INTENT AND GREATER CHOICE

Drawing has indeed changed.

Drawing has indeed changed, and has done so, in my opinion, in the best possible way, in that it has not eliminated any of the old ways, but simply added to them and expanded in scope. This means, of course, that the term "contemporary drawing" refers to every kind of drawing with every kind of imagery and every kind of intention and meaning from 1950 to today. Contemporary drawings are about everything, by which I mean to say that they cover the entire range—from drawings that are about a visual subject all the way to drawings that are about the nature of drawing itself.

The biggest change and expansion that has happened in the world of drawing is in the thinking that drawing artists must learn to do. Artists today have many more choices in imagery and materials than they did in the past. To navigate this ocean of choice they must understand and work with the abstract issues of surface, mark, space, composition, scale, and materials—all issues that they must deal with consciously and intentionally. The artists who recognize the importance of thinking about and working with these underlying abstract issues—whether they are creating realistic pencil drawings of a still life or are making a random collections of marks related to some force of nature— will succeed in making the art they want to make.

All of the abstract issues, which have been explained in the chapters in this book, have also increased in scope and expanded in complexity. To begin with, drawing surfaces, which used to be just paper, have expanded to include various kinds of walls, wood, cloth, glass, and many natural objects. Paper choices have become more numerous as well, with papers being made from things as diverse as plastic and dung. This expansion is a result of artists doing two things: recognizing and experimenting with the fundamental role played by the surface in the act of drawing, and taking drawing out of the frame, so as to bring it into a closer and possibly more perishable contact with other people and with daily life.

Mark-making continues to involve a response to surface, but its repertoire has been expanded by contemporary artists to include marks powered by forces, both natural and cultural, that skate on the edge of anyone's influence. It is interesting to find, however, that artists still make lines, tones, dots, and dashes, be it by hand or by machine or by a force beyond their control. The touch of the artist's hand is something that has traditionally been prized as an attribute of drawing. In contemporary drawing it is still prized, and is also being tested and played with by artists who use machines and those who offer up the act of mark-making to natural forces. Both are testing the edges of that human touch, and arriving at a variety of answers.

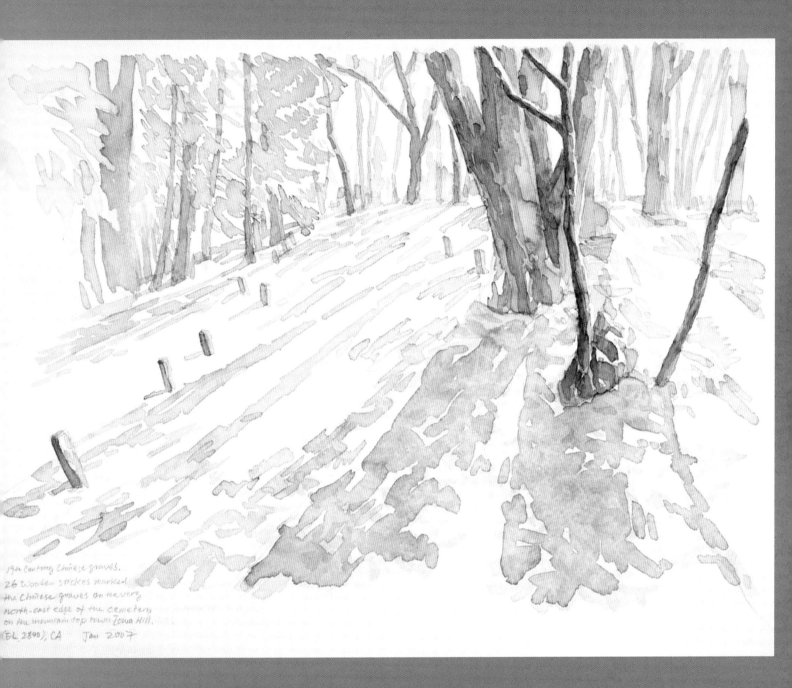

19th Century Chinese graves.
26 Wooden stakes marked
the Chinese graves on the very
north-east edge of the cemetery
on the mountain top town Iowa Hill.
(EL 2840), CA Jan 2007

ABOVE Zhi Lin, *Five Nineteenth-Century Chinese Graves in Iowa Hill, California*, 2009, Chinese ink on paper, 8 ³/₄ x 12 inches (22.2 x 30.5 cm) © 2010 Zhi Lin Courtesy of Koplin Del Rio Gallery, Culver City, CA

Lin's ink wash drawing of Chinese graves in California provides us with the sense that, by working in this most ancient and traditional Chinese technique, he is reclaiming these lives for their homeland. His technique and materials are as deeply connected to his message as is the subject.

> Contemporary drawings are about everything, by which I mean to say that they cover the entire range—from drawings that are about a visual subject all the way to drawings that are about the nature of drawing itself.

The nature of space in drawing has undergone significant change, in that it has become something artists are now conscious of, and consciously working with. Drawing artists today work with the reality of space as well as the illusion of it. Some also make drawings that actually are three-dimensional. Regardless of approach, however, all contemporary drawing artists know they need to be aware of what they are doing with space. Space is a presence and an active force within a drawing, and it must be recognized as such and worked with, through composition structures, surface choices, and mark-making decisions. The most common problems in drawing arise because the artist is thinking about the subject matter too much, and not attending to that subject's relationship with space.

The concept of composition in drawing has doubled. To a compositional structure wherein the artist seeks a balance of various visual elements and an eye pathway of some kind, can be added a new structure of "overallness," with no eye pathway and no dominant imagery. Artists working with this new structure still have balance as their ultimate goal, but they arrive at it differently, and provide a different aesthetic experience along the way.

The ability to work at vastly different scales is also a significantly new thing in drawing. This choice is due to a change in the minds of contemporary artists as much as it is due to a greater range of large materials. The fear of the fragility of drawings is gone, as is the desire to protect them under glass all the time. Large drawings still have the touch of the artist's hand and the sense of immediacy we all love, while small drawings, both small in format size and small in mark size, continue to enthrall. Key to the concept of scale is the drawing's relationship with the viewer; this is perhaps more true when thinking about scale than when dealing with any other concept. Large drawings have a very different relationship with the viewer than small drawings. Large drawings demand space and a range of distances for viewing, and can even overwhelm, whereas small drawings are always intimate, meant to be viewed up close, and sometimes quite private.

The drawing materials available to artists include all the old classics, but also feature new items. In one single shopping trip, for instance, you can buy papyrus, which stems from 6000-year-old technology, and Yupo, invented quite recently. These materials show us that drawing is indeed an eternal art form, both ancient and new.

Over all of this new expansion of choice and understanding of the abstract issues in drawing lies the most important change needed in the minds of contemporary artists. This change has to do with consciousness. To be a good contemporary artist you must work in a state of clear awareness and intent. To arrive at this state takes deliberate and repeated work, making a list of everything that is in a drawing, and going through a checklist of questions and answers about the drawing. But once you are there, the path you are following in your own work becomes clearer, you become more focused, and you do your own work better. This does not eliminate play, or chance, or randomness—there's still plenty of opportunity for working with the intention of playing, and letting the artistic chips fall where they may. However, it's really only through consciousness, through this awareness that you can improve. When you reach the point where you make your artistic decisions in a state of awareness of their various interconnected effects, that is, when you act intentionally, then you will be able to follow your ideas further, delve deeper into your imagery, and work harder with better results. That is what every good artist, whether obscure or famous, is always working for.

ABOVE Margaret Davidson, *Button Rain,* 2005, colored pencil and
watercolor on paper, 24 x 30 inches (61 x 76.2 cm)
© 2010 Margaret Davidson; Photo: Cary Cartmill

*In this drawing there are at least three layers, each of which is
engaged in translucency and shimmer. The surface and the image
dance, with some marks in the paper, some marks on it, and some
even hovering in front of it.*

BIBLIOGRAPHY

Accame, Maria and Ester Coen. *Sol LeWitt: Wall Drawings allo Studio G7*. Bologna, Italy: Damiani, 2006.

Aristides, Juliette. *Classical Drawing Atelier: A Contemporary Guide to Traditional Studio Practices*. New York: Watson-Guptill, 2006.

Arnheim, Rudolf. *The Power of the Center: A Study of Composition in the Visual Arts: The New Version*. Berkeley and Los Angeles, CA: University of California Press, 1988.

Basualdo, Carlos, ed. *William Kentridge: Tapestries*. (Philadelphia Museum of Art) New Haven, CT: Yale University Press, 2008.

Bouleau, Charles. *The Painter's Secret Geometry: A Study of Composition in Art*. New York: Hacker Art Books, 1980.

Brown, Kathan. *Ink, Paper, Metal, Wood: Painters and Sculptors at Crown Point Press*. San Francisco: Chronicle Books, 1996.

Codognato, Mario, ed. *Brice Marden: Works on Paper 1964–2001*. London: Trolley, 2002.

Cummings, Paul. *Twentieth Century Drawings from the Whitney Museum of American Art*. New York: Whitney Museum of American Art, 1987.

Davies, Hugh M., and Kathryn Kanjo. *Nancy Rubins*. San Diego, CA: Museum of Contemporary Art, 1995.

Dexter, Emma. *Vitamin D: New Perspectives in Drawing*. New York: Phaidon, 2005.

Doczi, György. *The Power of Limits: Proportional Harmonies in Nature, Art, and Architecture*. Boston, MA: Shambhala Publications, 1981.

Elderfield, John. *The Modern Drawing*. New York: Museum of Modern Art, 1983.

Erickson, Britta. *Words Without Meaning, Meaning Without Words: The Art of Xu Bing*. (Arthur M. Sackler Gallery of the Smithsonian Institution) Seattle, WA: University of Washington Press, 2001.

Fine, Ruth. *Contemporary American Realist Drawings: The Jalane and Richard Davidson Collection at The Art Institute of Chicago*. Chicago: The Art Institute of Chicago, 1999.

Finlay, Victoria. *Color: A Natural History of the Palette*. New York: Random House, 2002.

Frankel, David, ed. *Russell Crotty*. (CRG Gallery and Shoshana Wayne Gallery) Seattle, WA: Marquand Books, 2006.

Garrels, Gary. *Plane Image: A Brice Marden Retrospective*. New York: Museum of Modern Art, 2006.

Garrels, Gary. *Drawing from the Modern: 1975–2005*. New York: Museum of Modern Art, 2005.

Gray, Cleve. "Walter Murch: Modern Alchemist." *Art in America No. 3* (June 1963): 80–85.

Hartz, Jill, ed. *Agnes Denes*. Ithaca, NY: Herbert F. Johnson Museum of Art, Cornell University, 1992.

Hauptman, Jodi. *Georges Seurat: The Drawings*. New York: Museum of Modern Art, 2007.

Helfenstein, Josef and Jonathan Fineberg, eds. *Drawings of Choice from a New York Collection*. Champaign, IL: Krannert Art Museum, University of Illinois at Urbana-Champaign, 2002.

Hellandsjo, Karin. *Tegn: Jan Groths Kunst*. Oslo, Norway: Museet for Samtidskunst, 2001.

Henning, Fritz. *Drawing and Painting with Ink*. Cincinnati, OH: North Light, 1986.

Hickey, Dave. *Bridget Riley: Paintings 1982–2000 and Early Works on Paper*. New York: PaceWildenstein, 2000.

Hoptman, Laura. *Drawing Now: Eight Propositions*. New York: Museum of Modern Art, 2002.

Koumis, Matthew, ed. *Art Textiles of the World: Scandinavia, Volume 2*. Brighton, England: Telos Art Publishing, 2005.

Kovats, Tania, ed. *The Drawing Book: A Survey of Drawing; The Primary Means of Expression*. London: Black Dog, 2005.

Laliberté, Norman and Alex Mogelon. *Drawing with Ink: History and Modern Techniques*. New York: Van Nostrand Reinhold, 1970.

Livio, Mario. *The Golden Ratio: The Story of Phi, the World's Most Astonishing Number*. New York: Broadway, 2002.

Lyons, Lisa and Robert Storr. *Chuck Close*. New York: Rizzoli, 1987.

Mayer, Ralph. *The Artist's Handbook of Materials and Techniques*. Third Edition. New York: Viking, 1968.

Olsen, Scott. *The Golden Section: Nature's Greatest Secret*. New York: Walker, 2006.

Pérez-Oramas, Luis. *An Atlas of Drawings*. New York: Museum of Modern Art, 2006.

Petroski, Henry. *The Pencil: A History of Design and Circumstance*. New York: Knopf, 1989.

Poore, Henry Rankin. *Composition in Art*. New York: Dover, 1967.

Posner, Helaine. Kiki Smith. New York: Monacelli, 2005.

Ramírez, Mari Carmen. *Gego: Between Transparency and the Invisible*. Houston, TX: Museum of Fine Arts, 2005.

Rawson, Philip. *Drawing*. London: Oxford, 1969.

Rosenberg, Harold. *Saul Steinberg*. (Whitney Museum of American Art) New York: Knopf, 1978.

Rothstein, Bret. *Chimeras: Stephen Fisher*. Seattle, WA: Frye Art Museum, 2000.

Stevick, Robert D. *The Earliest Irish and English Book Arts: Visual and Poetic Forms before A.D. 1000*. Philadelphia, PA: University of Pennsylvania, 1994.

Strand, Mark. *William Bailey*. New York: Harry N. Abrams, 1987.

Sussman, Elisabeth, ed. *Eva Hesse*. San Francisco, CA: San Francisco Museum of Modern Art, 2002.

Tan, Shaun. *The Arrival*. New York: Arthur A. Levine, 2006.

Tanner, Marcia. *Tom Marioni: Trees and Birds, 1969–1999*. Oakland, CA: Mills College Art Museum, 1999.

Turner, Silvie. *Which Paper? A Guide to Choosing and Using Fine Papers for Artists, Craftspeople, and Designers*. New York: Design Press, 1992.

Waldman, Diane. *Arshile Gorky: A Retrospective*. (Solomon R. Guggenheim Museum) New York: Harry N. Abrams, 1981.

Watson, Ernest W. "Walter Murch: Painter of the Impossible, an Interview." *American Artist* (October 1955): pages 22–27 and 62–63.

Weingrod, Carmi. "From Egypt to Tennessee: The Prismacolor Pencil and Its Ancestors." *Inksmith: Information for Artists from Daniel Smith*. (September–October 1989): pages 5 and 7–10.

SOURCES

Art supply catalogs are rich with information on materials and products, with some even going into the history of the substance or paper. Below is a listing of the handful of companies that produce catalogs I use, as well as the handmade paper mill in the United States that I know of. These are just the ones I use. There are more, and I look forward to discovering them.

Art Supply Warehouse
www.aswexpress.com

Artist & Craftsman Supply
www.artistcraftsman.com

Blick Art Materials
www.dickblick.com

Daniel Smith Catalog of Artists' Materials
www.danielsmith.com

Jerry's Artarama
www.jerrysartarama.com

John Neal Bookseller
www.johnnealbooks.com

Kremer Pigments
www.kremerpigments.com

Natural Pigments
www.naturalpigments.com

New York Central Art Supply
www.nycentralartsupply.com

Paper & Ink Arts
www.paperinkarts.com

Pearl
www.pearlpaint.com

Stephen Kinsella
www.kinsellaartpapers.com

Twinrocker Handmade Paper
www.twinrocker.com

Utrecht Quality Art Supplies
www.utrecht.com

INDEX